Realistic Painting *with*

Alcohol Ink

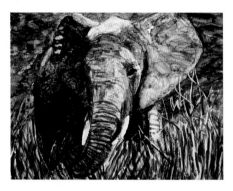

Learn Intermediate and Advanced Techniques with 17 Animal, Landscape, Still Life, and Portrait Projects

Laurie Williams and Sheryl Williams

ISBN 978-1-4972-0635-9

© 2023 by Laurie Williams, Sheryl Williams, and New Design Originals Corporation, *www.d-originals.com*, an imprint of Fox Chapel Publishing, 800-457-9112, 903 Square Street, Mount Joy, PA 17552.

Library of Congress Control Number: 2023942059

Unless otherwise noted, photography by Laurie Williams and Sheryl Williams.
Project and step-by-step photography © each respective contributor.
The following images are from Shutterstock.com: footer elements throughout book and header element throughout FM: Julia von Keller; 1–3 background and project opener background throughout: coldsun777; 4–5 background, 158 and 166–168 headers: tomertu; 24 alcohol: John Hanson Pye; 26 cotton balls: Touchr; 26 cosmetic pads: Alexander Demyanenko; 26 cotton swabs: innakreativ; 26 toothbrushes: P Maxwell Photography; 26 pipette: OHishiapply; 27 sponge: New Africa; 27 foam brushes: jessica li; 27 stir sticks: Matt Benoit; 27 canned air: wk1003mike; 28 micro tools: Sasha Turkina; 28 gift cards: smile23; 28 spray bottle: Sayers1; 31 gloves: 168 STUDIO; 31 goggles: takepicsforfun; 31 respirator: petroleum man; 62 background: bear_productions; 158 gray scale: Irina Anashkevich

We are always looking for talented authors. To submit an idea, please send a brief inquiry to acquisitions@foxchapelpublishing.com.

Printed in China
First printing

Introduction

Are you ready to take your alcohol ink painting skills to the next level? If so, you've chosen the right book! With this guide, you'll learn how to create stunning realistic art with alcohol ink! You'll be guided through the fundamentals of realistic painting, such as the process of building up layers of color and texture so that your artwork captures a sense of realism. From landscapes to portraits and everything in between, this book provides a range of fun projects designed to help you grow as an artist—and wow your friends, family, and others in the process!

When you think of alcohol ink, the last thing you might consider is using it as a medium for realistic painting. The flow of the inks lends itself to abstract and fantasy-style paintings, but once you've grasped the art of controlling the inks, the possibilities are almost endless! Its unique characteristics, such as the ability to move, blend, lift, and lighten, make it an ideal medium for learning and exploring realistic painting. Alcohol ink can easily become your gateway medium to learning core skills and techniques that can be applied to other mediums, as well.

Discovering realism in alcohol ink will help you unlock a new dimension of creativity! Whether you are a seasoned alcohol ink artist or a novice, get ready for your world to be changed by the vibrant colors, textures, and hues this unique medium offers. We are confident that you'll be delighted with the art you create, and we cannot wait to see what you do!

Laurie Williams and Sheryl Williams

Contents

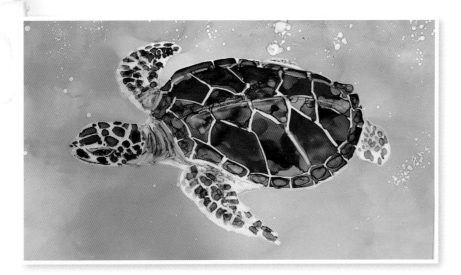

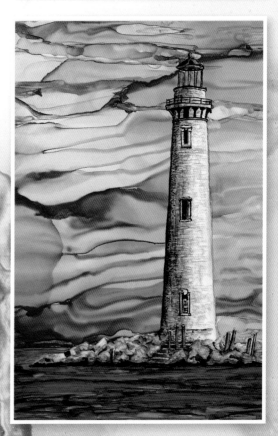

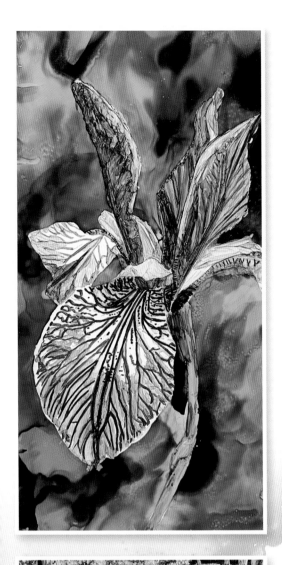

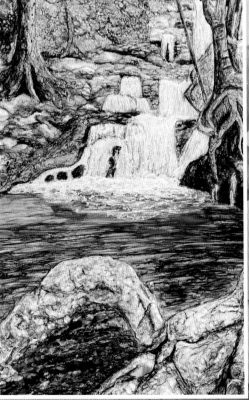

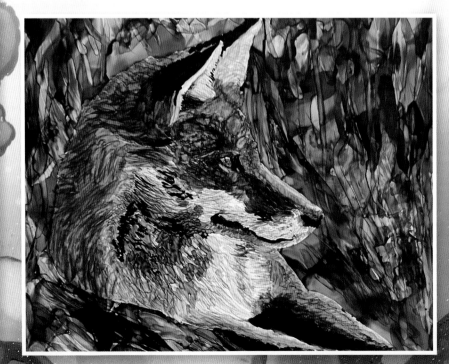

Inspiration Gallery

There are many possibilities for creating realistic art with alcohol inks, so we wanted to share just a few paintings from our contributors to inspire your artistic adventure.

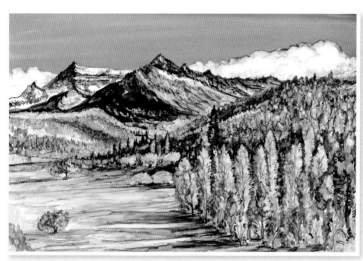

Autumn Serenity by Andrea Patton. Techniques used include perspective and distance created with saturation.

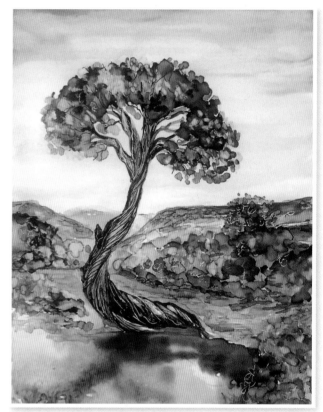

Nature's Dance by Andrea Patton. Techniques used include focal point created with detail.

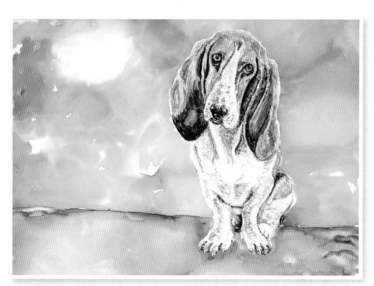

Sweet Basset Hound by Andrea Patton. Techniques used include focal point created with detail.

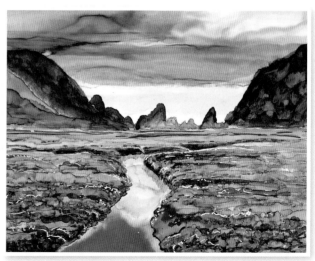

Riverside Symphony by Andrea Patton. Techniques used include perspective.

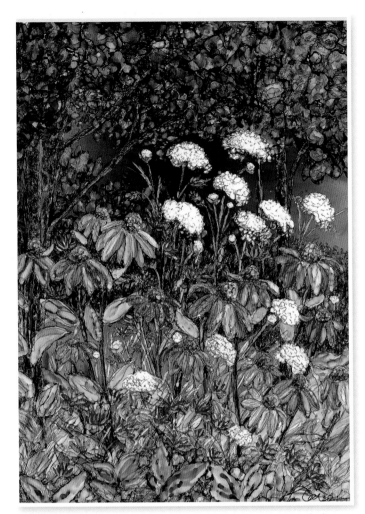

Wildflower Garden *by Korinne Carpino. Techniques used include focal point created with detail.*

Riverside Garden *by Korinne Carpino. Techniques used include focal point created with detail.*

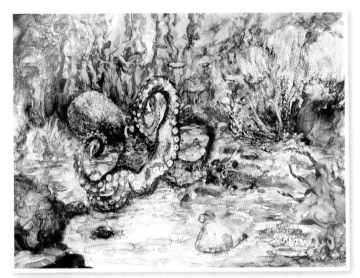

Tentacles *by Sharen AK Harris. Techniques used include focal point created with detail.*

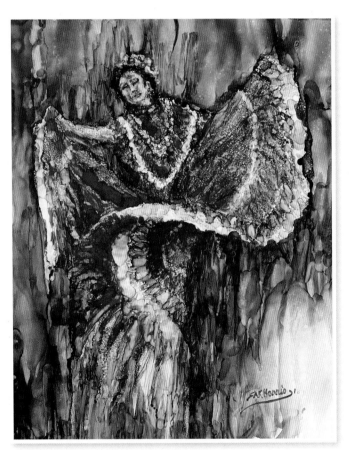

Let's Dance *by Sharen AK Harris. Techniques used include conveying motion and focal point created with detail.*

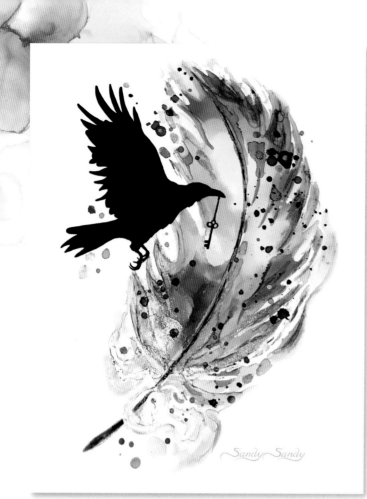

You Hold the Key by Sandy Sandy. Techniques used include focal point created with contrast.

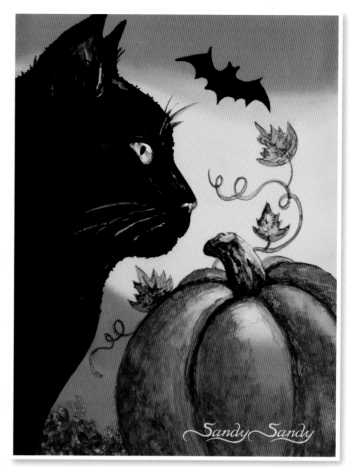

Black Cat Magic by Sandy Sandy. Techniques used include focal point created with contrast.

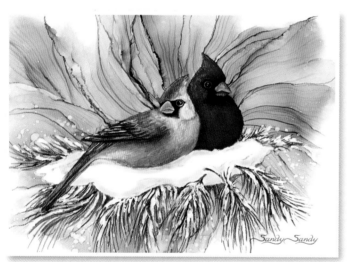

Mr. & Mrs. Red by Sandy Sandy. Techniques used include focal point created with saturation.

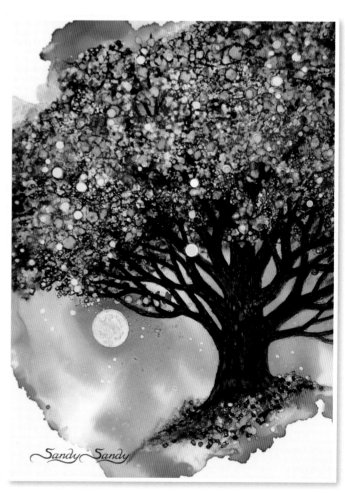

The Wisdom Tree by Sandy Sandy. Techniques used include focal point created with saturation.

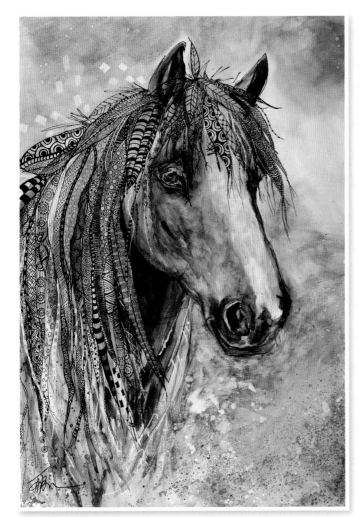

Wild and Free by Teresa K. Brown. Techniques used include focal point created with detail.

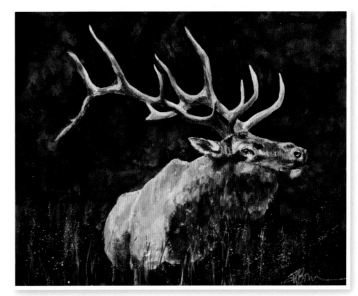

Call of the Wild by Teresa K. Brown. Techniques used include focal point created with contrast.

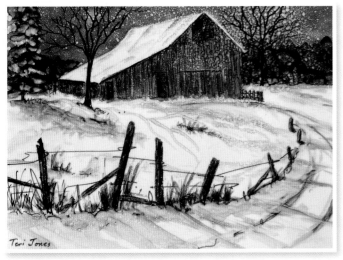

My Old Barn by Teri Jones. Techniques used include perspective and focal point created with contrast.

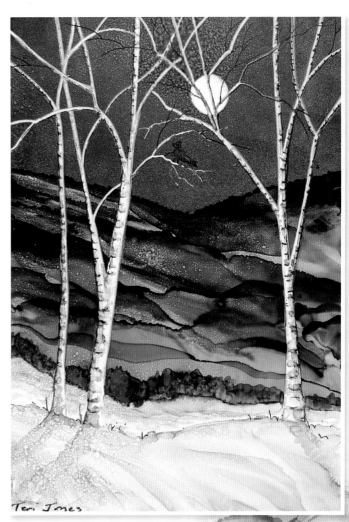

Quiet Night by Teri Jones. Techniques used include focal point created with contrast.

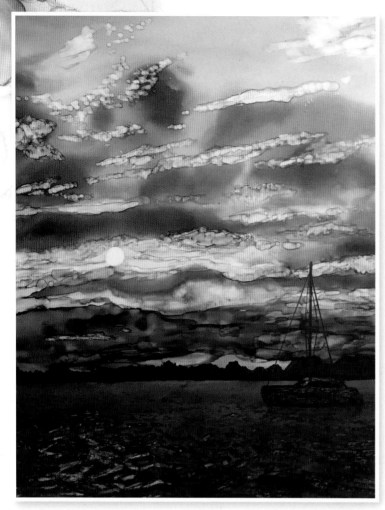

Manhassett Bay Sunset *by Vera Worthington. Techniques used include focal point created with contrast.*

The Opportunist *by Laurie Williams. Techniques used include focal point created with contrast and dimension created with shading.*

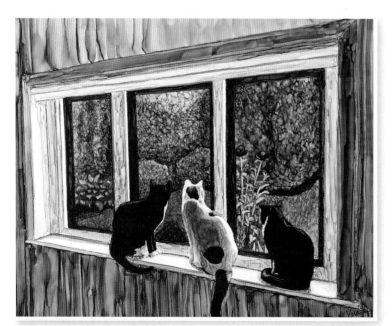

Garden Gazing *by Vera Worthington. Techniques used include focal point created with contrast.*

Bradley *by Vera Worthington. Techniques used include focal point created with contrast.*

East Hampton Waterfront by Vera Worthington. Techniques used include focal point created with contrast and detail.

A Case of You by Kimberly Langlois. Techniques used include focal point created with detail.

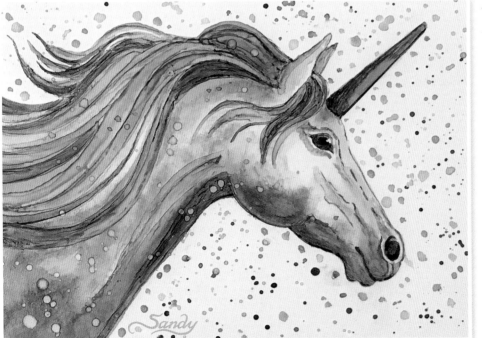

Magical Unicorn by Sandy Sandy. Techniques used include dimension created with shading.

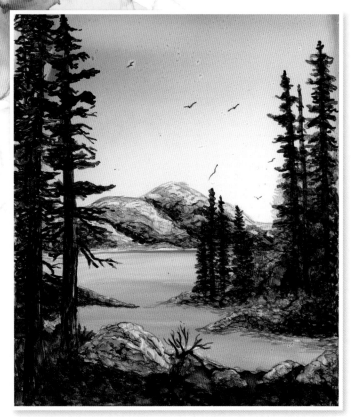

Mountain Flight by Sharon Lynn Parker. Techniques used include perspective and distance created with saturation.

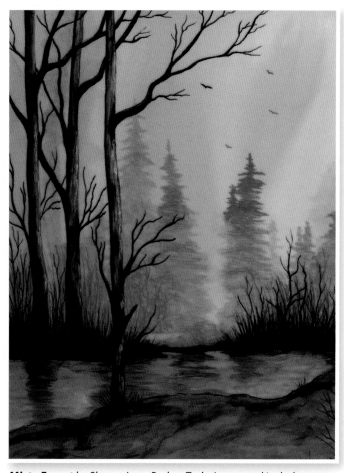

Misty Forest by Sharon Lynn Parker. Techniques used include perspective, dimension created with shading, and distance created with saturation.

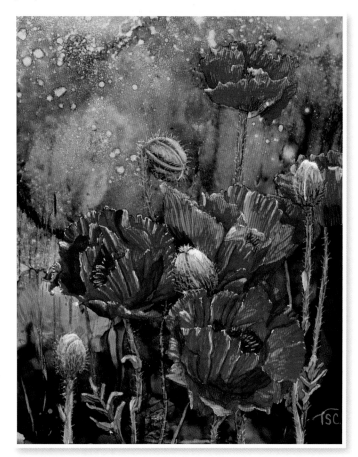

Fire-Red Poppies by Tammy Crawford. Techniques used include dimension created with shading, distance created with saturation, and focal point created with detail.

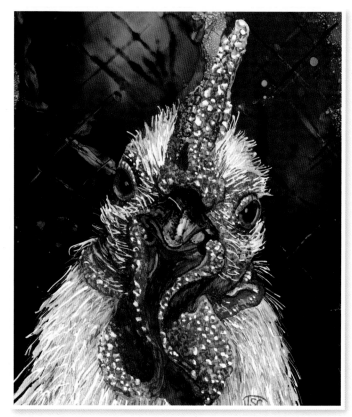

Cocksure by Tammy Crawford. Techniques used include dimension created with shading and focal point created with detail.

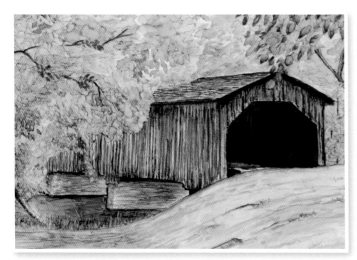

Summer's Crossing by Laurie Williams. Techniques used include focal point created with contrast.

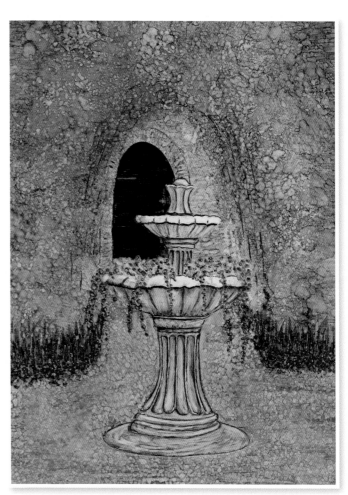

Whispering Fountain by Laurie Williams. Techniques used include focal point created with detail.

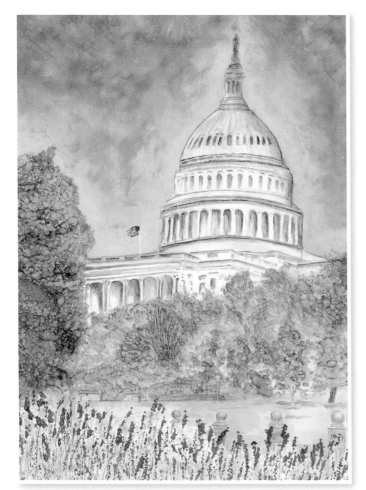

Capitol in Spring by Laurie Williams. Techniques used include focal point created with detail.

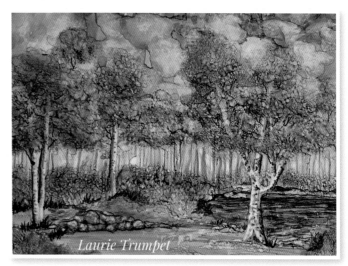

Pond of Tranquility by Laurie Williams. Techniques used include focal point created with contrast.

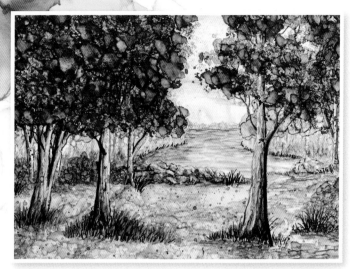

Autumn Stroll *by Laurie Williams. Techniques used include distance created with saturation.*

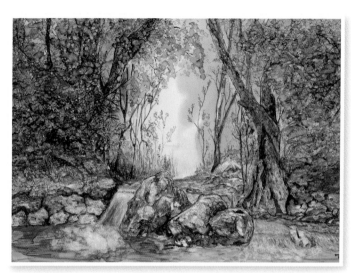

Destiny Falls *by Laurie Williams. Techniques used include dimension created with shading and focal point created with contrast.*

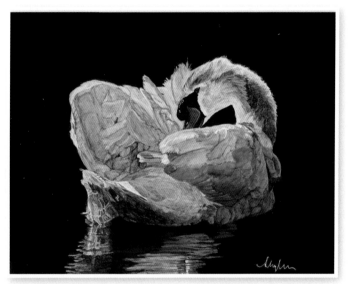

Mute Swan Preening *by Sheryl Williams. Techniques used include dimension created with shading and focal point created with contrast.*

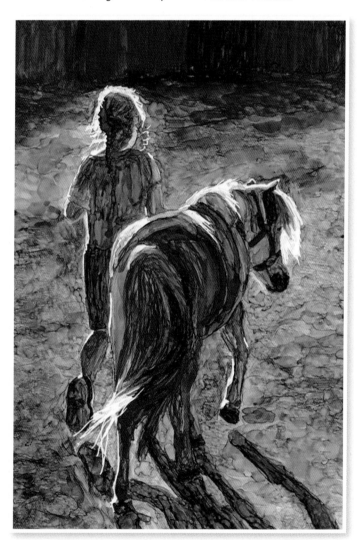

Buddies *by Sheryl Williams. Techniques used include dimension created with shading.*

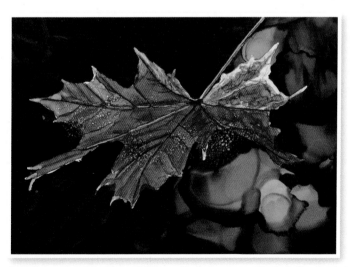

Fall Maple Leaf *by Sheryl Williams. Techniques used include focal point created with detail, saturation, and contrast.*

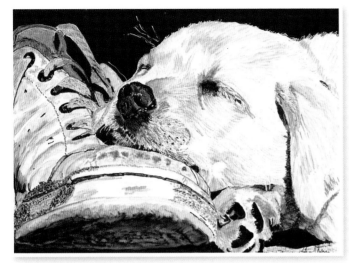

I Love My Shoe by Sheryl Williams. Techniques used include focal point created with contrast and detail.

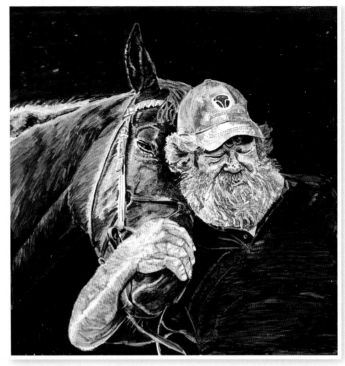

A Special Bond by Sheryl Williams. Techniques used include focal point created with contrast and detail.

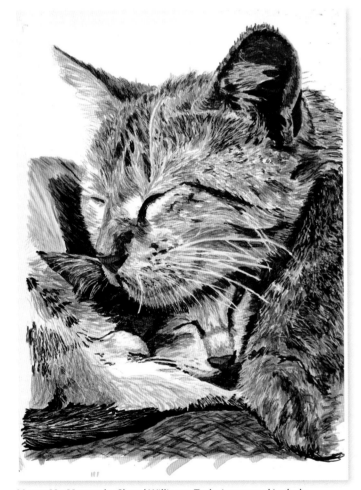

I Love My Mama by Sheryl Williams. Techniques used include texture and focal point created with contrast.

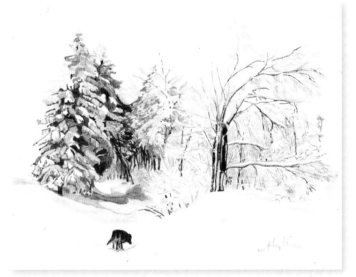

Lost Dog in the Snow by Sheryl Williams. Techniques used include perspective and focal point created with contrast.

Tools and Supplies

There is a core set of alcohol ink supplies that most artists use. With that said, however, there is an infinite number of additional supplies for creating various effects. It's practically impossible to list them all. To effectively showcase some of the most popular supplies, we've broken them down into a few categories:

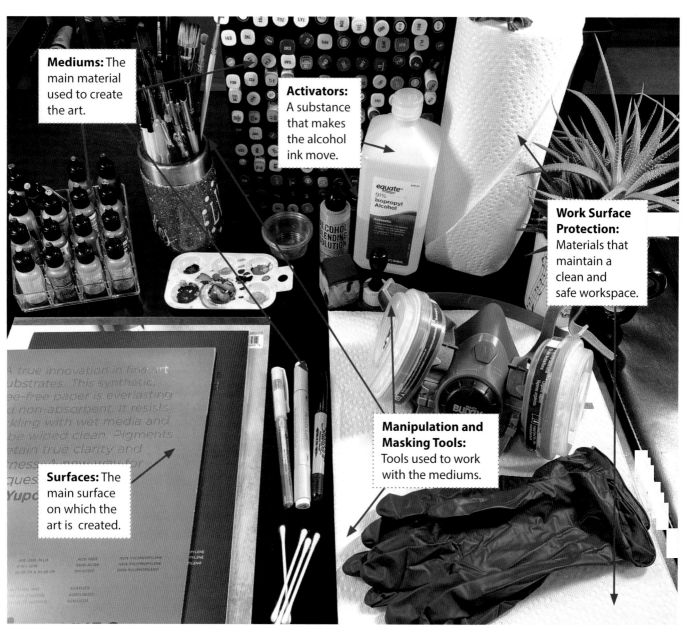

Mediums: The main material used to create the art.

Activators: A substance that makes the alcohol ink move.

Work Surface Protection: Materials that maintain a clean and safe workspace.

Manipulation and Masking Tools: Tools used to work with the mediums.

Surfaces: The main surface on which the art is created.

This is a well-stocked space for working with alcohol ink. It has bottled inks, markers, brushes, blending solution, tools, safety equipment, and more. Note that sealing and protective coatings (varnishes and sprays) aren't shown in this image because it's more efficient for us to store them where we use them. Spray coatings are best applied in a much larger open area, for example, so we store them near a suitable space.

Mediums

Mediums are the main material used to create your art, and for alcohol ink art, this includes bottled alcohol ink, alcohol ink–based markers, and various pens.

Alcohol Inks

Alcohol ink is an acid-free, vividly colored, alcohol-based dye that is liquid, translucent, and fast-drying. It can be used on any prepared surface but works best on nonporous surfaces. The main ingredients in alcohol inks are dye and isopropyl alcohol. The alcohol is what causes the ink to move, and the dye is the colorant that remains after the alcohol evaporates. Alcohol ink with higher alcohol content will move more when applied, while ink with less alcohol will move less. Many brands sell different varieties of alcohol ink products, and even within the same brand, the percentages of the ingredients may differ. It's worth noting, too, that different manufacturers use different types of alcohol.

Alcohol inks are a fluid medium and are often compared to watercolors, acrylic paints, and oil paints. Like watercolors, alcohol inks are translucent (acrylic and oil paints are opaque). Alcohol inks, however, vary greatly from these other mediums in that they can be reactivated with alcohol. The biggest difference, perhaps, is that alcohol inks are dyes that are suspended in isopropyl alcohol. All of the other mediums are pigment-based. Watercolors are pigments suspended in water, acrylic paints are pigments

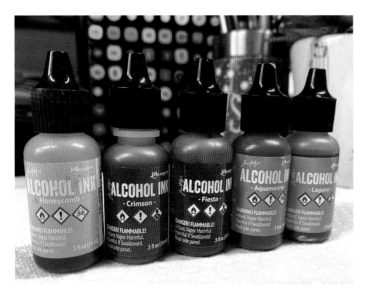

Ranger Tim Holtz is one of the most popular alcohol ink brands on the market because of the wide range of ink colors and ancillary products they sell.

suspended in an acrylic polymer, and oil paints are pigments suspended in oil—usually linseed oil. Because alcohol inks contain alcohol, they will move and remain fluid until the alcohol evaporates. In contrast, water-based mediums contain water molecules that bind strongly to each other and create solid surface tension—they will only move with gravity or interference.

As alcohol ink became more popular over the last decade, a few manufacturers moved to the forefront of the market. The following are two of the most popular brands, but some other popular ink manufacturers and brands to consider include Marabu, ZIG® Kurecolor®, Brea Reese™, and NARA.

Ranger Tim Holtz—Ranger Industries began making ink products in 1998 and is one of the leading providers of alcohol ink and other mixed-media products. They have a team of talented designers and continue to launch new products as the industry grows. Ranger's line of alcohol inks includes 87 different colors and even includes metallics, alcohol pearls, and several alloy Mixatives. Their alcohol ink comes standard in .5 fl. oz. (14.8ml) bottles. A select number of colors are also available in 2 fl. oz. (59.1ml) bottles.

Jacquard Piñata Color—Jacquard Products is a family-owned-and-operated art supply manufacturer located in Northern California that specializes in artist materials for use on fabric. They provide a wide range of supplies and materials to commercial studios and professional artists, as well as craftspeople, home crafters, do-it-yourselfers, kids, and hobbyists. Jacquard has a limited line of alcohol ink (only 23 colors), which are sold in packs of nine .5 fl. oz. (14.78ml) bottles. This "Exciter" pack includes white, black, gold metallic, and six additional colors. Jacquard also sells individual 4 fl. oz. (118.3ml) bottles for those looking to buy larger volumes of inks.

T-Rex Alcohol Inks—The T-Rex brand was founded by Tiffani and Stephen Buteau in Olalla, Washington. T-Rex inks are available in 100 unique colors. They are available in 0.7 fl. oz. (20ml) bottles, which are sold in 12-pack sets or by individual color. Select colors are available in larger 4 fl. oz. (118.3ml) bottles.

Alcohol Ink Markers

Alcohol ink markers are wonderful tools that allow you to have more control when applying inks to your pieces. They can be used to fill in spaces and, since the alcohol content is relatively low, you can use markers to layer strokes of color. There are many brands on the market and many different types available. Some brands of markers are more intense in color than others, so many artists mix different types of markers in their art. When buying markers, you should think about the cost, the range of available colors, the tip (or nib) shape, the barrel shape (is it comfortable in your hand), and the fit and color accuracy of the caps.

There are many different barrel shapes and cap fits available. Make sure the markers you use are comfortable in your hand and that the caps are secure. Shown here from left to right are Copic, Spectrum Noir, Shuttle Art, Blick Studio, and Staedtler markers.

Marker tips, known as nibs, are one of the most important things to consider, since the flexibility of the tip and the different shapes and sizes available will make different types of strokes. Most markers have two different nibs, one on each end. You'll find markers with brush-like nibs, broad chisel nibs, fine bullet nibs that are similar to brush nibs but have less flexibility, and fine tips.

You can also purchase clear blender markers or blender pens, which are colorless markers containing isopropyl alcohol or alcohol blending solution that are used to blend marker strokes and inks or to lift ink off the paper. Blender markers typically have dual tips with a bullet nib and a brush nib. Like alcohol ink markers and bottled ink, blender pens work best on nonporous surfaces.

The following are a few of the most popular alcohol ink marker brands, but some other popular marker manufacturers and brands to consider include Spectrum Noir™, Staedtler, Ohuhu˙, and Prismacolor˙ Premier.

Copic˙—Copic is a Japanese brand of refillable alcohol ink markers made by the Too Group. They are the gold standard for markers and are available in 358 colors and various nib shapes. They are also refillable, and the refills, which come in 0.42 fl. oz. (12ml) and 1.12 fl. oz. (32ml) bottles, can also be used just like bottled inks. You can even buy empty marker blanks that can be filled with different refills to create your own custom colors. They are a bit pricey, however.

Shuttle Art Art Markers—These dual-tip markers are available in 101 rich and intense colors. They have a comfortable triangular barrel and are sold at very accessible prices.

Blick Studio Brush Markers—These affordable dual-tip markers are available in 144 colors. They're refillable and the barrels have flat sides that will keep them from rolling around.

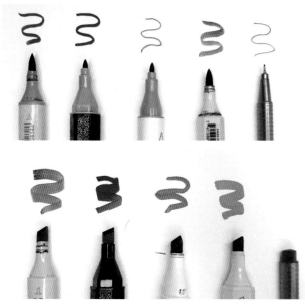

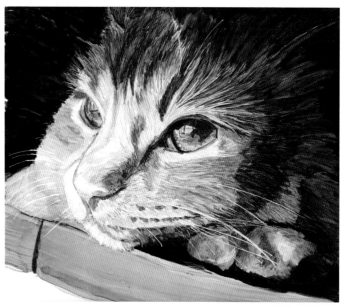

The width of the nib varies between brands (and, while most markers have two nibs, one on each end, some do not). Here are a few of the different nib shapes and sizes available. Shown here from left to right are Copic, Spectrum Noir, Shuttle Art, Blick Studio, and Staedtler markers.

This beautiful cat portrait was created with alcohol ink markers. Since the alcohol content in markers is relatively low, you can apply marker strokes on top of each other without affecting the bottom layer (making it easier to show texture—like a cat's fur).

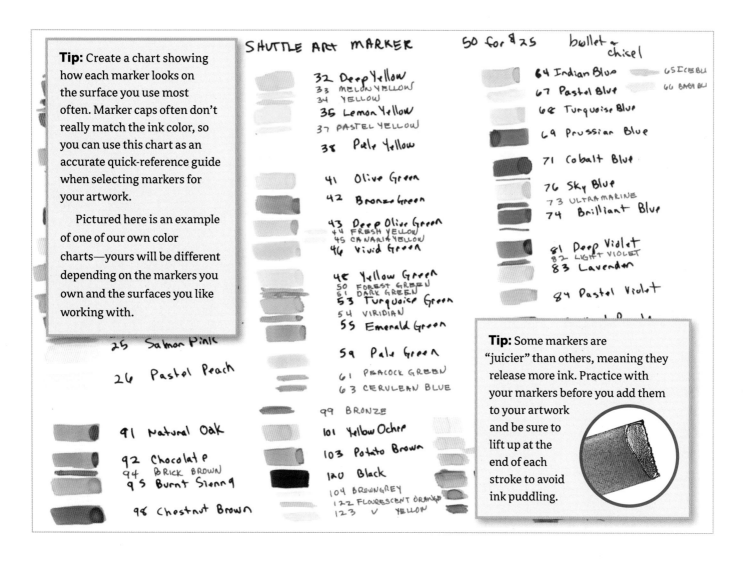

Tip: Create a chart showing how each marker looks on the surface you use most often. Marker caps often don't really match the ink color, so you can use this chart as an accurate quick-reference guide when selecting markers for your artwork.

Pictured here is an example of one of our own color charts—yours will be different depending on the markers you own and the surfaces you like working with.

SHUTTLE ART MARKER 50 for $25 bullet + chisel

32 Deep Yellow
33 MELON YELLOW
34 YELLOW
35 Lemon Yellow
37 PASTEL YELLOW
38 Pale Yellow

41 Olive Green
42 Bronze Green
43 Deep Olive Green
44 FRESH YELLOW
45 CANARIA YELLOW
46 Vivid Green

48 Yellow Green
50 FOREST GREEN
51 DARK GREEN
53 Turquoise Green
54 VIRIDIAN
55 Emerald Green

59 Pale Green

61 PEACOCK GREEN
63 CERULEAN BLUE

99 BRONZE
101 Yellow Ochre
103 Potato Brown
120 Black
104 BROWNGREY
122 FLOURESCENT ORANGE
123 V YELLOW

64 Indian Blue 65 ICE BLU
67 Pastel Blue 66 BABY BLU
68 Turquoise Blue
69 Prussian Blue
71 Cobalt Blue
76 Sky Blue
73 ULTRAMARINE
74 Brilliant Blue
81 Deep Violet
82 LIGHT VIOLET
83 Lavender
84 Pastel Violet

25 Salmon Pink
26 Pastel Peach
91 Natural Oak
92 Chocolate
94 BRICK BROWN
95 Burnt Sienna
98 Chestnut Brown

Tip: Some markers are "juicier" than others, meaning they release more ink. Practice with your markers before you add them to your artwork and be sure to lift up at the end of each stroke to avoid ink puddling.

Should You Use a Marker or a Paintbrush?

You may wonder how using an alcohol ink marker compares to using bottled alcohol ink and a paintbrush. The primary difference between using a marker or a paintbrush is the amount of ink and alcohol dispensed by each. A marker dispenses less ink and alcohol than a brush loaded with bottled ink.

Adding ink to a welled palette using a brush and bottled ink (left) and a marker (right), clearly shows the difference in alcohol dispensed. You can also see the different effects evaporation has on both.

Markers come in a huge range of colors, and you don't need to mix your own colors (although you can if needed). The alcohol content of marker ink is always the same. Blending with markers is easy (and some marker sets even include special blending tools). Blending is more controlled with a marker because there is less alcohol.

Blending with a brush and bottled inks will give you unpredictable results (left), but markers have a lower alcohol content and allow you to create a smoother, more controlled blend of colors (right).

Paintbrushes allow more control over the intensity of the color and the speed of the alcohol evaporation. It can be difficult to gauge exactly how much alcohol or ink is on your brush compared to the controlled amount in a marker's tip, but you can also more easily and precisely mix your own colors in a palette when using a brush and bottled ink.

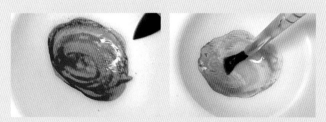

Trying to mix consistent colors with a marker is difficult because of the lower alcohol content (left). A brush and bottled ink give you greater control over the intensity and shade of your mixes (right).

Pens and Detail Markers to Use with Alcohol Ink

Alcohol inks create beautiful, poured shapes, but sometimes you want to add some fine details that require a controlled line. The best tool for this job is a pen or detail marker. Pens and detail markers work best when applied on top of dried alcohol ink to avoid smudging or smearing. When choosing pens and detail markers, you'll want to look for vibrant colors, high opacity, smoothness, smudge-proof ink, and lightfastness. Pen and marker inks can be colored with dye or pigments. Those colored with pigments will be more opaque and lightfast than those colored with dye.

Pens and markers are classified mainly by their carriers/ink types (water-based, oil-based, or alcohol-based). Oil-based and alcohol-based pens perform much the same.

Water-Based Pens and Detail Markers—Water-based pens and detail markers work well on alcohol ink. Take special care when choosing a tip as metal tips can get clogged and skip. Felt tips work well. Water-based pens include gel pens, rollerball pens, some paint markers, and fountain pens, among others.

Oil-Based and Alcohol-Based Pens and Detail Markers—Oil-based and alcohol-based pens and detail markers write better on slick surfaces than water-based

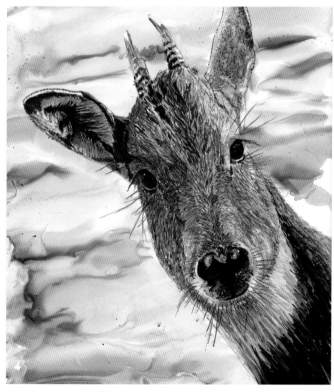

Himalayan Goral *by Sheryl Williams, demonstrates the level of fine detail you can achieve by incorporating pens into your alcohol ink art.*

ones. Permanent markers are oil-based. Alcohol-based pens include fine-detail markers made by alcohol ink marker manufacturers, such as those made by Copic.

Pens and detail markers can also be differentiated by their nib or tip. The nib dictates the width of the line, ease of application, tendency to clog, and the pressure required.

The following are a few of the most popular pens and detail markers used by alcohol ink artists, but you can also feel free to experiment with other brands to find the type you like best.

Sakura Pigma Brush—These pens are available in 11 colors and have very flexible felt tips that can make different shapes depending on the pressure applied. They use permanent, pigment-based, opaque ink that glides nicely over alcohol inks.

Faber-Castell Pitt Artist Pen Brush—These pens contain India ink, a rich pigment-based ink, and are available in 67 vibrant colors. Their ink is lightfast, permanent, waterproof and alcohol-ink proof, and transparent (so you can layer them). They come in nine sizes ranging from .004" (0.1mm) to .028" (0.7mm) and can produce fine to wide lines based on the amount of pressure applied. The tip is flexible, but not as flexible as the Sakura Pigma Brush.

Posca Paint—These paint pens come in four different tip sizes, are very opaque, and are great for signatures and doodles. There is a ball inside to mix the paint, so you should shake the pen and test it on paper before using. They come in 15 colors and are lightfast and waterproof. Always be sure to let the marks dry thoroughly.

Sakura Pigma Micron—These fine line markers have plastic nibs and come in sizes that range from very fine .006" (.15mm) to 0.24" (.6mm). The ink is pigment-based and permanent, and the number of colors available depends on the size of the tip you're using, up to 17 colors.

Stabilo point 88—These pens have plastic tips encased in metal that create .016" (.4mm) marks. They use water-based ink and are available in 47 colors.

Sharpie Water-Based Paint—These are not as opaque as Posca Paint. Press the tip down to start the flow on a test strip before applying directly to your artwork. These paint markers come in a variety of tip sizes and many colors and are fade- and water-resistant.

uniball Signo—These gel pens are available with tip sizes ranging from .009" (.28mm) to .04" (1mm). The ink used is opaque, but sometimes the rollerball will split the line you're drawing into two lines. We often use the UM-153 pen in White and the UM-120AC pen in Angelic.

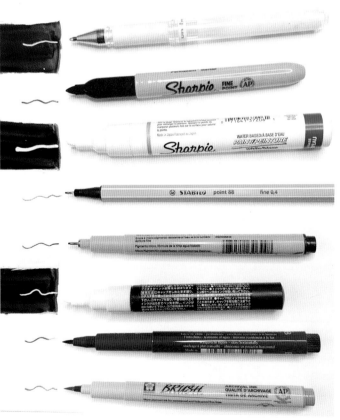

Nibs come in a variety of shapes and types, such as brush tips, fine points, bullet tips, and more. Shown here from top to bottom are the uniball Signo, Sharpie Fine Point, Sharpie Water-Based Paint, Stabilo point 88, Sakura Pigma Micron, Posca Paint, Faber-Castell Pitt Artist Pen Brush, and Sakura Pigma Brush pens.

Three Tests for Choosing a Pen or Detail Marker

Test 1—Test your pens and markers for smearing:

1. Pour some alcohol ink on white synthetic paper and let it completely dry.

2. Draw a line or scribble with your pens, then touch the pen marks and move your finger over them to see if the ink smears.

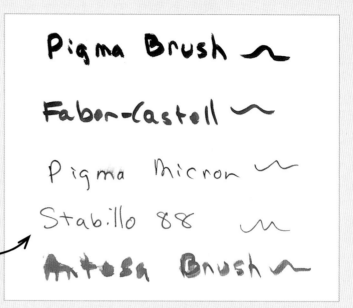

In this example test, only the Sakura Pigma Micron and the Stabilo point 88 pens smeared a bit.

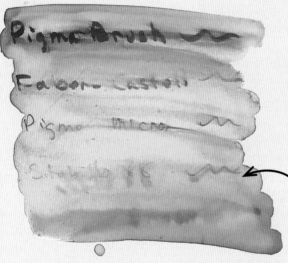

Test 2—Test the effect of pouring alcohol ink directly over the pen and marker inks:

1. Draw a line or scribble with your pens.

2. Pour some alcohol ink on top of the pen marks to see if the pen marks are still intact and the color is stable.

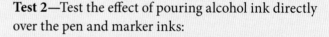

In this example test, some of the pens disappeared and all of the pens smeared when alcohol ink was poured on top of them.

Test 3—Test using the pens and markers on top of dried alcohol ink:

1. Pour some alcohol ink on your paper and let it completely dry.

2. Draw a line or scribble on top of the alcohol ink to see if the pen marks will remain intact and the color stable.

Pen and marker added on top of dry poured alcohol ink remains stable and doesn't smear. Pens and detail markers work best when added on top of dry alcohol ink.

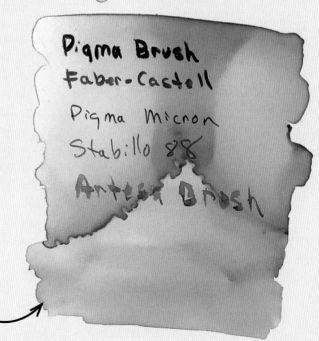

Surfaces

The ideal surface (or substrate) for painting realistic pieces with alcohol ink is a nonporous surface. A substrate's porosity is defined by the spaces or "pores" within the material's surface. Porous surfaces include things like cardboard, paper, canvas, and untreated wood. They all have cavities, which means the ink can seep into these surfaces. Because the inks are absorbed into porous surfaces, their final color may not be true, the inks may not move very far when poured, it may be difficult to blend the inks, and it may be hard to lift the ink off the surface to return to the base surface color.

Glass, plastic, varnished pieces, and metal are all nonporous and have smooth, uniform surfaces with no cavities. Vinyl and leather are also both nonporous, and many types of paper are treated to create nonporous surfaces. The characteristics we love about alcohol ink—its ability to move and glide and the resulting layers of transparent color—are best showcased by nonporous surfaces.

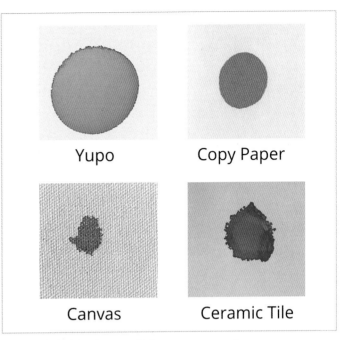

Here alcohol ink has been applied to two porous surfaces, copy paper and canvas, and on two nonporous surfaces, Yupo® synthetic paper and ceramic tile. The difference in the spread and vibrancy of the ink is obvious.

Popular Surfaces

Synthetic paper, photo paper, and treated canvas are the most popular surfaces for alcohol ink art because they are all cost-effective and easily sourced.

Synthetic Papers—Paper can be classified into pulp-based and synthetic paper. An example of pulp-based is standard watercolor paper. Synthetic paper is also called "tree-free" because it is made out of synthetic plastic-like polymers that are used to enhance the material. There are hundreds of synthetic papers, modeling films, adhesive laminates, and ceramic tile papers out there with which you can experiment, including those from brands like Yupo, Grafix® Dura-Lar® and Dura-Bright®, TerraSlate, NARA, and Yasutomo Mineral.

Photo Paper—Photo paper is a great option for those trying to avoid the high expense of synthetic paper. Use the back side to achieve the best results since the glossy side of photo paper is designed to absorb ink. The back side of most premium photo papers contains plastic components like other synthetic papers. Beware of photo papers with brand logos printed on the back side.

Synthetic paper is the most popular surface for creating alcohol ink art. It's available in many different colors and formats.

Canvas—Canvas is a popular art surface in general. Working directly on an unprepared canvas is not recommended (though several painters here do anyway) because canvas is porous, and the ink will sink into the fibers. Preparing your canvas with a primer to make it nonporous (see the Prepared Surfaces section below) is the more conventional method for using canvas with alcohol ink.

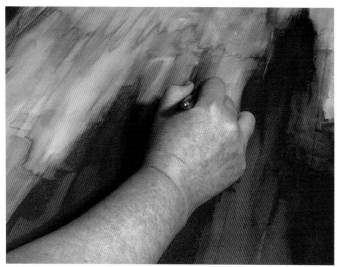

A prepared canvas is an ideal surface for working with alcohol inks.

Prepared Surfaces

While it is true that alcohol ink works best on nonporous surfaces, the truth is you can paint on almost any surface if it's been prepared with a medium that transforms it into a nonporous surface. Some of the most popular mediums to use in preparing porous surfaces are gesso, KILZ 2® ALL-PURPOSE Primer, gel mediums, and spray paint.

Gesso is a great primer for use with alcohol ink. It's an acrylic medium used to prime surfaces for painting. Typically, you will want to use a couple of layers to get the best coverage. It will give your surface a definite texture and will dry hard, so it is best applied with a soft bristle or sponge brush when being used for an alcohol ink painting. Gesso is not entirely nonporous, and the inks will sink in a bit, so be prepared for this. Also, all brands of gesso are different in consistency and material makeup and will behave differently. Test them before using them in pieces.

Most canvases are sold already prepared with gesso. Even when a canvas has been treated with gesso, the inks do tend to soak into the canvas. When you drop ink, you are often left with a blobby stain that is not easily manipulated. Artists that work on gessoed canvas usually dilute their inks with alcohol and apply them in thinner coats, building up their painting layer by layer.

Activators

The two most common activators used by alcohol ink artists are alcohol blending solution and isopropyl alcohol (91% and 99%). Alcohol blending solution is made to reactivate, lighten, remove, or blend alcohol ink colors. It is simply alcohol ink without the dye—it has the same formulation of solvents (isopropanol and glycol ether) and resins. Blending solution moves and behaves similar to alcohol ink and it's especially useful in combination with metallics and pearls. Isopropyl alcohol has a strong concentration of alcohol. When it meets alcohol ink, it displaces or pushes the ink. Like blending solution, alcohol can be used to activate, blend, and lighten alcohol ink. It's important to note that alcohol in higher concentrations (91% or 99%) work best. You can also use alcohol with lower concentrations or water-diluted alcohol to produce softening effects rather than moving or lifting the ink. If isopropyl alcohol fumes bother you, you can try using ethyl alcohol (grain alcohol) or hand sanitizer. Hand sanitizer has at least 60% alcohol in a gel formulation.

Alcohol blending solution and isopropyl alcohol are used for similar purposes, but the ways each behave with alcohol ink are quite different. Blending solution is more of a blending agent for colors, while isopropyl alcohol (being much stronger) displaces and even "erases" colors. Blending solution increases the work time required because it contains resins, which dry slower than pure alcohol. You'll have to wait longer for blending solution to dry, but it will allow you more control over your finished piece. Isopropyl alcohol generates more flow of the ink than blending solution. Blending solution is usually only available in smaller 2 fl.oz. (56.83ml) bottles, while isopropyl alcohol is available in larger bottles, usually 32 fl.oz. (946.35ml). Using blending solution can be expensive compared to using alcohol, which is why many alcohol ink artists work with isopropyl alcohol most of the time. Deciding which solution is best for your projects will likely depend on your personal preference and budget. It's great to have both in your stash to use in various situations.

Isopropyl alcohol is an inexpensive option for activating alcohol inks, but keep in mind that it is stronger and dries faster than alcohol blending solution. If isopropyl alcohol fumes bother you, try using hand sanitizer, which isn't as strong as 91% or 99% isopropyl alcohol, but will still work to activate and move alcohol inks.

Paintbrushes

Paintbrushes are probably the most common tool used in realistic alcohol ink painting. There are a number of different types of brushes that are used in various situations to create different effects. The more you paint, the more you will develop your own brush preferences and techniques.

When you dip a paintbrush into alcohol ink, the ink is pulled up into the bristles. Different brush shapes will work differently with the inks. You'll also need to consider which bristles you prefer. Brushes come with synthetic, synthetic blend, and natural hair bristles. Brushes with natural hair bristles are more delicate and more expensive. Brushes with synthetic bristles are the least expensive. Brushes that combine synthetic and natural bristles are a great middle ground. You can use any of these brushes with alcohol ink, just be sure to clean them after use. Round, angle, flat, filbert, and deerfoot stippler brushes are especially useful for painting with alcohol ink:

Round brushes are labeled with a number—the smaller the number the smaller the brush and the finer the line. Use round brushes to fill in areas and use small thin round brushes as liner brushes (to paint very fine lines). Note that brush numbers are not consistent across different brands.

Angle brushes, also known as slanted brushes, have an angled shape with a flat edge and a slanted edge. The angle allows for easy application of the ink in hard-to-reach areas, such as the corners of eyes or the crevices of a nose. An angle brush can also be used to create hair-like strokes, points, and zig zags. They are available in different sizes, from small to large, and can be made of synthetic or natural hair. The bristles are usually stiff to create sharp lines, but some angle brushes have softer bristles designed for blending.

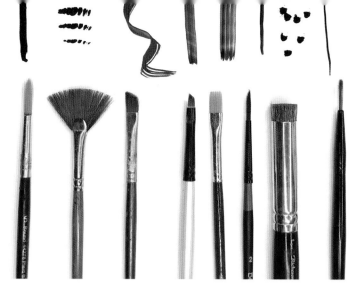

Different types of paintbrushes, from left to right: #5 Round Brush, Fan Brush, Angle Shader Brush, Angle Brush, Shader Brush, #⅜ Round Brush, Stippling Brush, and Round Liner Brush.

brush will draw up a large amount of ink. They are available in a wide range of sizes, and the bristles can be synthetic or natural hair such as hog, sable, squirrel, or other animal hair.

Filbert brushes are used for painting and blending. They are characterized by their oval or rounded shape, which allows for greater control and precision when painting curves or blending colors. Like the flat brush, the filbert brush will draw up a large amount of ink depending on its size. Filbert brushes are available in a wide range of sizes and bristle types, making them suitable for a variety of painting techniques.

Deerfoot stippler brushes are stippler brushes with a unique shape, resembling a deer's foot. Deerfoot stippler brushes are used to create textured backgrounds in alcohol ink painting. One common use with alcohol ink is for creating foliage in landscape paintings. These brushes are natural, usually made from hog hair.

Refillable Water Brushes—These brushes are commonly used for watercolor art, but you can fill them with inks or isopropyl alcohol to paint directly on a surface. They're useful for mixing your own unique colors, as well.

Flat brushes have a flat, straight edge and a square or rectangular shape. These brushes are ideal for creating smooth, even strokes and for covering large areas quickly. Depending on the size, a flat

> ### Cleaning and Protecting Your Brushes
>
> All paintbrushes need to be cleaned after use. With alcohol ink you want to swirl the brush in isopropyl alcohol and then wipe it with a paper towel or cotton ball. Repeat until all the color is gone. Always clean your brushes when changing from one color to another.

Other Manipulation Tools

Almost anything can become a tool for manipulating alcohol inks. From traditional art supplies like masking materials to unusual items like canned air or crumpled wax paper, alcohol inks are a fertile ground for experimenting with techniques and textures. The more you paint with alcohol ink, the more likely you are to find your favorite manipulation tools. For example, some artists love using a Fantastix to lift and blend their ink, while others prefer to use a blending pen or damp brush. The best way to learn your preferences is to try a variety of tools to find what best suits you and your unique artistic style.

Cotton Balls—You can dip cotton balls directly into alcohol ink to apply color to a surface or dip them in isopropyl alcohol or alcohol blending solution to add texture and lighten areas on a piece. Cotton balls are also useful color-blending tools.

Alcohol Ink Applicators—Alcohol ink applicators have a wooden handle with a hook-and-loop fastener that can be used to adhere a piece of felt to the applicator. Add one or more ink colors directly to the felt pad and dab them on your surface to apply the ink (and blend colors). The dryer the felt, the deeper the resulting color.

Cosmetic Pads—You can use easy-to-find foam cosmetic pads to create different textures and color blends in your art.

Cotton Swabs—Dip round or pointed cotton swabs into a bit of alcohol ink and use them to draw or dab directly onto your surface.

Toothbrushes—Dip toothbrushes into a bit of ink and slowly press your thumb across the toothbrush to create small droplets of ink on your surface.

Eyedropper or Pipette—Eyedroppers or pipettes give you a bit more control than standard nozzle applications. Use them to apply smaller amounts of ink, alcohol blending solution, or isopropyl alcohol.

Sponges and Foam Brushes— Apply two or three ink colors on one side of a sponge or foam brush. Then drag it across your surface to create blended color gradients.

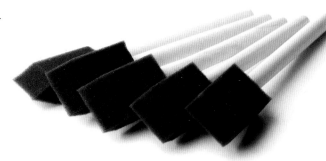

Coffee Stir Sticks—Use plastic coffee stirrers held parallel to the surface to move the inks around.

Canned Air—Canned air, more commonly used for dusting around computers, keyboards, and other office equipment, is one of the most popular tools for manipulating alcohol ink. Artists release bursts of air to blow the inks in specific directions, creating elegant flows of color.

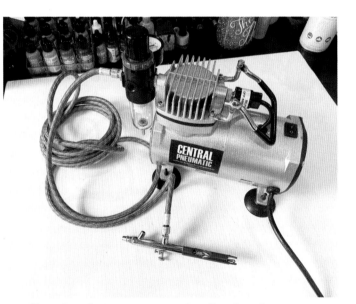

Small Airbrush Compressor—Small airbrush compressors are often used by artists and hobbyists for airbrushing paint onto a surface. With alcohol ink, they are used to create similar, more controlled, effects to those made by canned air.

Crumpled Wax Paper—Dip crumpled wax paper directly into alcohol ink and dab it onto your surface to create textured effects.

Micro Dental or Makeup Tools—These small tools commonly used for delicate tasks like artificial eyelash placement, can be used to add tiny details to your alcohol ink pieces.

Old Gift Cards—Use old gift cards to scrape and push the inks. The colors will blend, creating a great variety of textures.

Tsukineko® Fantastix®—Fantastix are white fiber-filled barrels that come with bullet and brush tips. They absorb ink to allow for precise painting and you can use them without ink to blend.

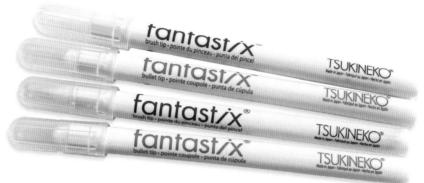

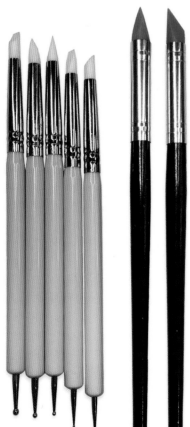

Silicone Tip Masking and Dotting Tools—Of course, masking applicators are useful for applying masking fluid, film, or tape, but you can also use these tools to create different textures in your alcohol ink pieces. The dotting tools are particularly useful for adding small dots of alcohol ink to a piece.

Mister or Spray Bottle—After you add some ink to your paper, a small mister or spray bottle will work to apply fine droplets of isopropyl alcohol on top, creating delicate misty effects.

Masking Fluid, Masking Film, or Contact Paper—These materials can be painted or adhered directly onto a piece to mask an area meant to remain free of alcohol ink. You can mask off the base surface to preserve a white spot or mask off an already dried painted element to retain the color.

Sealing and UV Protection

Alcohol inks are dye-based and translucent by nature and will fade and lose their lovely vibrancy over time if left unprotected in direct sunlight. Some colors may even fade away completely. Most artists find that their alcohol ink colors remain stable if hung indoors away from direct sunlight, and, if treated correctly, these pieces can hold their vibrancy for years to come. The following are just a few popular products that will seal and protect your pieces (see How to Seal Alcohol Inks below):

- Krylon® Kamar® Varnish
- Krylon Triple-Thick Crystal Clear Glaze
- Dupli-Color® Clear Engine Enamel Gloss
- Golden® Archival Varnish
- Rust-Oleum® Crystal Clear Enamel
- Krylon Gallery Series™ UV Archival Varnish
- Jacquard Piñata High Gloss Varnish

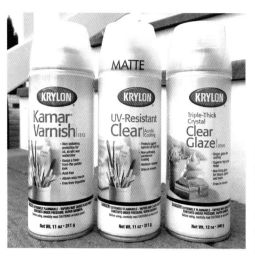

Combine a few products to protect your pieces—a varnish to set or stabilize the alcohol ink, then UV protection on top.

Other Factors That Contribute to Fading

Lightfastness is a concern, but many other factors can contribute to fading, including humidity, temperature, the substrate used, and the use of blending or lightening mediums. Humidity and temperature have both been proven to cause fading in most mediums, and some artists have found that paintings created using significant amounts of alcohol or blending solution tend to fade more dramatically than those using little to no blenders. We generally haven't had any problems when using blenders, but it's important to know it might have an effect.

How to Seal Alcohol Inks

Adding several coats of UV protectant will help combat fading but applying the UV protectant directly to alcohol ink will cause the inks to activate and move. Many UV varnishes and protectants contain isopropyl alcohol or acetone. It is essential to first apply a sealer that will not reactivate the inks. Remember to work in a well-ventilated area.

Always begin with the manufacturer's application instructions and adjust according to the humidity in your environment. We've had success using the following methods:

Method 1

Apply two to three light coats of each of the following, allowing each layer to dry before applying the next layer.
1. Apply sealant (such as Krylon Kamar Varnish).
2. Apply UV protectant (such as Krylon UV-Resistant Clear Coating or Golden Archival Varnish).
3. Apply an optional finish (such as Americana® Triple Thick Gloss Glaze™, Krylon Preserve It!®, or ArtResin®). Make sure that the artwork has had sufficient time to dry and cure after steps 1 and 2 before applying a finish.

Method 2

Apply two to three light coats of each of the following, allowing each layer to dry before applying the next layer.
1. Apply Sealant/UV protectant (such as Krylon Gallery Series UV Archival Varnish).
2. Apply an optional finish (such as Americana® Triple Thick Gloss Glaze™, Krylon Preserve It!®, or ArtResin®). Make sure that the artwork has had sufficient time to dry and cure after steps 1 and 2 before applying a finish.

If you are still concerned about the longevity of your original alcohol ink artwork, try selling prints of your art and keep your originals stored in a safe environment. There are a number of different high-quality print options available, some using archival inks that are estimated to last over 100 years! Alcohol ink art looks amazing in print format, especially on glossy or luster paper. Plus, you can resize small originals into larger prints and even print onto a number of substrates, including canvas and metal!

Note: Some of these products are difficult to source outside the United States. We recommend trying Molotow One4All Acrylic Water-Based Varnish or Ghiant Varnish H2O if you are outside the United States.

Work Surface Protection

Alcohol ink painting is often messy, so it's a good idea to cover and protect your work surface. Two popular options are paper towels and puppy training pads. Paper towels are absorbent and can be saved and used as collage papers in mixed-media projects. Puppy pads are superabsorbent and have a plastic lining protecting the surface beneath. You can also avoid the mess by using special containers for mixing or storing liquids, and there are even products available to keep you from spilling your alcohol inks. The following are a few items that can be helpful when trying to keep your workspace clean.

Place plain paper towels beneath your art to protect your work surface from drips and spills. Try cutting up the resulting dyed paper towel to create mixed-media collages.

PTFE (Teflon) Sheets—PTFE sheets are often used by crafters who need heat protection, but they will also work well to protect your work surface when using alcohol ink, as well. They can easily be wiped clean of the inks.

Glass Media Mats—Glass mats, such as Tonic Studios' Tim Holtz' Glass Media Mat, which comes in left-handed and right-handed varieties, also make great alcohol ink work surfaces. They come in a number of different sizes and are great for working with small projects. Because they are made of glass, the alcohol inks will easily wipe clean.

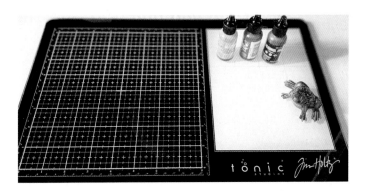

Welled Palettes—Made of plastic or porcelain, a welled palette contains several depressed areas where you can put your ink. You can paint out of them by dipping your brush, or another tool, into the palette. You can also allow the ink to evaporate to make a more concentrated ink in the well and even mix colors in the wells. To clean your palette, wipe each well with an alcohol-dipped cotton ball until all of the ink is removed. You can also protect your palette and save time on cleanup by covering it with aluminum foil!

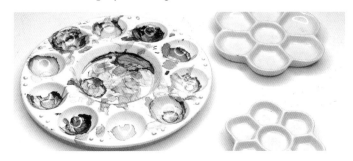

Containers—Shot glasses work well to hold alcohol or blending solution. You can also use any small jar or plastic condiment containers. Clean them out with alcohol. Some artists keep this "dirty" alcohol for painting.

Ink Cozy™—Ranger has come out with these wonderful silicone rings that work as bottle stands to keep your inks from tipping over. They really work!

Safety Considerations

Isopropyl alcohol, the base compound in alcohol inks and a common tool for working with alcohol ink, is considered to be toxic. Due to the toxicity of the medium, certain precautions, including ensuring adequate airflow in your environment and wearing personal protective equipment, should be taken when working with alcohol ink.

Adequate Airflow

When working with alcohol inks, as well as many other art materials, it is extremely important that you are working in an area that has good air circulation. Choose a studio space that has windows you can open for ventilation. A larger workspace is better than a tiny workspace, but if you do have to work in a small space or during a time when it's not feasible to open a window, it is helpful to use a small fan pointing away from you to prevent the fumes from lingering in your immediate work area. Never ventilate into another room, however.

Another option or added precaution, although not perfect, is to use an air filter and purifier. While an air purifier can significantly reduce the number of harmful elements in the air, it cannot eliminate them. An air purifier will take in the exposed air in your studio, capture the harmful vapors, and release clean air back into your studio.

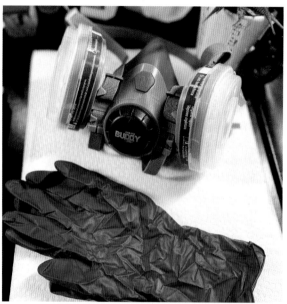

Alcohol ink is often a freewheeling, flexible medium, but safety and personal protection should always be a priority for artists working with any materials.

Personal Protective Equipment

A few pieces of personal protective equipment are recommended for working with alcohol inks and isopropyl alcohol in general. As with all art materials, it is important to carefully read, understand, and follow the safety recommendations provided by the manufacturers.

Gloves—Gloves will protect your hands from stains and messes, but they will also protect you from absorbing any chemicals from the alcohol into your body. You will want to use gloves that are compatible with isopropyl alcohol—nitrile gloves are best suited for this.

If you choose to wear gloves, be sure to use something like nitrile gloves, which are compatible with isopropyl alcohol.

Splash Goggles—Vented splash goggles will help protect your eyes from any splashes, dust, or fumes.

Some of the techniques in the book can create splashing—always protect your eyes.

Respirator—We highly recommend wearing a respirator with filters that are rated to protect against organic vapors. Choose a mask that will be comfortable for you to wear for long periods of time and has adjustable straps so you can fit the mask properly to your face. If you want to fully protect yourself from an organic vapor such as ethyl alcohol or isopropyl alcohol, you will need to wear either a half-face or full-face respirator with two organic vapor cartridges (one for each side of the mask). You'll want filters such as P95 particulate filters or something similar—the specifications on the product will tell you whether it is rated to protect against organic vapors.

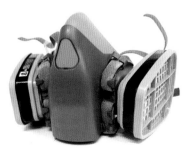

Choose a respirator mask that will be comfortable for long-term wear so you can protect yourself from vapors during the whole artistic process.

Elements of Realistic Painting

• •

Realistic painting is a style of painting (whether accomplished with oil paints, watercolors, acrylic paints, alcohol inks, etc.) that aims to depict a subject as accurately and realistically as possible. Realistic paintings often have a high level of detail and strive to capture the subtle nuances of light, color, and form that are present in the real world. They can depict a wide range of subjects, including people, animals, landscapes, and still lifes.

There are several elements artists must understand to create realistic paintings, including the use of value (the relative lightness or darkness of a color) to create the illusion of three-dimensional forms, the use of perspective to create a sense of depth and distance, and the use of color to accurately depict a subject. Realistic painting can be challenging and time-consuming since artists must pay close attention to these features, but it can be an extremely rewarding process since it allows artists to create highly detailed, near-lifelike images.

The following sections discuss a few of the important items to consider when developing realistic pieces:

- Focal and vantage points
- Perspective
- Composition and balance
- Light sources
- Color and value

Focal Points

The **focal point** is the area of an artwork that draws the viewer's attention first and holds it the longest. The focal point can be created through the use of various elements such as color, line, texture, and composition. A piece can have more than one focal point, but you don't want to work from a reference photo with too many focal points because the viewer won't know where to look. You also want to make sure the focal point is in focus and not blurry or dark.

Finding Inspiration— Copyright Considerations

What are you going to paint? This question is faced by every artist when they start a new project. Some of us immediately start sketching out original concepts. Others take their own photos. Some are inspired by photographs they find online. Still others use a mix of reference images and sketches of the same subject to combine into their finished painting.

No matter what you decide to paint, be conscious of copyright. Creative Commons (CC) is a nonprofit organization that provides a set of copyright licenses that allow creators to share their work with others in a way that allows for reuse and redistribution. The most restrictive CC license is the "All Rights Reserved" license, which does not allow for any reuse or redistribution of the work. At the other end of the spectrum, the most permissive CC license is the "CC0" license, which allows for unlimited reuse and redistribution of the work without attribution. ***Choosing images that are distributed under "CC0" is the safest option when choosing reference photos.***

Here are some of the best sources of photographs with Creative Commons licenses:

Pixabay.com—All the photos on Pixabay can be used for free for commercial and noncommercial purposes across print and digital formats and attribution is not required. Giving credit is not necessary but always appreciated. You can edit and adapt the photos as you like.

Pexels.com—All the photos on Pexels can be used for free. Pexels has its own licensing, but some photos are covered by the CC0 license. You can use all the photos for commercial and noncommercial purposes and attribution is not required. Giving credit is not necessary but always appreciated. You can edit and adapt the photos as you like.

Flickr.com—Flickr has some photos with CC0 licenses and some with "All Rights Reserved" licenses. Check the license on each photograph.

Unsplash.com—Unsplash has an "Unsplash" license, similar to the CC0 license and allowing every image to be used for free for both commercial and personal uses.

Pmp-art.com—PaintMyPhoto has many beautiful photos available. However, if you plan to sell an image based on a PMP photo, you must ask for permission from the photographer and must usually give attribution to the photographer.

Facebook.com—Facebook has many reference photo groups that give you permission to use and modify the photographers' photos. Check the terms of use on images from a group and verify directly with the owner to be safe.

Human figures, animals, letters, numbers and symbols, and man-made objects automatically attract the brain's interest and act as focal points. You can also create strong focal points in your artwork using value or color contrast, lines of motion, or areas of complexity and fine detail.

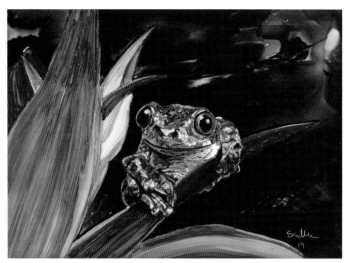

*The tree frog in **Peacock Tree Frog** is a clear focal point because of the contrast between the simple background and the highly detailed frog's skin.*

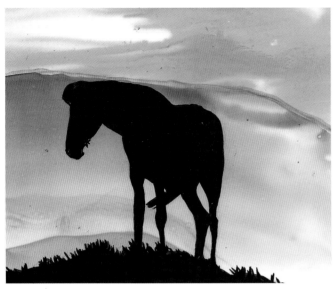

This horse silhouette creates a strong focal point through contrast. The horse is all black and the background colors are pale, so your eye goes right to the horse.

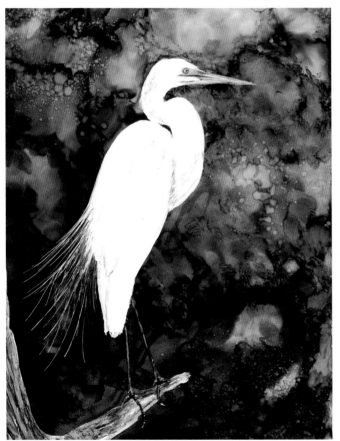

This piece by Andrea Patton creates a strong focal point via the opposite effect: the bright white bird stands out against the dark background.

Lines of motion are lines (or paths, in this case) that lead the viewer's eye to the focal point.

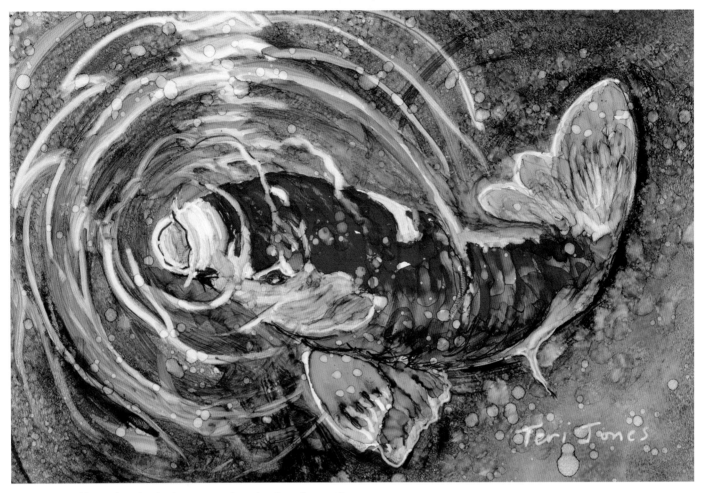

Teri Jones used lines of motion in the water to draw the viewer's attention.

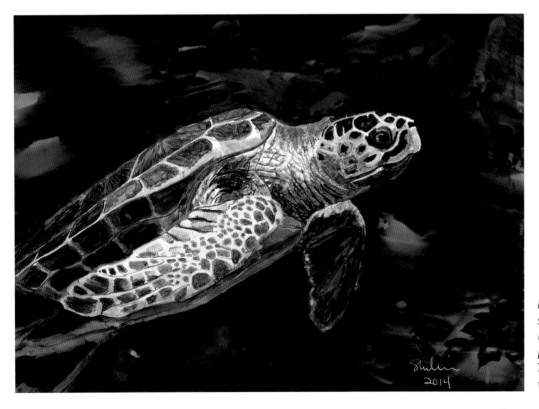

In this piece, the sea turtle is a similar color to the background, but it stands out as a strong focal point because it is highly detailed. The detail contrast grabs the viewer's attention.

Perspective and Vantage Points

In art, **perspective** is the technique used to depict three-dimensional space on a two-dimensional surface, such as a canvas or a piece of paper. It allows the artist to create the illusion of depth and dimensionality in a work and to depict objects in a way that appears lifelike and realistic. Size, placement, value, and angles combine to create the appearance of depth and distance.

The following example shows a simplified way to capture the correct perspective of a building from different angles using a horizon line and vanishing points. Pieces created with two vanishing points have two-point perspective.

In this simple drawing of a house, all of the vertical lines are parallel.

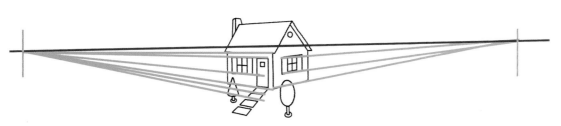

The horizontal lines are not parallel, however. Instead, they align with the horizon line (marked in red) and meet at the vanishing points (marked in blue).

Follow along with this example to draw your own house using two-point perspective:

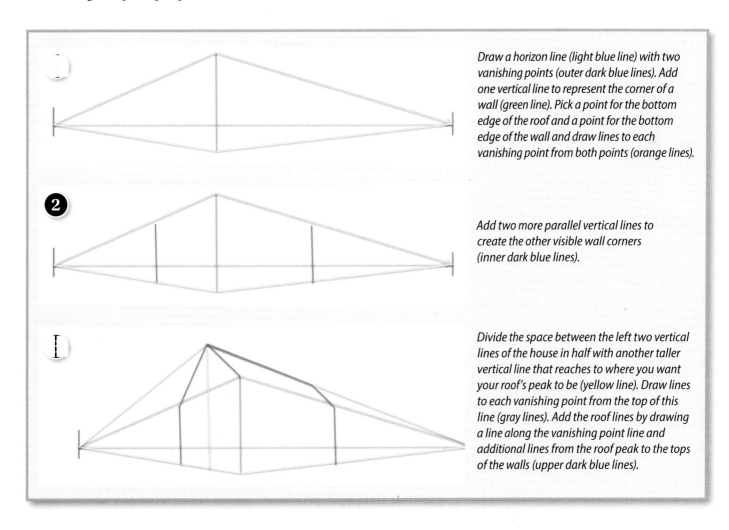

Draw a horizon line (light blue line) with two vanishing points (outer dark blue lines). Add one vertical line to represent the corner of a wall (green line). Pick a point for the bottom edge of the roof and a point for the bottom edge of the wall and draw lines to each vanishing point from both points (orange lines).

Add two more parallel vertical lines to create the other visible wall corners (inner dark blue lines).

Divide the space between the left two vertical lines of the house in half with another taller vertical line that reaches to where you want your roof's peak to be (yellow line). Draw lines to each vanishing point from the top of this line (gray lines). Add the roof lines by drawing a line along the vanishing point line and additional lines from the roof peak to the tops of the walls (upper dark blue lines).

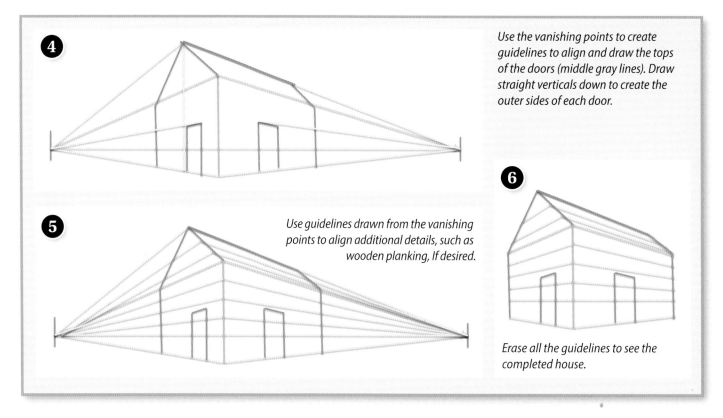

4 Use the vanishing points to create guidelines to align and draw the tops of the doors (middle gray lines). Draw straight verticals down to create the outer sides of each door.

5 Use guidelines drawn from the vanishing points to align additional details, such as wooden planking, If desired.

6 Erase all the guidelines to see the completed house.

The **vantage point** refers to the perspective from which a scene is depicted. The vantage point changes the location of the horizon line and the angle of the subject. It can have a significant impact on the overall look, mood, and atmosphere of a piece and can affect the way that the viewer perceives the scene. There are several different types of vantage points that an artist can use in their work, including:

Eye level—An eye-level vantage point is the most common vantage point and is when the scene is depicted as if the viewer is standing at the same height as the objects in the scene.

High angle—A high-angle vantage point is when the scene is depicted as if the viewer is looking down on it from above. This can create a sense of distance and make the objects in the scene appear smaller.

Low angle—A low-angle vantage point is when the scene is depicted as if the viewer is looking up at it from below. This can create a sense of power and can make the objects in the scene appear larger.

Worm's-eye view—A worm's-eye vantage point is when the scene is depicted as if the viewer is looking up at it from a very low angle, almost as if they are lying on the ground. This can create a sense of drama and make the objects in the scene appear larger and more imposing. Drones can be used to create the opposite effect: the very high bird's-eye view.

Here are a few examples of different vantage points as used in realistic alcohol ink paintings:

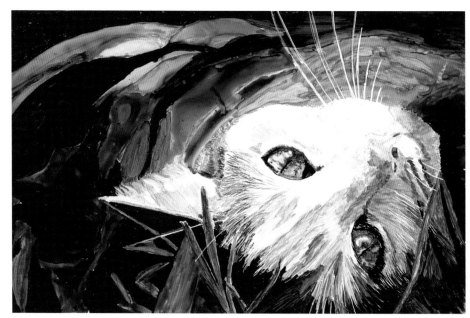

Cat Upside Down in the Grass demonstrates the eye-level vantage point.

Fall in Santa Rosa presents the scene from a high-angle vantage point.

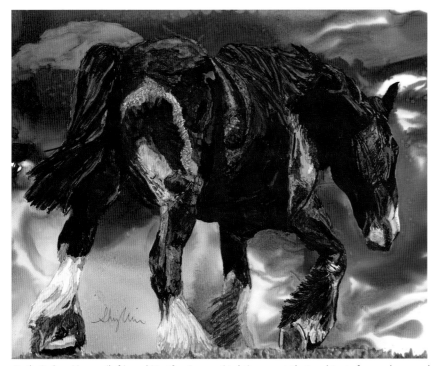

Both *Going Home* (left) and *Up the Aspen* (right) present their subjects from a low angle to create a sense of awe.

Composition and Balance

You have probably heard of the rule of thirds and the golden ratio or Fibonacci sequence. These are guidelines to help you compose your painting in the most attractive way possible. The golden ratio is found throughout nature and our brains recognize this pattern as something pleasant. You will find the golden ratio in flower petals, hurricanes, pinecones, faces, and even the formation of the universe.

The rule of thirds is a simplified version of the golden ratio. It's both easy to envision and use. Simply place the focal point of your painting on any of the intersections of a 3" x 3" (7.6 x 7.6cm) grid.

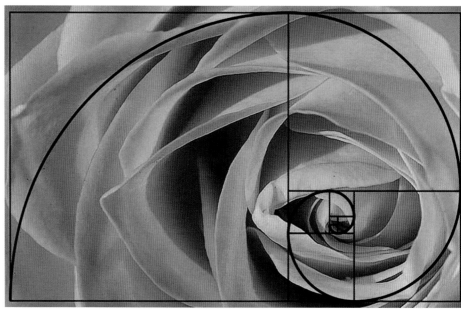

Your eye is directed to the center of this type of spiral, and when the ratio is converted to rectangles, you can use it as a guide to compose satisfying natural images.

Light Sources

When we paint, we often think a lot about the subject but don't spend as much time thinking about the light source. The following series of photos were taken with light shining on a rock from different angles:

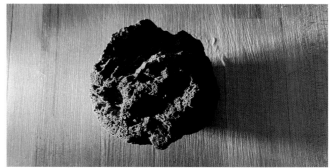

This image is best framed by placing the focal point (the eye) on the meeting point of the grid lines created when you break a space up into thirds.

These two photos mimic the sunrise in the east/sunset in the west. The light is strongest on the lower edge, but most of the rock is in darkness and the shadow cast by the rock is very long.

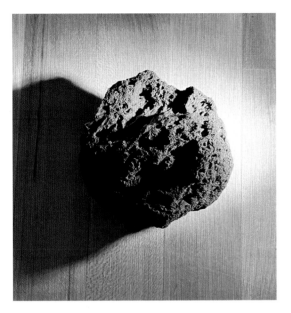

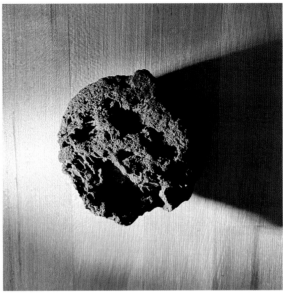

These two photos show slightly higher light sources (think of the sun around 10 AM or 7 PM). Much more of the rock is in light and the shadow cast by the rock is sharper and shorter.

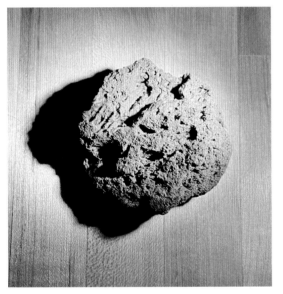

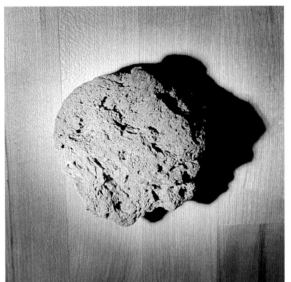

Here the light is almost above the rock on either side, but not quite (think 11 AM or 2 PM). Most of the surface of the rock can be seen and the colors are also easier to see. The cast shadow is very small in both.

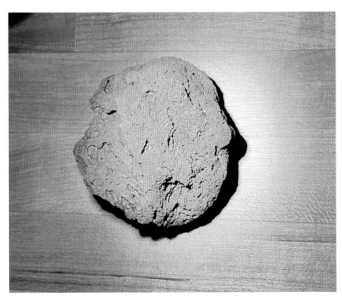

When the light is directly over the object (think the sun at noon), the shadows on the surface are gone or minimal and the cast shadow has almost disappeared. The color variations are very visible.

The light source will dictate the light, shadows, and even colors of our subject. The cast shadow and the shadows on the object will show the viewer where the light is. If you plan to design your own painting, take the time to decide where the light source will be and (if the light source is the sun) what time of day it is. That way you can be consistent with your shadows.

The direction and intensity of the light source can also have a significant impact on the overall look and feel of a piece. The direction of the light source affects the way that forms and surfaces are illuminated and creates highlights and shadows that help to define the three-dimensional space of a scene. The light source can also change the mood of an image through shadows, contrast, and color. For a painting to be successful, the light source needs to

be consistent to avoid confusing the viewer. There are five different angles from which a light source can shine:

- Side or low lighting
- Backlighting
- Top lighting
- Front lighting
- Diffused or overcast lighting

Side or low lighting features a light source that is low down on one side of the piece. This is a style often used by Renaissance masters. The light is bright, and the shadows are long—creating beautiful contrast (think of early morning or late afternoon photography). Often the color of the light is different because colors are washed out by the strong sunlight of midday.

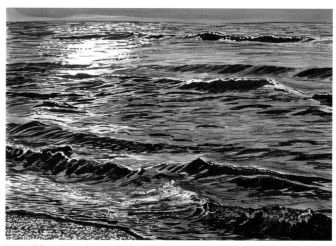

In **Golden Sea**, the sunlight shows on the tops of the waves and the front of the waves are in shadow.

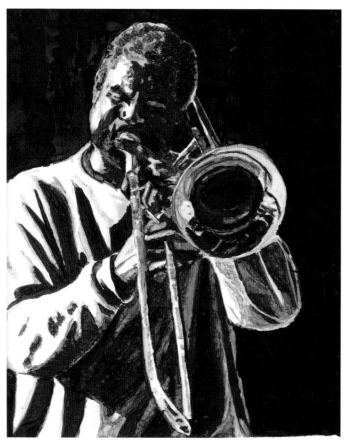

This painting of a trombone player has very strong side lighting and nice, long shadows.

Backlighting is when the light is behind the subject. The shadows are right in front of the viewer and a bit of the light sneaks around the subject into view, causing a glow. Backlit images can be a bit harder to achieve.

Top lighting is midday light in which the light source is right above the subject. The shadows are very short, if there are any at all, and there's little of the drama created by long, distinct shadows. Many photographs and

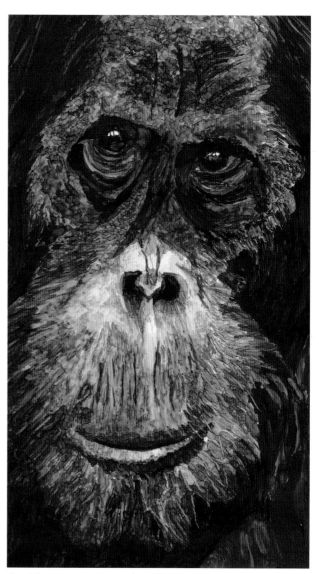

For this orangutan piece, the subject is interesting enough to save the less interesting lighting.

paintings are done with top lighting—the paintings tend to appear somewhat flat.

Front lighting is similar to top lighting because the light source is right in front of the subject. The shadows are short, if there are any at all, and the image appears flat.

The intensity of the light source can also be important. A strong, harsh light creates strong shadows and a sense of drama, while a softer, diffused light creates a more subtle and peaceful atmosphere. The color of the light source can also affect the overall mood and atmosphere of a piece, with warmer colors like red and yellow creating a more energetic or passionate atmosphere, and cooler colors like blue and green creating a more calming or serene atmosphere.

Diffused or overcast lighting refers to a type of lighting in which the light source is spread out or scattered in a room or space rather than being focused or directed on a specific area. This type of lighting is often used to create a soft, evenly distributed light that reduces glare and shadows. This type of lighting can be dull because there isn't a distinct light source casting strong shadows.

Overall, the light source is an important element to consider when creating a piece of art, as it can help to define the mood and atmosphere of the scene and bring the forms and surfaces of the work to life.

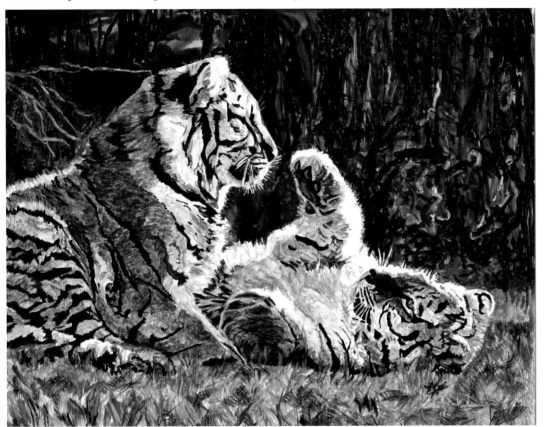

The subject, story, and contrast make these tiger cubs interesting despite the front lighting.

Diffused light is easiest to show by comparison. The photo on the left has diffused or overcast lighting and lacks interesting focal points, depth, and shadows. The photo on the right has side lighting—the light source is clear, and the image has interesting pits and shadows.

Color

Color is what attracts so many people to alcohol inks. Their colors are so rich, vibrant, and transparent. To decide which inks to use, you need a certain level of understanding of color theory. Color theory is a set of principles used to determine which colors will look appealing when used together. The basic principles of color theory include the color wheel and creating color harmony through the use of color schemes. In realistic painting, understanding color theory arms you with the knowledge to effectively use value and color to depict depth and atmosphere in paintings.

The **color wheel** is a visual representation of the relationships between different colors. It is divided into primary, secondary, and tertiary colors.

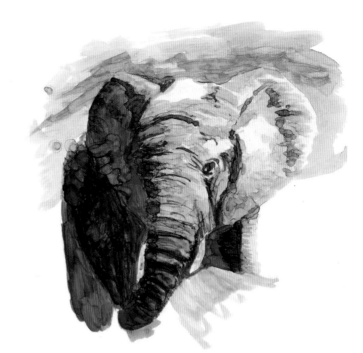

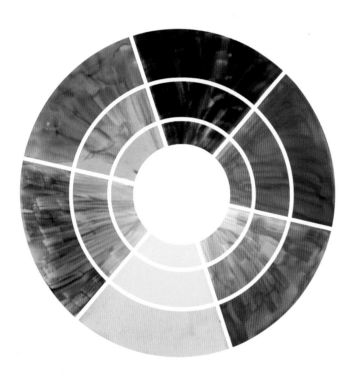

The primary colors are red, blue, and yellow. The secondary colors are orange, green, and purple (which are created by mixing the primary colors). You can also make tertiary colors by mixing these primary and secondary colors.

Color harmony refers to the use of colors that look pleasing together. There are several ways to create color harmony, including the use of complementary, analogous, triadic, and monochromatic color schemes.

- **Complementary** color schemes use colors that are opposite each other on the color wheel, such as violet and mustard. Complementary colors create vibrancy and excitement when used together. However, if they mix, they create brown (often called "mud").

- **Analogous** color schemes use colors that are next to each other on the color wheel, such as red, orange, and yellow. Analogous colors will always look pleasant together.

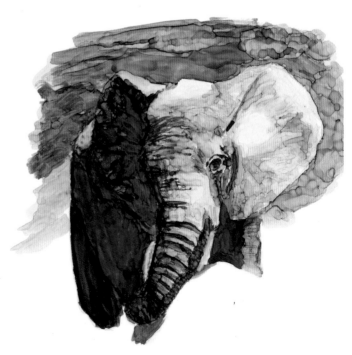

- **Triadic** color schemes use three colors that are equally spaced on the color wheel, easily visualized as creating a triangle on the color wheel.

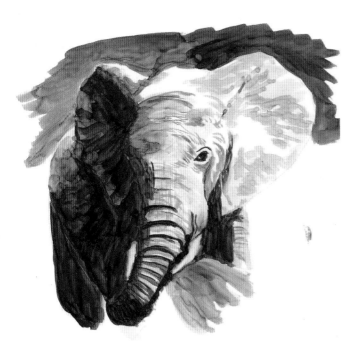

- **Monochromatic** color schemes use different shades and tints of a single color

Transparent versus Opaque

Transparency is the quality of ink that allows it to be seen through. Transparent inks allow light to pass through them onto the paper. Opacity is the inability to see through the ink—light is blocked from passing through. Think of a window with a fabric covering. If the fabric is very light and gauzy, you might be able to see through the fabric to the outside (transparent). If the fabric is thick and heavy, you probably wouldn't be able to see through (opaque)

Alcohol inks can be made more transparent by diluting them with alcohol, but for more opaque inks, you need to buy special brands, such as Octopus Fluids, or add a mixative, such as Ranger's Snow Cap Mixative. These mixatives and opaque inks must be shaken until the small ball bearing inside moves freely and mixes the fluid. Additionally, because they are created with pigments, a blending solution is required to induce flow and reaction and they won't move once they are dry.

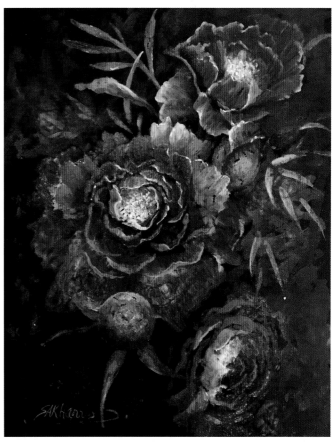

Sharen AK Harris's **Peony** *shows how dramatic opaque inks can appear on a darker background.*

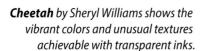

Cheetah *by Sheryl Williams shows the vibrant colors and unusual textures achievable with transparent inks.*

Saturation and Atmosphere

In art and design, saturation refers to the intensity of a color. A color is said to be highly saturated if it is undiluted and vibrant, while a color with low saturation is pale or muted. In alcohol ink, the less alcohol used in the blend, the more saturated the color and vice versa. Adding multiple layers of the same color will also create a saturated final product. You can also mix alcohol inks with white, gray, or black to adjust the saturation. For example, adding white to a color will make it less saturated.

In general, high-saturation colors tend to draw more attention and can be used to make an image or design more dynamic. Low-saturation colors, on the other hand, can be used to create a more calming or subdued effect. The appropriate level of saturation will depend on the desired look and feel of the finished piece. In landscape painting, for example, the saturation level helps to convey a sense of distance. The atmosphere has a significant effect on the appearance of color, often by the scattering of light. This

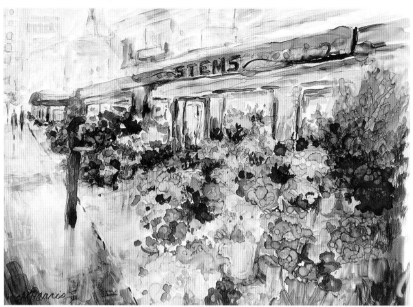

This alcohol ink painting by Sharon AK Harris demonstrates how high saturation in the foreground and low saturation in the background create a sense of depth.

prevents yellows, oranges, and reds from being seen from a distance and mutes far-off colors. Distant mountains will appear purple or blue, with low saturation. You can increase the saturation of objects in the foreground to bring them closer. You can decrease the saturation of objects in the distance to make them appear to recede.

The atmosphere can also affect the appearance of color in different environments and at different times of day. On a clear day, for example, the sky will be a much brighter blue than on overcast or hazy days. At sunrise and sunset, the sunlight passes through a thicker section of the atmosphere. As a result, the sunlight at these times of day is best conveyed with more red or orange. Overall, the atmosphere can have a significant impact on the appearance of color, and it is important for artists and designers to consider this when choosing and using colors in their work.

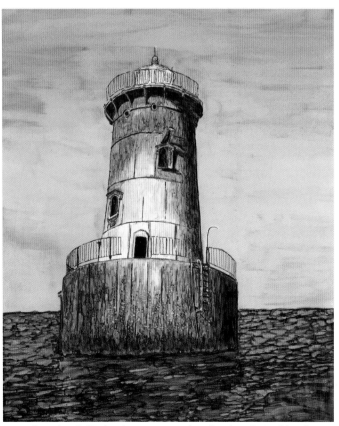

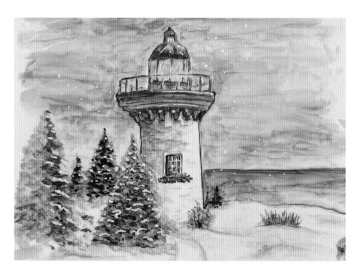

On a clear day (left), the sky appears to be a bright, vibrant blue, but on hazy or overcast days (right), the sky appears more gray or white, as the light is more diffused and the blue color is less visible.

Value

For any image, the viewer can identify the object even if there is no color and only a range of grays, from black to white. We call this range of grays the "value." Many viewers get caught up in and excited by the glorious colors but to create truly accurate realistic images we need to pay attention to the values.

For humans to see anything there needs to be light. The way the light shines on an object, the amount of light shining, and the angle of the light gives us information our brains use to understand the object and its location. When we paint, we strive to create the illusion of light. Some artists only work in black, gray, and white. What is their secret? They identify and paint the values!

The first step to effectively using value in your pieces is to start with reference images and sketches that have a good value range.

Let's assume that you have selected a reference photo with a wide range of lights and shadows. How can you translate that information to your painting? I've found the best way to prepare to accurately paint your image is to create a value study using grayscale.

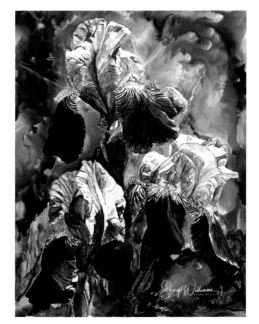
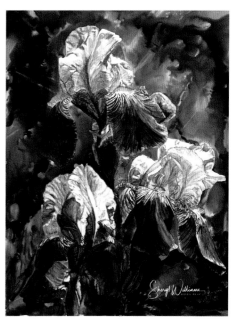

The same painting in both the color (left) and black and white (right) has identifiable flowers against a distinct background because of the range of highlights, shadows, and midtones.

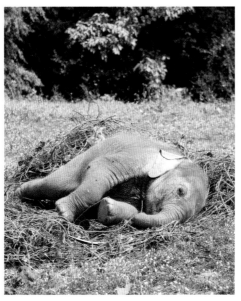
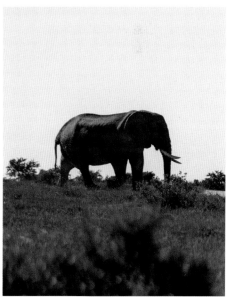

These two images aren't ideal. The first (left) has minimal light contrast and the contours are difficult to see. The second (right) doesn't have enough light to fully show the elephant's details.

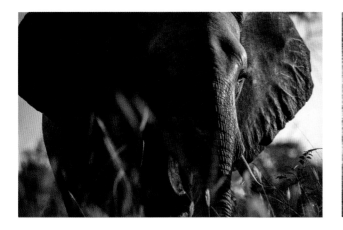

These photos have great value. The first (left) is very dramatic because the right side has a large range of values and the left side is all in shadow. The second (right) has enough value to show even small details like the wrinkles in the skin.

Value Exercise: Create a Value Study Using Grayscale

Whenever you paint an object, you need to know where the lights and shadows are and all of the values in between that will make the painting look three-dimensional. According to Merriam-Webster, a gray scale is "a series of regularly spaced tones ranging from black to white through intermediate shades of gray." You can study these characteristics in your reference photo to then apply them to your painting by matching colored markers to each section by value. Hold onto the value study you make in this exercise for use in painting Fox in the Grass on page 64.

Materials and Supplies

- Black and White Reference Photo from page 160 printed 8.5" x 11" (21.6 x 27.9cm)
- Artist's Tape
- Two 9" x 12" (22.9 x 30.5cm) Clear Synthetic Film Sheets (Grafix .003" Acetate or Dur-alar)
- Alcohol Ink Markers in a range of gray tones:
 - » Black (Concept Dual-Tip Art Markers Black #120)
 - » Darkest Gray (Concept Dual-Tip Art Markers Cool Grey #9)
- » Darker Gray (Concept Dual-Tip Art Markers Cool Grey #8)
- » Dark Gray (Concept Dual-Tip Art Markers Cool Grey #7)
- » Gray (Concept Dual-Tip Art Markers Cool Grey #6)
- » Light Gray (Concept Dual-Tip Art Markers Cool Grey #5)
- » Lighter Gray (Concept Dual-Tip Art Markers Cool Grey #4)
- White Copy Paper
- Scissors
- Small Hole Punch
- Gray Scale copied from page 158

The artist used the products in parentheses. Substitute your choice of brands, tools, and materials as desired.

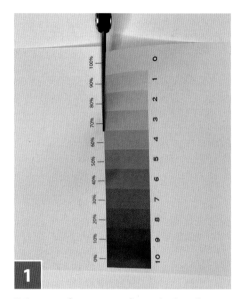

1

Print out the gray scale and trim along the edge where the percentages are labeled. Note: the percentages on this gray scale represent the percentage of white included.

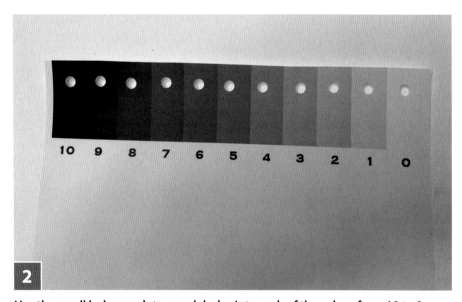

2

Use the small hole punch to punch holes into each of the values from 10 to 0.

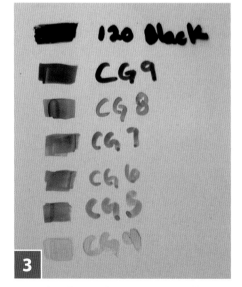

3

Tape the sheet of clear synthetic film on top of the white copy paper. Make marks on the clear synthetic film with each marker from darkest to lightest.

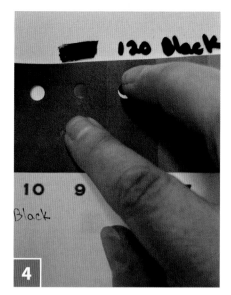

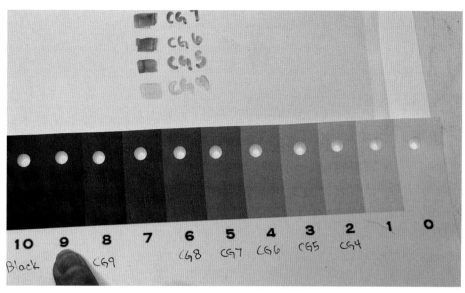

Place the prepared gray scale on top of the gray marks on the clear synthetic film and, looking through the holes, match each mark to a value. Note which marker matches which value.

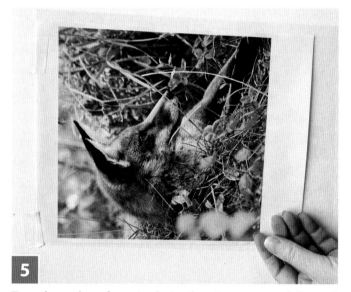

Tape down the reference photo, then tape a second sheet of clear synthetic film on top of the reference photo.

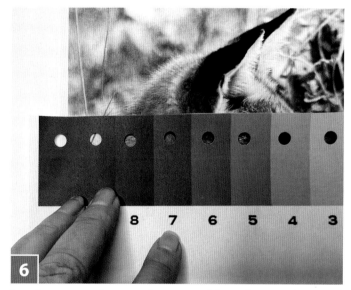

Lay the prepared gray scale on top of the reference photo and select an area to match. Look through the holes and move the gray scale as needed until you find the value that most closely matches the selected area.

Tip:

For value studies, limit yourself to a few markers (we used Cool Grey #9 for values 9 and 10, Cool Grey #8 for values 7 and 8, Cool Gray #7 for values 5 and 6, Cool Gray #6 for values 3 and 4, and Cool Gray #4 for value 2). The marker strokes may appear lighter than you expect at first, but following these ranges will give you good information.

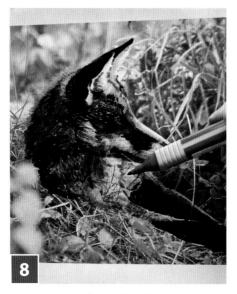

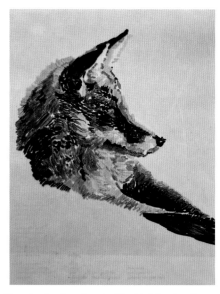

7

8

Repeat step 6 for each value, working from the darkest value to the lightest value. Slip a sheet of white copy paper under the clear synthetic film to see the completed value study. The value study shows you all the shading and looks three-dimensional.

Finding and Adjusting Color Values

Now that you understand the value of value and know how to create a value study in preparation for a painting, you need to learn how to apply these concepts to brilliantly colored inks. The first step is to learn the values of your colored inks straight from the bottle. The photos below and on page 49 show the quickest way to figure out this base value.

Color in the darkest areas on the clear synthetic film, following the direction of the fur and ignoring the grasses and leaves in front of the fox. Continuously refer to the gray scale and holes to identify the correct marker to use in each area. Slip a sheet of white copy paper under the clear synthetic film to see these darkest values.

Tip:

As you work with lighter and lighter values, there is more alcohol in the marker. You only need to lightly press to apply the ink.

Create a chart of all your inks by pouring a drop of each onto white synthetic paper. Label each with the color name and use your gray scale to estimate which value level the color matches best.

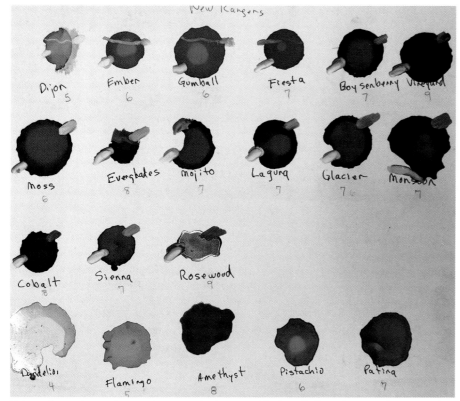

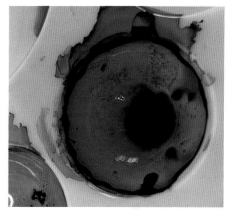

The value of alcohol ink can be modified by adjusting the amount of alcohol in the mix. Less alcohol creates a darker color and more alcohol creates a lighter color. You can also darken the ink by applying additional layers. There are limits to how dark each ink can go, however, and you may need to mix your ink with black to get it darker.

Take a photo of your chart and convert the image to black and white, then use the gray scale to see how well you matched the values.

Ink darkens as the alcohol in it evaporates. This Ranger Mojito ink is almost black at the dryer outer edges of the palette wells.

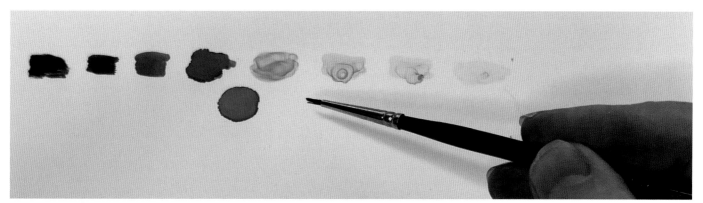

Test adding different levels of alcohol to your ink and painting with it to see the light color you can achieve.

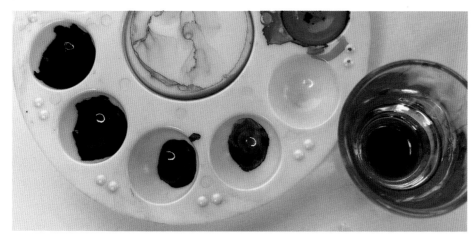

Very dark inks, like Ranger Vineyard, also get darker as the alcohol evaporates and lighter if alcohol is added. You can even use the ink left in your cleaning container to create the lightest of colors.

Elements of Realistic Painting **49**

Texture

Capturing texture is often a matter of adequately conveying light and shadow with value, but when painting an animal with fur, you must also consider length and direction and layers. As with value, you can create a fur or texture study to learn how to apply these elements to your realistic painting.

Texture Exercise: Create a Fur Study

Whenever you paint an animal, you need to understand the texture of their skin or fur. Fur is particularly tricky, but creating a study helps to simplify this complex texture into more approachable elements. You can study the length and direction of the fur (or wrinkles, spots, etc.) in your reference photo to then apply them to your painting. Hold onto the fur study you make in this exercise for use in painting Fox in the Grass on page 64.

Materials and Supplies

- **Color Reference Photo from page 160** printed 8.5" x 11" (21.6 x 27.9cm)
- **Artist's Tape**
- **One 9" x 12" (22.9 x 30.5cm) Clear Synthetic Film Sheet (Grafix .003" Acetate or Dur-alar)**
- **Alcohol Ink Markers in the following colors:**
 - » **Red**
 - » **Green**
 - » **Blue**
- **White Copy Paper**

The artist used the products in parentheses. Substitute your choice of brands, tools, and materials as desired.

1 **Tape down the reference photo, then tape a sheet of clear synthetic film on top of the reference photo.** Designate which marker color will match which fur length (we used red for short fur, green for medium-length fur, and blue for long fur).

2 **Begin with the short fur.** Draw lines running the length and direction of the short fur with the red marker. You do not need to draw every hair, you're just trying to capture the location and direction in general. On the fox, the shortest fur is on the muzzle, nose, and around the eye.

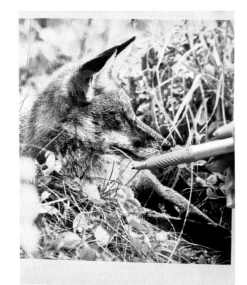

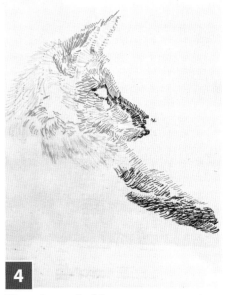

3 **Repeat step 2 for the remaining two fur lengths.** On the fox, the medium fur is on the head, around the base and edge of the ear and on the forelegs. The long fur is on the back of the head, the back part of the ear, and under the neck.

4 **Slip a sheet of white copy paper under the clear synthetic film to see what might be missing from the fur study.** Fill in any areas as needed. The fur study shows the length and direction of the fur.

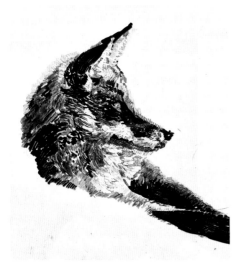

Combined with the value study, you have all the information needed to create a realistic piece.

Realistic Painting Techniques

The following techniques are some of the most effective options for creating the effects and colors required in realistic alcohol ink painting. Most are used in the projects beginning on page 62, but they can all be incorporated into your own realistic painted pieces.

Blending, Lifting, and Staining

Most alcohol ink art is based around allowing the colors to flow and blend together. Lifting is another common technique that removes all or a portion of the ink to create contrast, add highlights, or clean the surface for the application of another color. Lifting is achieved by using something like a cotton ball, Fantastix, or water brush containing isopropyl alcohol or alcohol blending solution to reactivate and "lift" ink away from the surface. The amount of isopropyl alcohol or alcohol blending solution on the tool and the type of surface you're using will determine how reactive the ink becomes and how much the ink can be lifted. Staining is an effect created by lifting. It can be frustrating if you are trying to get your surface lifted back to white but it can be a lot of fun if you are using the staining to enhance your painting. Not all inks will stain the same way since some dyes in the inks are more intense or permanent. Because there are so many brands of alcohol ink on the market—all with their own unique formulas—it's helpful to create a staining chart with your brand of inks by dropping one drip each of your alcohol ink colors on the surface you plan to work with. Use your favorite lifting tool (blending pens, water brushes, cotton balls, etc.) to lift out as much color as possible until you are unable to lift anymore. The residual color on the surface is the stain you can expect to see from that color.

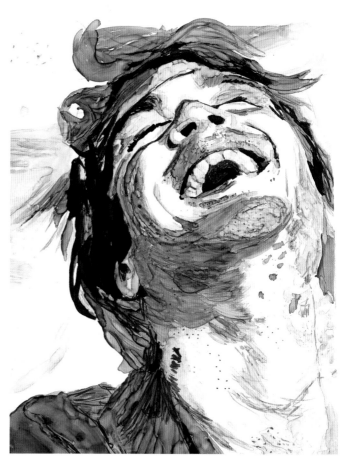

This detailed portrait by Sheryl Williams was created using water brushes to blend and lift the alcohol ink. The blending and lifting techniques create depth and texture.

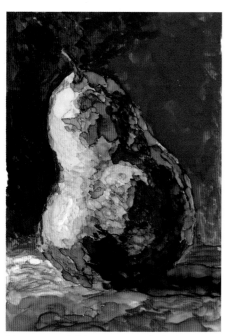

You can use dabbing motions with the blending techniques to create entire paintings. This colorful pear image perfectly blends many bright colors to create a sense of light and shadow.

Tip: Try dabbing water brushes or paintbrushes into ink, then press the brush down on the surface and lift it straight up. Dabbing will create a vibrant mark that doesn't move very much on the surface. Use this motion to apply and layer colors.

1

Fill the water brush with isopropyl alcohol.

Materials and Supplies

- Alcohol Inks in the following colors:
 » Blue (T-Rex's Glacier Blue)
 » Light Green (T-Rex's Irish Moss)
 » Dark Green (T-Rex's Jurassic Green)
 » Brown or Gray (NARA's Christmas Wood)
- White Synthetic Paper Sheet
- Paper Towel
- Water Brush
- 91% or 99% Isopropyl Alcohol or Alcohol Blending Solution
- Welled Palette

The artist used the products in parentheses. Substitute your choice of brands, tools, and materials as desired.

2

Add the light blue ink to your welled palette and dip the tip of the water brush into the wet ink. Paint across the top of the paper by dragging the water brush across the page. Continue painting back and forth until you've covered two-thirds of the page. The color will fade as you use the brush.

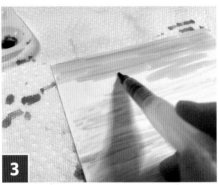

3

Add a few drops of the light green ink to your welled palette and dip the tip of the water brush into the wet ink. Turn the paper upside down and paint with the light green ink exactly like you did with the light blue ink.

4

Where the light green ink meets the blue ink on the paper, brush back and forth to blend the two colors together. **Because the water brush is "wet" with isopropyl alcohol, it will** reactivate the blue ink underneath and blend the two colors.

> **Tip:** You can also use the wet tip of the water brush to "reactivate" ink that has dried on the palette. Wet ink will give you the most intense color, however.

5

Clean the water brush by dipping it into a container of isopropyl alcohol and wiping the brush nib on a paper towel until you no longer see color coming off the brush.

6

Lightly touch the clean, wet water brush to the dried light blue ink and swirl your brush in a circular motion. This will loosen and lift some of the blue color to start forming cloud shapes. Depending on the type of synthetic paper you are working with, you may be able to lift the ink to create white clouds, or create stained lighter blue clouds.

7

When you lift alcohol ink color, it accumulates on the water brush. Wipe the excess ink on a paper towel in between strokes to avoid simply redistributing the ink. Continue to lift more color, creating clouds and cleaning the brush in between each until you are happy with the sky.

8

Place the clean, wet brush on the dried light green ink where you want your tree trunks to begin. Gently drag the brush up into the blue area to lift color away and form the tree trunks. Wipe any excess ink onto your paper towel. Add tree trunks until you are happy with the painting. Feel free to add large branches, as well.

9

Add a few drops of the dark green ink to the welled pallet and dip the tip of the water brush into the wet ink. Lightly dab all along the line where the light blue ink meets the light green ink. The ink will bloom organically to create the look of a line of trees in the distance.

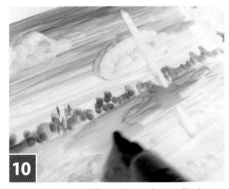

10

Add more light blue ink to the welled palette and dip the tip of the water brush into the wet ink. Paint a lake close to the tree line, making sure the top edge of the lake is flat.

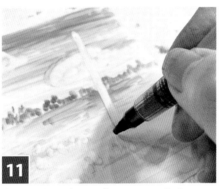

11

If you painted over the tree trunks in step 10, use a clean, wet water brush to lift the color out again. You can also lift some of the light green ink to add texture to the grass.

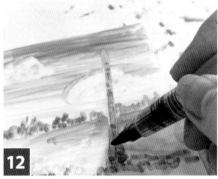

12

Add some brown or gray ink to the welled pallet and use the water brush to paint in the tree trunks as shown.

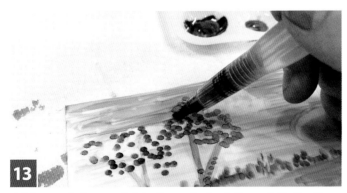

13

Add more dark green ink to the welled palette and dip the tip of the water brush into the wet ink. Dab leaves on the paper near the tops of the trees.

14

Add more light green ink to the welled palette and dip the tip of the water brush into the wet ink. Dab more leaves near the tops of the trees to create a blended effect and fill in the space. Continue dabbing with the water brush until you finish defining the tops of the trees. You can also use this color to add more detail and texture to the grass.

Realistic Painting Techniques **53**

Masking

Another popular technique for creating white space in alcohol ink paintings is masking. Masking (or "resist") refers to blocking a surface to protect it from the ink, then unmasking it to reveal the original color. These masked areas can be left unpainted or can have other ink colors applied to them. There are several tools that can be used to mask off areas when using alcohol inks.

Using Masking Fluid and a Brush

Masking fluid is a wonderful solution for masking smaller areas and edges. You can apply masking fluid with a brush or silicone-tip tool, covering up the areas you want to resist the

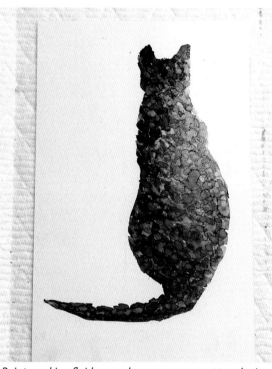

Paint masking fluid around an area you want to color in to protect the pieces you want to remain uncolored.

ink. Once it's applied, you must allow the fluid time to dry. This drying time will depend on how thick you apply the masking fluid and the humidity level in your area. You can test this by tapping your finger on the surface to see if any of the fluid sticks to your finger. When the masking fluid is dry, it acts sort of like rubber cement and can be removed by rubbing your finger or a rubber cement remover over the fluid. Once this pressure is applied, the dried fluid will begin to rub away, revealing the masked area. Always make sure your ink layer has dried completely before removing masking fluid.

Materials and Supplies

- **Alcohol Inks in the following colors:**
 - » **Red-Brown (Ranger's Tim Holtz Rust)**
 - » **Light Brown (Ranger's Tim Holtz Ginger)**
 - » **Dark Brown (Ranger's Tim Holtz Teakwood)**
 - » **Yellow-Orange (Ranger's Tim Holtz Butterscotch)**
- **¼ White Synthetic Paper Sheet**
- **Tape**
- **Paper Towel**
- **Carbon Paper**
- **Template**
- **Pen**
- **Liquid Masking Fluid (Pebeo® Drawing Gum)**
- **Round or Flat Paintbrushes**
- **Soap**
- **Welled Palette**

The artist used the products in parentheses. Substitute your choice of brands, tools, and materials as desired.

1 **Place a piece of synthetic paper on top of a paper towel.** Place the carbon paper carbon side down on top of the synthetic paper. Place the template (we used the cat silhouette template on page 158) on top of the carbon paper, making sure it lines up with the synthetic paper.

2 **Trace the image of the cat onto the synthetic paper by following the template lines with your pen.** Then remove the template and carbon paper.

3 **Cover the paintbrush thoroughly with soap to protect the bristles.**

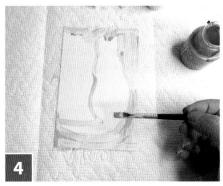

4

Use the protected paintbrush to carefully apply the masking fluid to everything except the cat. Don't worry about how smoothly you apply the masking fluid, just be sure everything you want to resist the ink is covered. Wait for the masking fluid to dry.

5

Drip the four alcohol ink colors into different wells on the welled palette. Dip a clean paintbrush into the red-brown alcohol ink. Dab the ink inside the cat by pressing the brush down and then lifting up, using this technique to fill the cat's body. Don't worry about dabbing ink onto the masking fluid since it will be removed at the end.

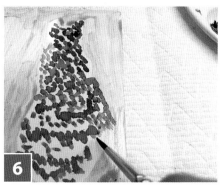

6

Dip your brush into the light brown alcohol ink and dab the ink throughout the cat's body.

7

Dip your brush into the dark brown alcohol ink and dab the ink along the left edge of the cat and along the cat's tail to create shading.

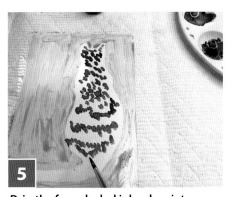

8

Dip your brush into the yellow-brown alcohol ink and dab the ink along the right side of the cat and blending into the cat's tail to create the feeling of light shining on that side of the body. Continue to dab the inks until the cat's body is completely filled in.

9

Let your painting dry completely. Use one hand to hold the paper steady and gently rub your finger on the masking fluid. You will feel the masking fluid lift up (it is similar to rubber cement). Continue to remove the masking fluid being extra careful around the edges of the cat. You can use masking tape or other removal tools as needed.

Masking Fluid Removal Tools

Silicone-tip tools with pointed ends are great alternatives to brushes for applying and lifting masking fluid. You can easily remove dried masking fluid from the tool. Masking fluid pickups, which are flat pieces made of dried rubber cement, and masking tape can also be used to lift up masking fluid.

Creating a Barrier Layer

A barrier layer is a layer of translucent medium applied between the surface of a painting and subsequent layers. It serves as a barrier to prevent the underlying ink from reactivating or moving. Applying a barrier layer is useful for managing value in paintings, as demonstrated in the Elephant project on page 70 in this book. The barrier layers allow you to strategically layer on top of the base to manage dark and light areas identified in your value study. You need to allow the barrier layer to dry completely before applying more alcohol ink on top. This can take up to 24 hours depending on your choice of medium and the humidity levels in your area.

When creating a barrier layer, you need to use a medium that is compatible with the ink and surface you are working on to avoid any activation or movement of the base layer. In the United States and Canada, most artists use Krylon Kamar Varnish or Krylon Gallery Series UV Archival Varnish to create barriers. Jacquard now sells brush-on Piñata High Gloss Varnish, which can also be used as a barrier layer. Alternatives for those sourcing supplies outside of the United States include Molotow One4All Acrylic Water-Based Varnish or Ghiant Varnish H20. The important thing to look for in a barrier layer medium or varnish is one with very low levels of acetone or alcohols.

Brush Painting and Evaporation

Paintbrushes allow artists to play with an interesting aspect of using alcohol ink—the alcohol goes through various stages of evaporation, changing the color of the ink. When you first pour alcohol ink, it moves around freely. As the alcohol evaporates, the ink left behind is more concentrated. The more concentrated the ink, the darker the ink appears. Additionally, the more the alcohol evaporates, the thicker the ink gets. With less fluid in the ink, you can control the ink and use it to paint finer details without it blooming out of control.

Materials and Supplies

- Alcohol Inks in the following colors:
 » Yellow (Ranger's Tim Holtz Lemonade)
 » Green (Ranger's Tim Holtz Meadow)
 » Blue (Ranger's Tim Holtz Sailboat Blue)
- ¼ White Synthetic Paper Sheet
- Paper Towel
- 91% or 99% Isopropyl Alcohol or Alcohol Blending Solution
- Welled Palette
- Cotton Balls

The artist used the products in parentheses. Substitute your choice of brands, tools, and materials as desired.

1

Place a piece of synthetic paper on top of a paper towel. Place three or four drops of each ink color in wells in the welled palette.

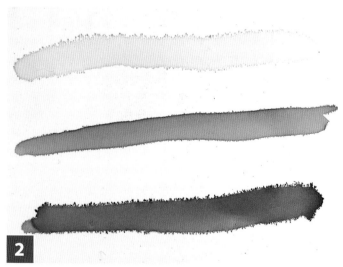

2

Dip the paintbrush in the wet yellow alcohol ink and paint a line. Clean the paintbrush and repeat with the green alcohol ink. Clean the paintbrush and repeat with the blue alcohol ink. Clean the paintbrush. (You want to clean the paintbrush before applying each color to avoid introducing more alcohol into the next color.)

3

You will notice that the ink in the welled palette will start to form beads around the edges. This is where the alcohol has started to evaporate.

4

Repeat step 2, this time dipping your paintbrush into the beads of concentrated ink around the edges rather than the wet ink in the center. The lines painted with the evaporated ink are thinner and the evaporated ink does not spread as much as the fresh ink did.

5

Eventually all the alcohol will evaporate, leaving only the dye behind.

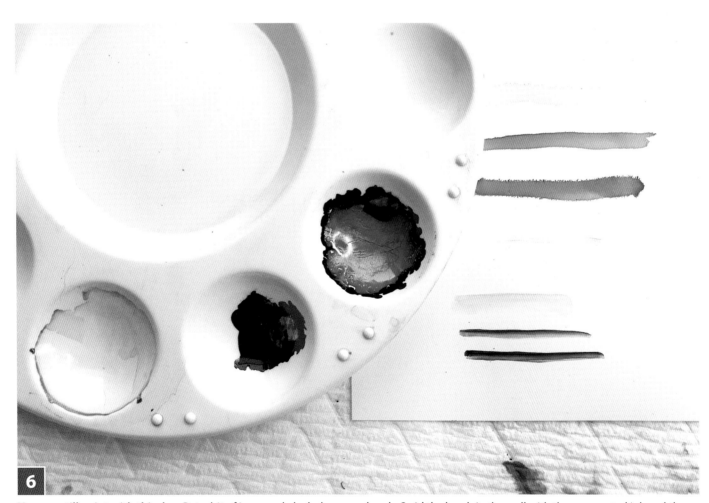

6

You can still paint with this dye. Put a bit of isopropyl alcohol on your brush. Swirl the brush in the well with the evaporated ink and the alcohol will reactivate the ink. The lines on the bottom of this paper have been painted with the reactivated ink. The color is much more concentrated and darker.

Push and Glide Painting

Use a paintbrush to maneuver the alcohol ink to fill a specific space (rather than allowing it to naturally flow). You'll use the base flower image to learn the Layering Inks technique on page 60.

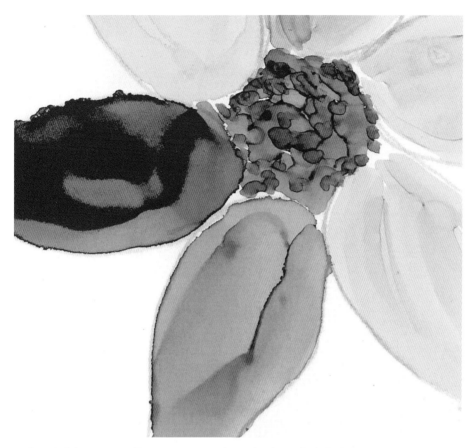

Materials and Supplies

- Alcohol Inks in the following colors:
 » Yellow (Ranger's Tim Holtz Dandelion)
 » Yellow-Orange (Ranger's Tim Holtz Butterscotch)
 » Mustard Yellow (Ranger's Tim Holtz Honeycomb)
 » Pale Orange (Ranger's Tim Holtz Sunset Orange)
 » Coral (Ranger's Tim Holtz Coral)
 » Dark Pink (Ranger's Tim Holtz Watermelon)
- ¼ White Synthetic Paper Sheet
- Paper Towel
- Tape
- Carbon Paper
- Pen
- Welled Palette
- Small Round Brush (#3 or #4)
- Cotton Ball
- 91% or 99% Isopropyl Alcohol or Alcohol Blending Solution

The artist used the products in parentheses. Substitute your choice of brands, tools, and materials as desired.

Push and glide painting allows you to control exactly where alcohol ink flows. You push the ink close to your edges, then allow the ink to naturally spread right up to the line.

1

Place a piece of synthetic paper on top of a paper towel. Place the carbon paper carbon side down on top of the synthetic paper. Place the template (see page 158) on top of the carbon paper, making sure it lines up with the synthetic paper.

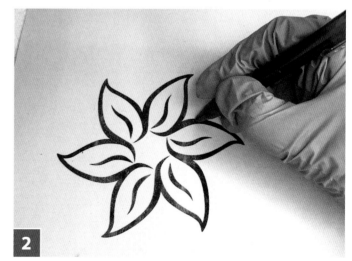

2

Trace the image of the flower onto the synthetic paper by following the template lines with your pen. Then remove the template and carbon paper.

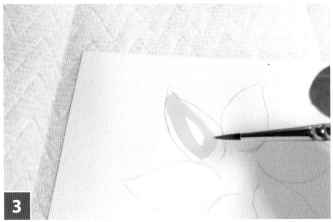

3

Place the yellow ink into the welled palette. Dip your paintbrush into the yellow ink and paint one of the flower petals, leaving room between the ink and the traced edges. Fill in the petal, watching as the ink spreads to the edges. Gently push the ink as needed from the center to the outer edges of the petal. Clean your paintbrush.

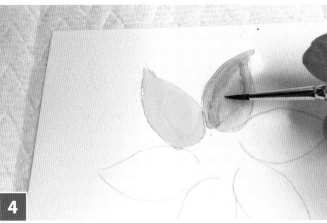

4

Repeat step 3 with the yellow-orange alcohol ink. Note that the Butterscotch alcohol ink we used for this petal spreads less than the Dandelion alcohol ink we used for the first petal. This is because the Butterscotch alcohol ink contains less alcohol.

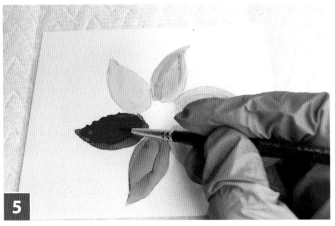

5

Repeat step 3 with the remaining colors, filling each consecutive petal with one of the alcohol ink colors: mustard yellow, pale orange, coral, and dark pink.

6

Dip your brush in the dark pink alcohol ink and gently dab ink into the center of the flower.

7

Repeat step 6 with the pale orange alcohol ink.

8

Add more dark pink alcohol ink dabs on top of the pale orange dabs to fill the center of the flower. Save this project and use it to learn how to layer (see Layering Inks on page 60).

Layering Inks

Since alcohol inks are translucent, you can add layers of color to build new colors and create different wash effects. You'll use your flower painting from the Push and Glide Painting technique on page 58 to explore how layering affects alcohol inks.

Materials and Supplies

- **Alcohol Inks in the following colors:**
 - » **Yellow (Ranger's Tim Holtz Dandelion)**
 - » **Yellow-Orange (Ranger's Tim Holtz Butterscotch)**
 - » **Mustard Yellow (Ranger's Tim Holtz Honeycomb)**
 - » **Pale Orange (Ranger's Tim Holtz Sunset Orange)**
 - » **Coral (Ranger's Tim Holtz Coral)**
 - » **Dark Pink (Ranger's Tim Holtz Watermelon)**
- **¼ White Synthetic Paper Sheet**
- **Paper Towel**
- **Welled Palette**
- **Small Round Brush (#3 or #4)**
- **Cotton Ball**
- **91% or 99% Isopropyl Alcohol or Alcohol Blending Solution**

The artist used the products in parentheses. Substitute your choice of brands, tools, and materials as desired.

Original *Modified*

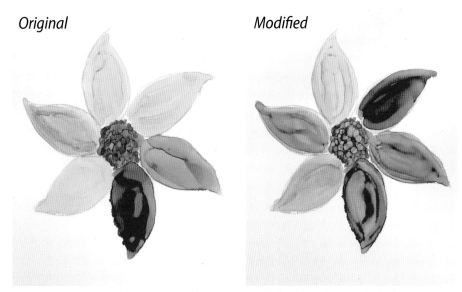

Layering can create subtle changes or dramatic color shifts, depending on the look you're going for.

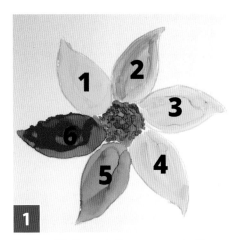

1

Begin with the painting you created in the Push and Glide lesson on page 58. Make sure it is completely dry. Number the petals from 1 to 6, starting with the yellow petal.

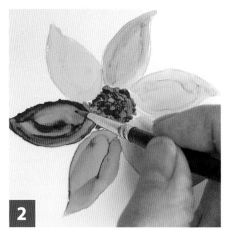

2

Add more yellow ink to your welled palette. Dip your brush into the yellow ink and layer it on top of petal #6. The color should change from dark pink to orange because the dark pink layer below is now being viewed through the yellow layer. Clean the paintbrush by dipping it in the isopropyl alcohol and wiping it clean on the paper towel.

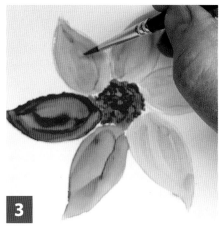

3

Add more pale orange ink to your welled palette. Dip your brush in the pale orange ink and layer it on top of petal #1. The color should change from yellow to light orange. Clean the paintbrush.

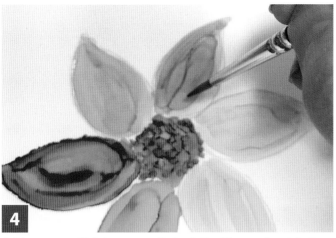

Add more coral ink to your welled palette. Dip your brush in the coral ink and layer it on top of petal #2. The color should change from yellow-orange to dark orange. Clean the paintbrush.

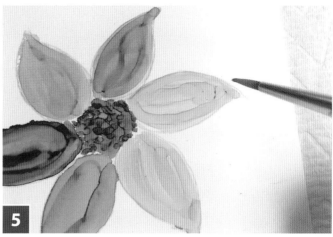

Add more yellow ink to your welled palette. Dip your brush in the yellow ink and layer it on top of petal #3. The color should change from mustard yellow to bright yellow. Clean the paintbrush.

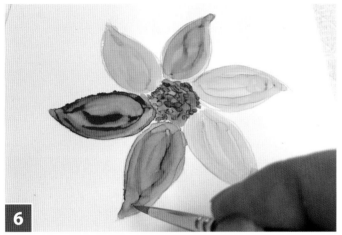

Add more coral ink to your welled palette. Dip your brush in the coral ink and layer it on top of petal #5. The color should become more intense because you've layered coral on top of coral. Clean the paintbrush.

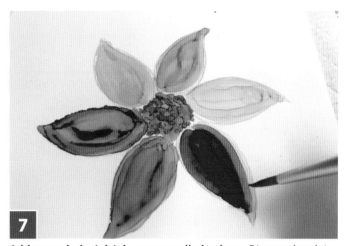

Add more dark pink ink to your welled palette. Dip your brush in the dark pink ink and layer it on top of petal #4. The color should change from pale orange to light red. Clean the paintbrush.

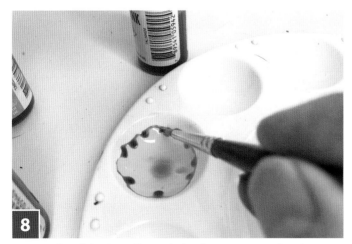

Dip your brush in the yellow ink that has evaporated and beaded up in the palette.

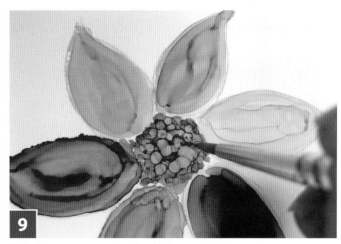

Dab the concentrated yellow ink onto the flower's center.

PROJECTS

This collection of projects, diverse in subject matter, showcases the magnificent possibilities of creating realistic art with alcohol ink. Each project is carefully curated to teach a variety of techniques and applications that bring out the best of alcohol ink. Learn how to apply the realistic techniques and concepts taught in this book to add intricate details and texture to your paintings. Using these projects as inspiration, discover new ways to bring depth and realism to your creations.

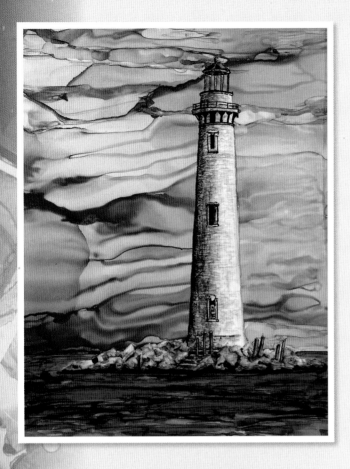

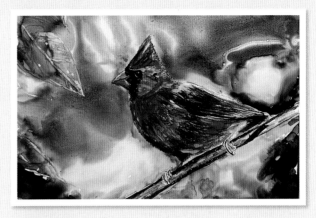

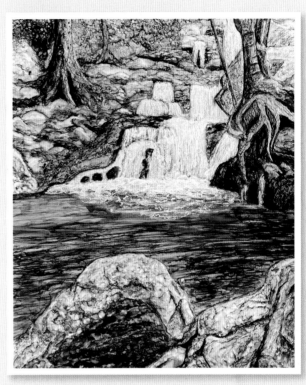

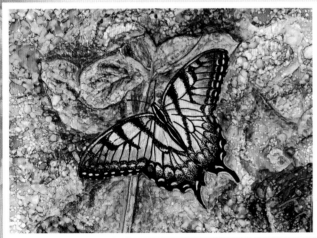

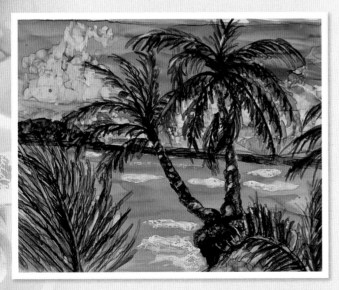

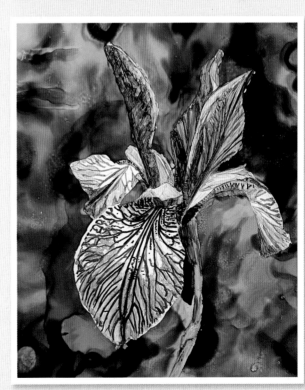

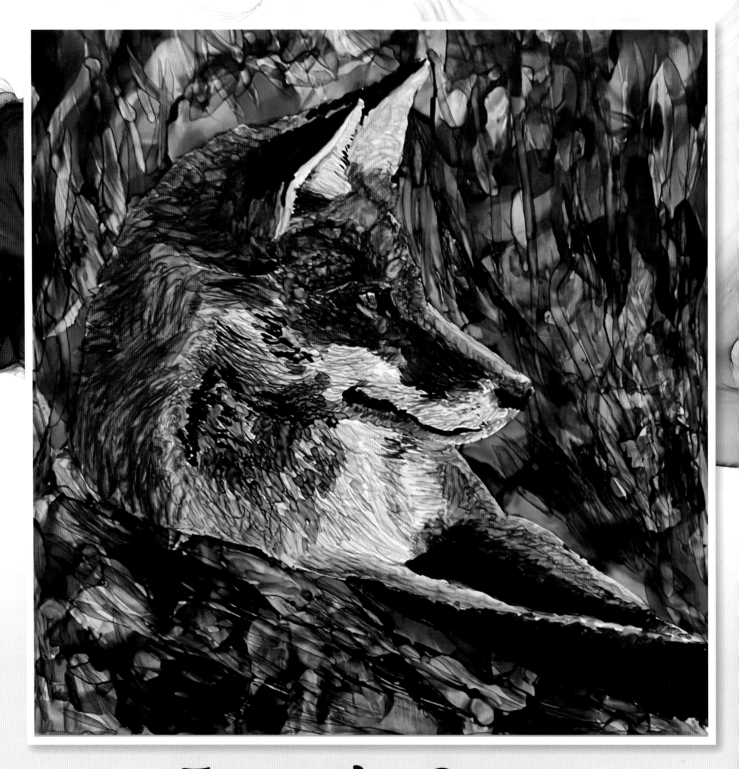

Fox in the Grass

This project is a great introduction to using a value study
(see page 46) and fur study (see page 50) to create a realistic
painting with three clear dimensions.

by Sheryl Williams, *https://sherylwilliamsart.com*

Materials and Supplies

- Black and White Reference Photo from page 160 printed 8.5" x 11" (21.6 x 27.9cm)
- Color Reference Photo from page 160 printed 8.5" x 11" (21.6 x 27.9cm)
- Alcohol Inks in the following colors:
 - » Rich Green (Ranger's Tim Holtz Mojito)
 - » Green (Ranger's Tim Holtz Botanical)
 - » Dark Green (Ranger's Tim Holtz Everglades)
 - » Olive Green (Ranger's Tim Holtz Lettuce)
 - » Orange (Ranger's Tim Holtz Sunset Orange)
 - » Light Brown (Ranger's Tim Holtz Latte)
 - » Green-Brown (Ranger's Tim Holtz Mushroom)
 - » Mustard Yellow (Ranger's Tim Holtz Honeycomb)
 - » Golden Brown (Ranger's Tim Holtz Caramel)
 - » Red-Orange (Ranger's Tim Holtz Valencia)
 - » Red-Brown (Ranger's Tim Holtz Sepia)
 - » Dark Brown (Ranger's Tim Holtz Rosewood)
 - » Brown (Ranger's Tim Holtz Teakwood)
 - » Gray (Jacquard's Piñata Color Shadow Grey)
- Alcohol Ink Markers in the following colors:
- Black (Copic 100)
 - » Cool Gray 90% (Blick Studio Brush Marker #031)
 - » Cool Gray 80% (Blick Studio Brush Marker #030)
 - » Cool Gray 70% (Blick Studio Brush Marker #029)
 - » Cool Gray 60% (Blick Studio Brush Marker #028)
 - » Cool Gray 50% (Blick Studio Brush Marker #027)
- 9" x 12" (22.9 x 30.5cm) White Synthetic Paper Sheet (Dura-Bright)
- 91% or 99% Isopropyl Alcohol
- Container (to hold isopropyl alcohol)
- Carbon Paper
- Pen or Stylus
- Artist's Tape
- Masking Fluid (Pebeo Drawing Gum)
- Paintbrushes
 - » Medium Round
 - » #2 Fine-Tip Brush (Creative Mark Rhapsody Round Kolinsky Sable Artist Brush)
- Soap Bar
- Coffee Stirrers
- Welled Palette
- Cotton Cosmetic Rounds
- Blender Pen
- Ultra-Fine Gray Marker (Marvy Uchida Dark Grey Le Pen)
- Fox Value Study (see page 46)
- Fox Fur Study (see page 50)

The artist used the products in parentheses. Substitute your choice of brands, tools, and materials as desired.

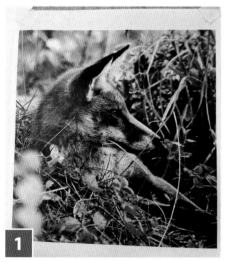

Place the sheet of white synthetic paper down on your work surface, cover with the carbon paper face down, then top with the black and white reference photo. Secure the pieces with tape.

Trace the outside edge of the fox using a pen or stylus. The carbon paper will transfer the lines onto the white synthetic paper.

Tip: Mark the four edges of the reference photo so you can easily realign the image when working on the later steps.

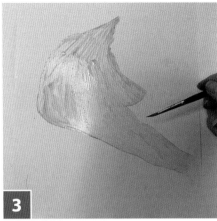

3

Dampen the soap bar and heavily coat the medium round paintbrush with the soap to prevent masking fluid from sticking to the brush bristles. Fill in the fox outline with the masking fluid and let it dry completely. It will be tacky to the touch.

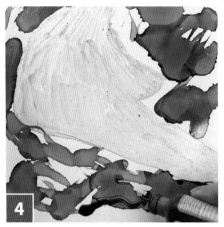

4

Pour the rich green, green, dark green, and olive green inks from the bottles onto the background, mixing the colors as desired and covering everything except the masked fox. You can get very close and even overlap the edges of the fox as the masking fluid will protect this area.

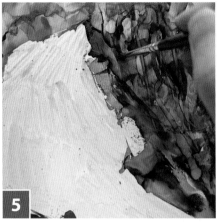

5

Add the orange ink to the welled palette and brush strokes of orange onto the poured background to create grasses.

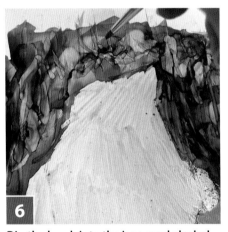

6

Dip the brush into the isopropyl alcohol and paint additional, lighter grasses on the background.

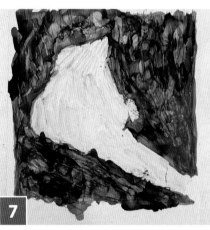

7

Add the green inks used to pour the background to the welled palette. Use the end of a paintbrush or a coffee stirrer to blend and move the inks to create taller grasses. Move the inks vertically above and to the sides of the fox and horizontally below, where the fox is lying on the grass. Allow the inks to fully dry and clean out the welled palette.

8

Use your finger to push and lift off the masking fluid.

Tip: You may see some green specks where the masking fluid allowed tiny bits of ink to come through. Since the fox's edges are dark, you could just paint over them, but if you want to clean them up, use a blending pen. Be sure to wipe the blending pen on a cotton round as you work so you don't deposit additional ink onto the fox.

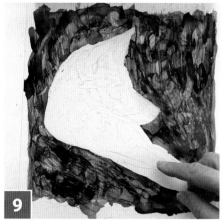

9

Place the carbon paper face down on top of the painting, then realign the reference photo on top. Secure the pieces with tape. Trace the inner details of the fox using a pen or stylus. The carbon paper will transfer the lines onto the white synthetic paper.

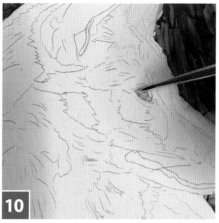

10

Use a very small brush to dab some light brown ink into the lower section of the eye. Then add some green-brown ink to the back corner of the eye. Be sure to leave a white highlight at the top.

Tip: If you accidentally get ink into the highlight area, use your blender pen to lift the color out.

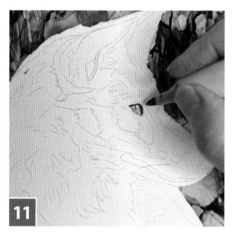

11

Use the fine tip of the black marker to line around the eye and add the black slit for the pupil.

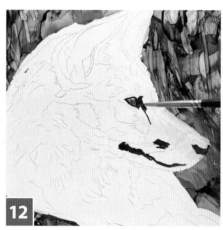

12

Use the black marker to add in the nose, mouth, and darker areas around the eye. If you need to darken the browns in the iris, add another layer of each ink color.

13

Add the mustard yellow, golden brown, red-orange, red-brown, dark brown, and brown inks to the welled palette and allow the inks to evaporate. Use the medium round brush to paint in the fur, following your value study and fur study to add colors and fill in the length and direction of the fur. At first the inks will be pale.

14

Continue adding layers to darken the colors, then use the black marker to fill in the dark tips of the ears.

15

Continue to add colors and textures to the top of the fox's head, following the reference photo. I used very pale mustard yellow ink for the light fur in the fox's ears and blended the black marker with the brown ink on the back of the ears to make a unique dark gray color.

16

On the back of the fox's head, add a base layer of orange ink, then add strokes of golden brown and red-brown ink on top, following the length and direction information from your fur study.

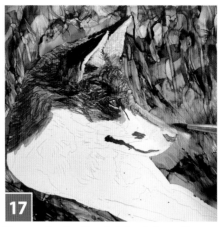

17

Use mustard yellow ink fresh from the bottle to paint in the lightest top part of the muzzle (where the sun is shining on it).

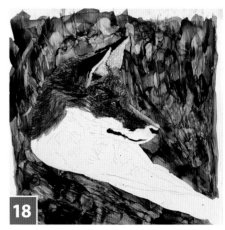

18

Use evaporated mustard yellow and brown inks to fill in the other areas of the muzzle. Add more layers of brown ink if necessary to capture the value of the shadow on the muzzle.

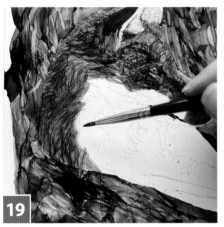

19

Add another layer of evaporated brown ink to the furry area at the back of the head as needed.

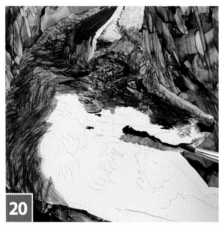

20

Begin adding gray ink to areas in shadow like the cheek and below the mouth and blend the black of the nose up and out into the muzzle.

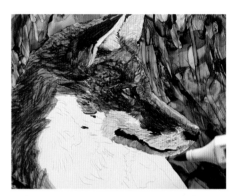

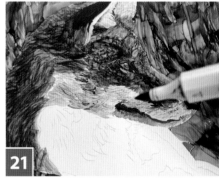

21

Use the cool gray 50% marker to create a light gray base color, then apply strokes of cool gray 60% and cool gray 70% on top, following the direction and length of the fur.

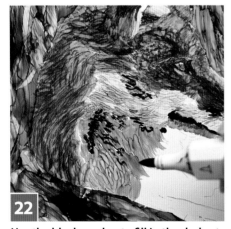

22

Use the black marker to fill in the darkest pieces of fur, then add strokes of cool gray 80% and cool gray 90%, following the direction and length of the fur.

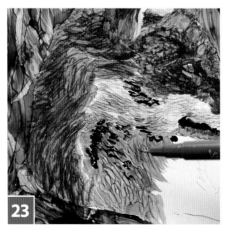

23

Use the ultra-fine gray marker to break up the wider strokes and add more texture.

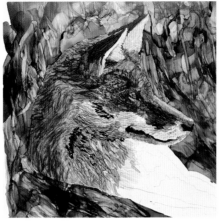
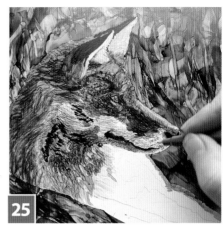

24

Paint lightly with mustard yellow ink to blend the area where the fur goes from orange to gray. You may need to darken or lighten the gray sections to correctly shape the jaw line.

25

Use the ultra-fine gray marker to add dots for where the whiskers come out of the muzzle.

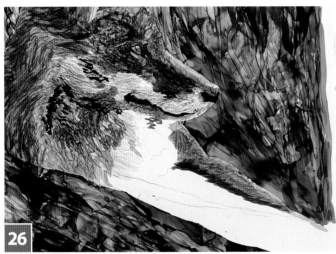
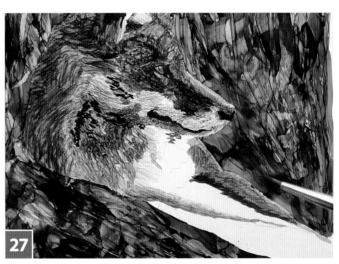

26

Add a section of mustard yellow ink to the outside edge of the leg, then add a section of orange below it, and finish with a section of red-brown.

27

Add a section of mustard yellow ink to the top edge of the lower leg, then add a section of orange below it.

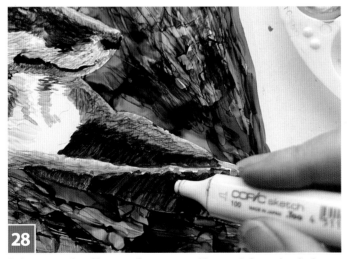
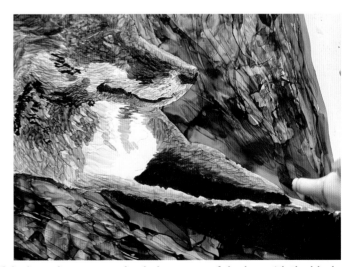

28

Paint a couple of layers of evaporated brown ink on the dark part of the legs, then go over the darkest areas of shadow with the black marker. Compare your finished piece to the value study by laying it on top. Adjust any areas that need to be lightened or darkened.

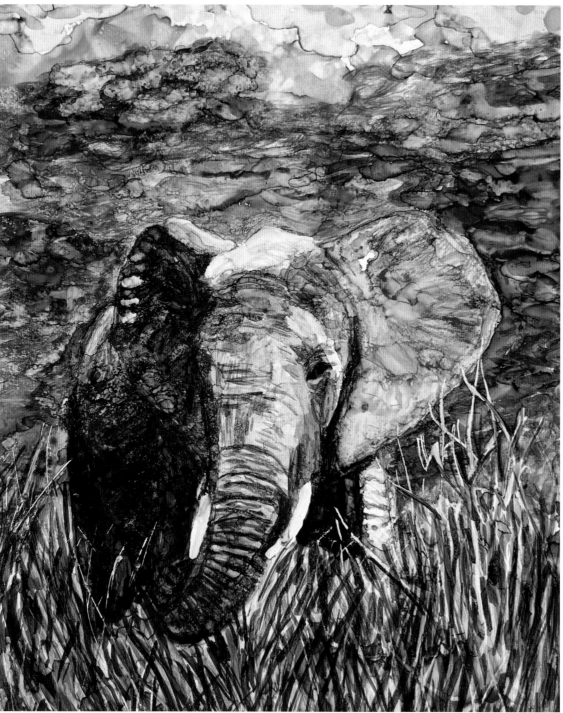

Elephant in Primary Colors

This project explores the importance of value and uses the Creating a Barrier Layer technique from page 56 to create dynamic layers of color. Create a value study (see page 46) first, to find the lights, midtones, and darks, then you'll work with the three primary colors to create these values and a pale background and rich foreground to convey depth.

by Sheryl Williams, *https://sherylwilliamsart.com*

Materials and Supplies

- Black and White Reference Photo from page 159 printed 8.5" x 11" (21.6 x 27.9cm)
- Color Reference Photo from page 159 printed 8.5" x 11" (21.6 x 27.9cm)
- Alcohol Inks in the following colors:
 - » Pale Yellow (Ranger's Tim Holtz Lemonade)
 - » Light Blue (Ranger's Tim Holtz Stonewashed)
 - » Light Red (Ranger's Tim Holtz Watermelon)
 - » Yellow (Ranger's Tim Holtz Dandelion)
 - » Red (Ranger's Tim Holtz Ember)
 - » Blue (Ranger's Tim Holtz Cobalt)
- 9" x 12" (22.9 x 30.5cm) White Synthetic Paper Sheet (Dura-Bright)
- 91% or 99% Isopropyl Alcohol

- 3 Containers (to hold isopropyl alcohol)
- Carbon Paper
- Pen or Stylus
- Artist's Tape
- Masking Fluid (Pebeo Drawing Gum)
- Paintbrushes
 - » Paintbrush with Angled Handle Tip
 - » 3 Medium Round Brushes
 - » Large Round Brush
- Welled Palette
- Fantastix with Pointed Tip
- Ultra-Fine Gray Marker (Marvy Uchida Dark Grey Le Pen)
- Elephant Value Study (see page 46)

The artist used the products in parentheses. Substitute your choice of brands, tools, and materials as desired.

1 Place the sheet of white synthetic paper down on your work surface, cover with the carbon paper face down, then top with the black and white reference photo. Secure the pieces with tape.

2 Trace the details of the elephant using a pen or stylus. The carbon paper will transfer the lines onto the white synthetic paper.

Tip: Mark the four edges of the reference photo so you can easily realign the image when working on the later steps.

3 Go over the drawing with the ultra-fine gray marker.

4 Use the angled tip of the paintbrush handle to apply the masking fluid to the tusks, highlights, and grasses. Let it dry completely. It will be tacky to the touch.

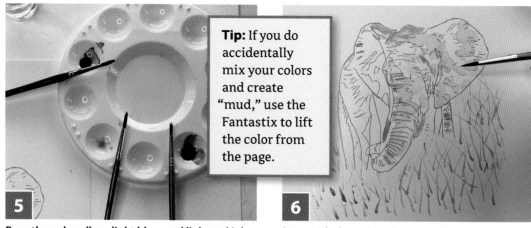

5 Pour the pale yellow, light blue, and light red inks into the welled palette and designate one brush and one container of isopropyl alcohol for each color to avoid mixing the inks. If needed, dilute the red ink to match the value of the other two colors.

6 Start with the pale yellow ink, dabbing it onto the lightest areas of the elephant as shown.

7 Dab the light red ink along the right side of the elephant and add dabs of both light red and light blue into the shadowed areas on the elephant as shown. Paint large dabs of all three colors on the background and within the grasses. Use the Fantastix to blend any harsh or dark lines created where wet and dry inks meet.

8 Create a barrier layer across the surface of the entire piece as shown on page 56. Once it's set, fill two wells each of the welled palette with the yellow, red, and blue inks (one well will be for pure color and the other will be used for mixing new colors). Continue to use a separate brush and isopropyl alcohol container for each color.

9 Paint blue ink on the left ear and apply red on top of the blue to create darker shades and deep purples. Keep adding layers and mixing colors in the palette as desired to create the dark shaded areas.

10 Create midtones by dabbing the yellow ink in the lighter places on the ears as shown. Hold your brush perpendicular to the paper to make fine lines and creases and add additional layers to darken the creases as needed.

Define the trunk with dark lines, then fill in the rest of the midtones with red and yellow as shown. When you add the yellow to the reds it becomes a vibrant dark orange. Dab more yellow on top of the dark colors to lighten the values as needed.

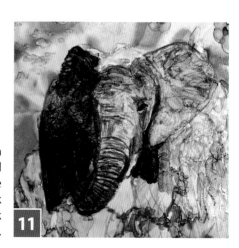

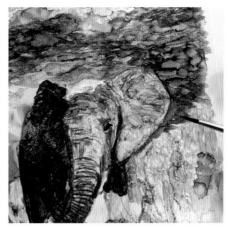

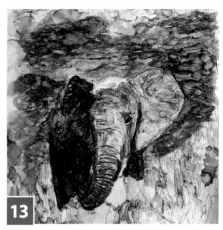

Use the large round brush to mix the blue and yellow ink in the palette to create different green shades. Add these different greens and yellows to the background in horizontal strokes to create the sense of branches covered with leaves.

Continue adding greens on the background and to either side of the elephant. Do not add any where the grasses will be. Use lighter colors behind the darker side of the elephant and darker colors against the lighter side of the elephant.

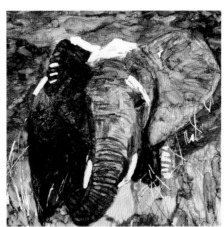

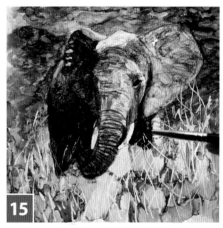

Use your finger to gently remove the masking fluid.

Use the pale yellow ink to paint in the highlights on the elephant, add shape to the tusks, and fill in the grasses.

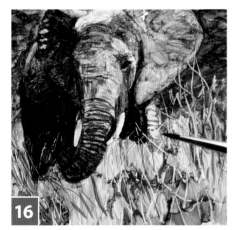

Selectively add some reds and oranges (made by mixing the red and yellow ink) on top of the pale yellow. Make sure that your strokes follow the shape of the grass. Add short strokes of red in between the grasses to indicate grass behind.

Add strokes of blue grass on top.

Lightly go over these blue strokes with orange to blend the colors a bit and create a more natural, cohesive area. Add a few green grasses to finish the piece.

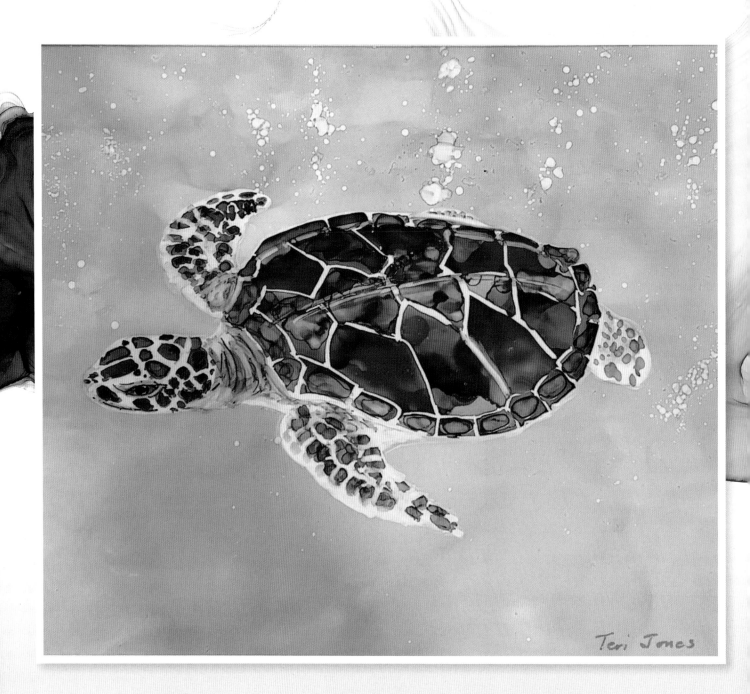

Tranquil Sea Turtle

In this engaging project, you'll be focusing on creating a detailed representation of a sea turtle. A unique aspect of this project involves working on both sides of a translucent surface, allowing for an intriguing interplay of depth and color. Techniques such as pouring and blending ink are used to achieve a fluid, vibrant undersea backdrop, while lifting and brush painting help shape the form and texture of the turtle itself. Lastly, fine-tipped markers are employed to add intricate details, enhancing the realism, and bringing your sea turtle to life. This project offers a unique application of alcohol ink techniques to create a vibrant and realistic underwater scene.

By Teri Jones, *https://terijones.com*

Materials and Supplies

- Black and White Reference Image from page 160
- Alcohol Inks in the following colors:
 - » Yellow-Orange (Ranger's Tim Holtz Butterscotch)
 - » Coral (Ranger's Tim Holtz Coral)
 - » Gray-Purple (Ranger's Tim Holtz Eggplant)
 - » Light Apricot (Ranger's Tim Holtz Peach Bellini)
 - » Yellow-Green (Ranger's Tim Holtz Pistachio)
 - » Light Teal (Ranger's Tim Holtz Pool)
 - » Pale Burnt Orange (Ranger's Tim Holtz Terra Cotta)
- 8½" x 10½" (21.6 x 26.7cm) Clear Synthetic Paper Sheet (DuraLar Matte Translucent)
- White copy paper

- Artist's Tape
- 91% Isopropyl Alcohol
- Container (to hold isopropyl alcohol)
- White Oil-Based Pencil (Posca)
- Black Fine-Tip Marker (Sharpie)
- Clear Alcohol Ink Marker
- Small Round Paintbrushes
- Coffee Stirrers
- Welled Palette
- Cotton Swabs, Blender Pen, or Fantastix
- Paper Towels

The artist used the products in parentheses. Substitute your choice of brands, tools, and materials as desired.

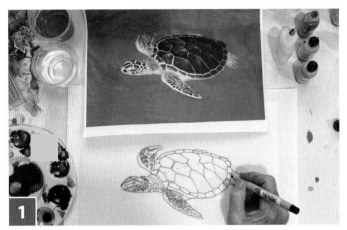

1

Sketch the turtle onto the white copy paper with a black marker or dark pencil.

2

Place the clear synthetic paper over the sketch and use the white pencil to trace the white lines of the interior shell and any important features of the turtle, being careful to connect all the sections so the pencil lines can contain the ink. Use tape to secure the piece as you work.

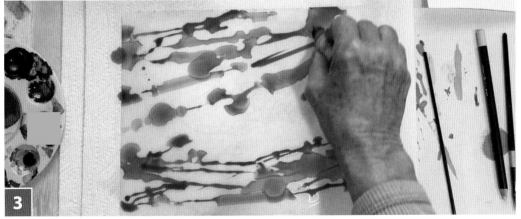

3

Turn the clear synthetic paper over and lightly tape it down on a board so that you can pick it up. Spritz this back side with alcohol, then immediately pour the blue and green inks over the surface.

Tip: Working on transparent or translucent paper will let you work on the piece from the opposite side when needed. You'll easily be able to see the image when you have the piece flipped to the back side.

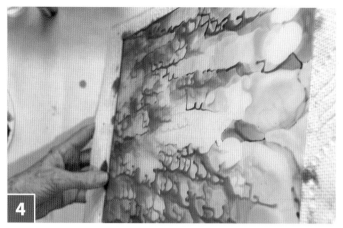

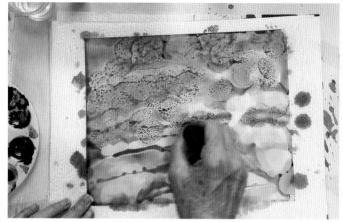

Add small amounts of the light apricot ink and allow the colors to mingle and flow, picking up the board to help the process and keeping the entire surface wet until your background looks like water. Use a coffee stirrer or other blending tool to mingle the colors if you prefer. Let the inks fully dry.

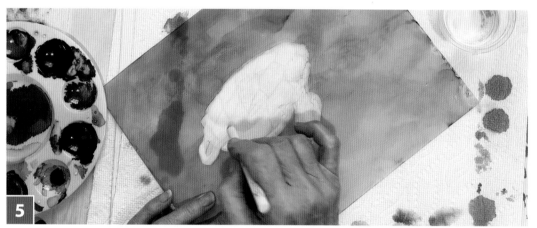

Tip: Always have a soft layer of something like folded paper towels underneath the painting so that the ink is not scratched when you work on the other side of the paper.

After the ink has thoroughly dried, use a cotton swab, blender pen, or Fantastix lightly dampened with isopropyl alcohol to remove the ink from the turtle. Make sure the tool you are using is not too wet and have patience.

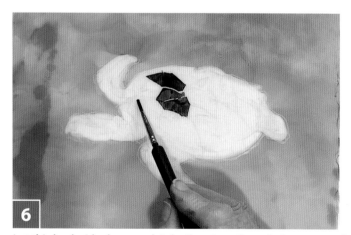

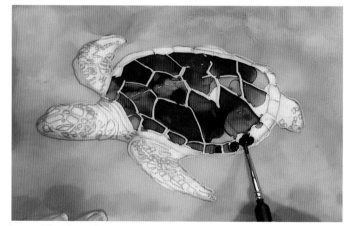

Let this back side dry completely, then turn the painting over to the front side. Place the gray-purple, coral, pale burnt orange, and yellow-orange inks into the welled palette, then use a small brush to tap each color one at a time into the segments of the shell. The colors should mingle on the paper and fill the segments. Let the piece dry completely.

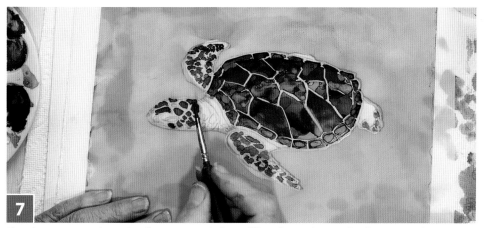

Tip: When finishing your piece, seal and protect both sides of the paper. You only need one coat of varnish on the back of the painting to help protect it from reflected light, however. Put a clean white sheet of paper behind the painting when matted or mounted to cause the colors to "pop."

7

Use the gray-purple and yellow-orange inks to fill in the scales on the flippers and the head. Allow the colors to mingle on the paper and fill the segments. Let the piece dry completely.

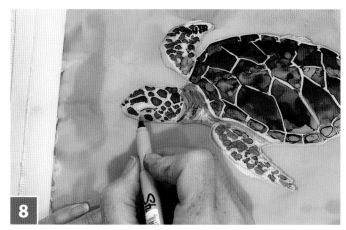

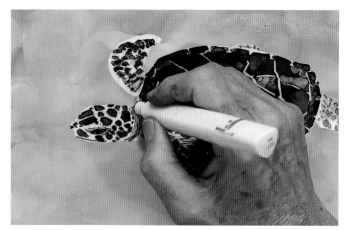

8

Begin to refine the turtle using the black fine-tip marker to add details and a clear alcohol ink marker to lift highlights. Focus first on the turtle's eyes and distinctive skin tiles to capture the realism. Don't forget the mouth, which is under the eye and almost in shadow.

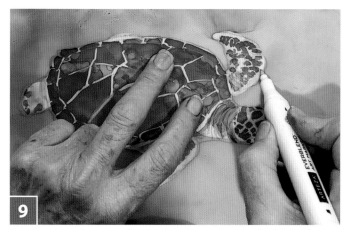

9

Let the piece dry completely, then flip it over and add shadows on the back side of the paper, being careful to not disturb the water.

10

Dip a small brush in isopropyl alcohol, then sharply tap it against a marker or pencil to lightly sprinkle alcohol on the back side of the painting and form small bubbles. Practice on another piece of paper first to get a feel for this process. Let the piece dry completely.

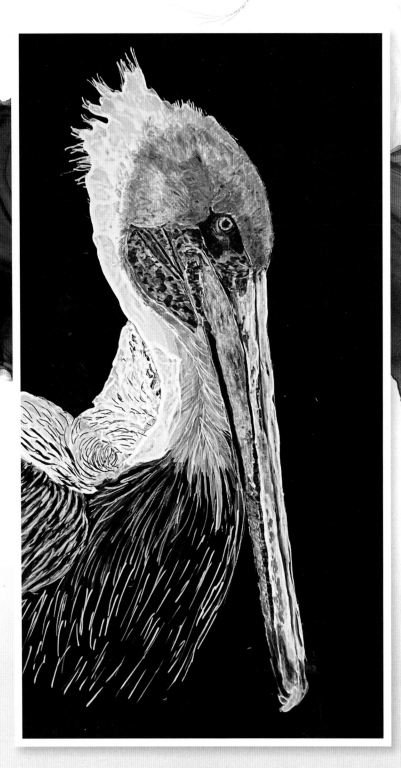

Materials and Supplies

- Black and White Reference Photo from page 159
- Color Reference Photo from page 159
- Alcohol Inks in the following colors:
 - » Opaque White (Ranger's Tim Holtz Snow Cap Mixative)
 - » Yellow-Orange (Ranger's Tim Holtz Butterscotch)
 - » Golden Brown (Ranger's Tim Holtz Caramel)
 - » Tan (Ranger's Tim Holtz Sandal)
 - » Pale Blue (Ranger's Tim Holtz Cloudy Blue)
 - » Red (Ranger's Tim Holtz Crimson)
 - » Coral (Ranger's Tim Holtz Peach Bellini)
 - » Red-Brown (Ranger's Tim Holtz Sepia)
 - » Orange (Ranger's Tim Holtz Sunset Orange)
- 9" x 12" (22.9 x 30.5cm) Black Synthetic Paper Sheet (Nara)
- 91% or 99% Isopropyl Alcohol
- Container (to hold isopropyl alcohol)
- White Transfer Paper (Saral Wax-Free Transfer Paper)
- Pen or Stylus
- Artist's Tape
- Paintbrushes
 - » Medium Round Brush
 - » #2 Fine-Tip Brush (Creative Mark Rhapsody Round Kolinsky Sable Artist Brush)
- Welled Palette
- Cotton Cosmetic Rounds
- Blender Pen
- Fine-Point Black Pen
- Fine-Point White Acrylic Marker (Posca)
- Black Alcohol Ink Marker

The artist used the products in parentheses. Substitute your choice of brands, tools, and materials as desired.

Shaded Pelican

This project is all about the transparent quality of alcohol inks. On a black substrate you can't see the ink color unless there is opaque white underneath. This piece also includes a painting technique from the old masters—grisaille, in which you paint entirely over a foundation of grays that imitate sculpture with all the shaping and texture created before the color is applied.

by Sheryl Williams, *https://sherylwilliamsart.com*

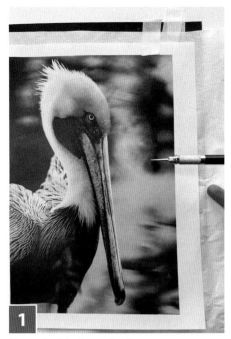

1 Place the black synthetic paper on your work surface, cover with the white transfer paper face down, then top with the black and white reference photo. Secure the pieces with tape.

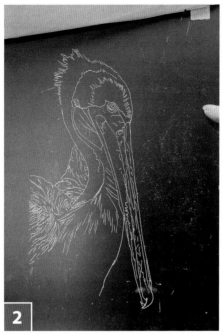

2 Trace the details of the pelican using a pen or stylus as shown. Don't worry about the white dust from the transfer paper as it can be removed with a brush and isopropyl alcohol.

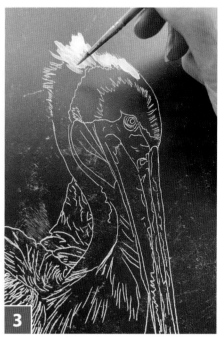

3 Begin building the grisaille layer with the opaque white and the medium round brush on the top of the head, following the direction of the feathers.

Tip: Thicker mixative will appear white and thinner mixative will appear gray. For the lightest areas of the pelican, add two to three layers. For the medium areas, add one or two layers. For the darkest areas, dilute the mixative so that it is very pale. Your strokes will leave a sculptural texture that will show through when color is added.

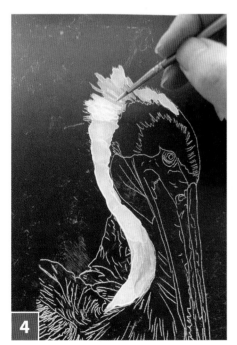

4 Follow the area down the back of the head, adding enough mixative to make the lightest areas very thick and opaque white.

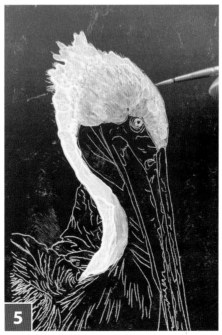

5 Fill in the top of the head and add more texture as shown.

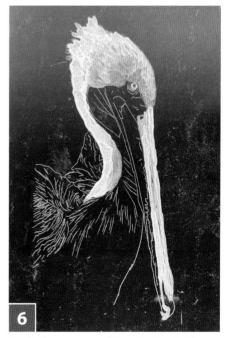

6 Apply the opaque white mixative to the top of the bill, creating a lot of texture as shown.

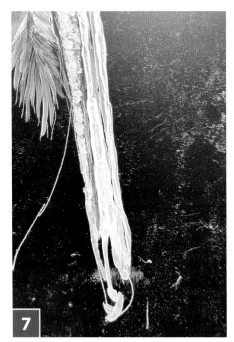

7 For the bill closest to the body, dab the opaque white to create horizontal texture marks.

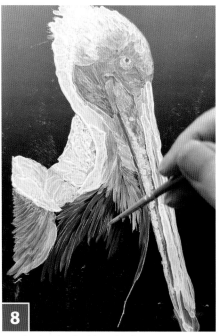

8 For the back, thickly add the opaque white, following the general direction of the feathers. Paint more layers if needed. For the very light feathers on the body, dilute the mixative and paint very pale wispy feathers.

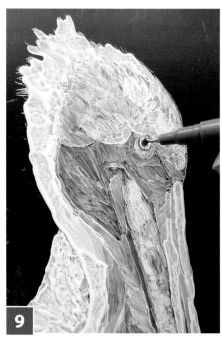

9 Use alcohol on a cosmetic pad to clean up any stray lines or marks on the paper and use the fine-tip black marker to define the eye.

10 Allow the yellow-orange, golden brown, and tan inks to evaporate in the welled palette as shown.

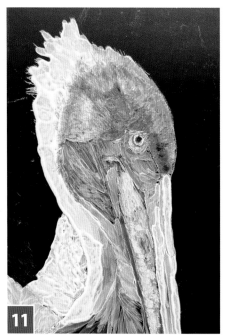

11 Dab the yellow-orange all over the head. Then darken a few sections by adding golden brown on top. If an area seems a bit too dark, add a bit more lightness by dabbing some of the opaque white on top or mixing it with the golden brown ink to create a lightened color.

12 Add the pale blue and red inks to the welled palette and allow the pale blue to evaporate a bit. Switch to a very small paintbrush. Mix some of the red with the opaque white in the palette to create some of the lighter shades for the eye.

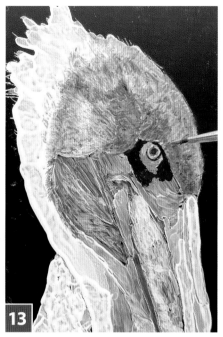

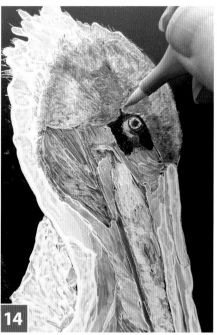

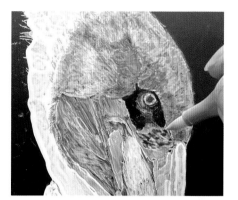

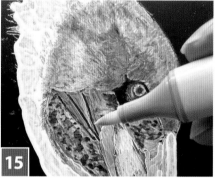

13 Use red ink to add the darkest color around the eye, then use the lighter red to fill in the pink shades.

14 Use a blender pen to lift out the dark ring around the eye and the little crease above the eye as shown.

15 Dab with the blender pen to add the texture below the eye and the back of the mouth as shown. Create the lines of separation in the cheek.

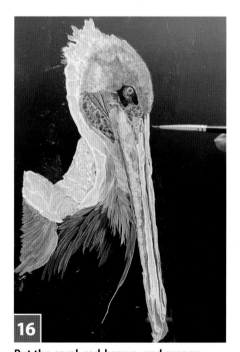

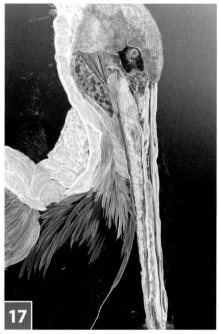

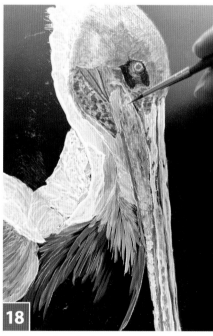

16 Put the coral, red-brown, and orange ink in the welled palette and let them evaporate. Dab the coral all along the bill. There will be a few darker areas and that's fine. Then use the red-brown to make a line between the bill sections.

17 Use the red-brown ink to add darker colors and spots along the bill, then add orange to the darker spotting at the bottom and the bill lines.

18 Apply coral to the lower part of the bill, dabbing as you go. If you need to lighten the area, mix some of the coral ink with the opaque white ink and continue to dab.

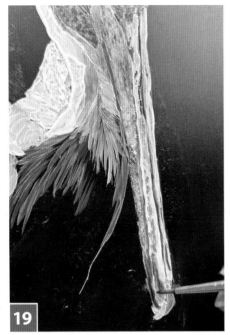

19

Farther down, begin to add red-brown horizontally to create the correct color and texture. Leave a darker line between the two sections of the bill. Finish the tip with longer vertical strokes.

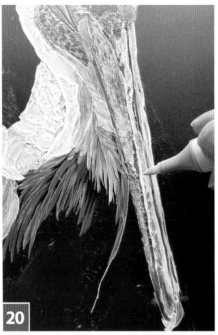

20

Use the blender pen to dab horizontally in the darker separating line to add texture.

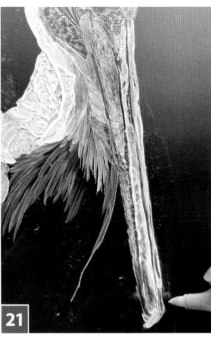

21

Fill the tip of the bill with evaporated tan ink and dab just a bit with the blender pen to create the darker spot at the end.

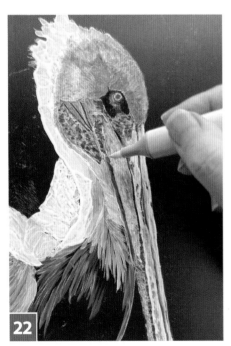

22

Finish the bill by lifting a clean edge on the left side of the bill with the blender pen.

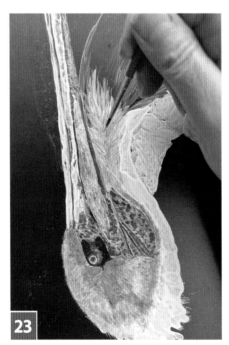

23

Turn your painting upside down and add strokes of yellow-orange for the neck and chest feathers. Turning the paper will allow you to create strokes that are narrow at the tip and wider toward the body.

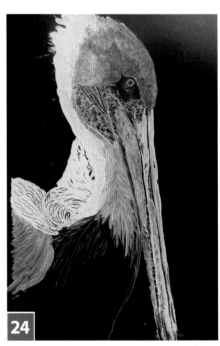

24

Turn your painting right side up, then use the fine-point black pen to mark in spaces between the white feathers.

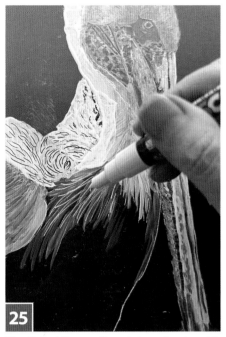

25

Use the white acrylic paint marker to add additional feather strokes on the body as shown.

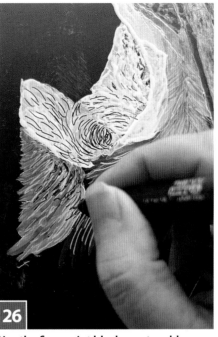

26

Use the fine-point black pen to add more details between the light gray feathers.

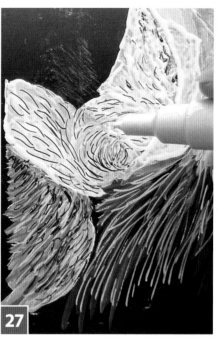

27

Use the white acrylic paint pen to soften any black marks as needed.

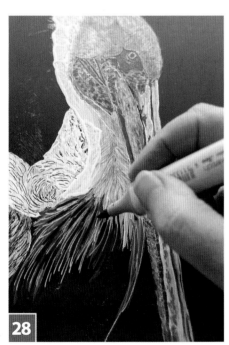

28

Use the black alcohol ink marker to add more shading and detail to the lower body.

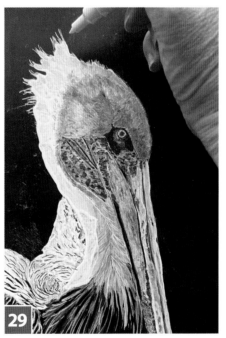

29

Use the white acrylic paint pen to add thin white tips to the feathers on the head.

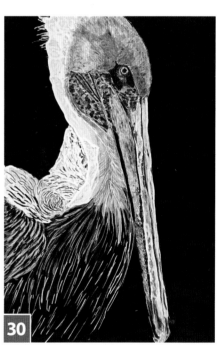

30

Use the white acrylic paint pen to fill in the rest of the body with general feather strokes.

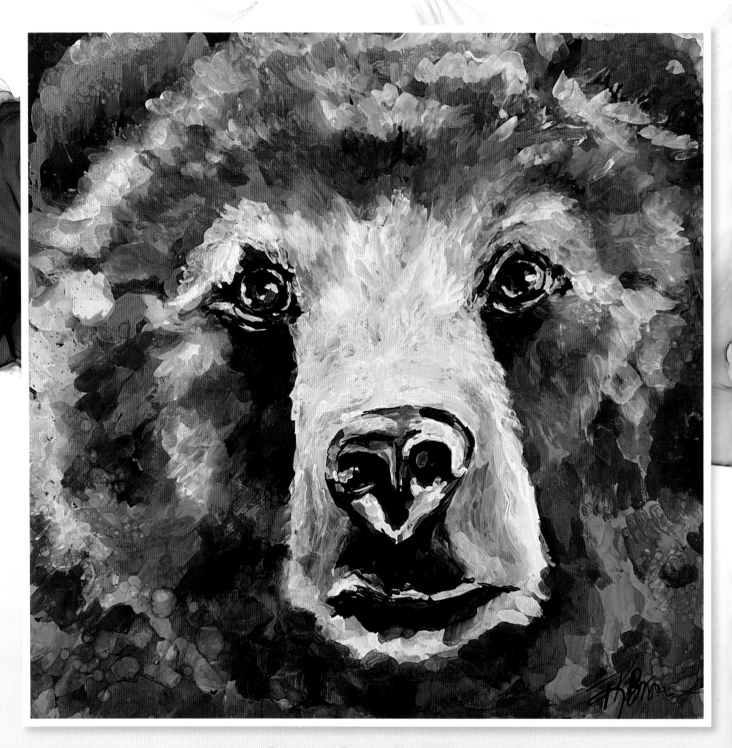

Colorful Bear

In this project, you'll be creating an expressive depiction of a bear on a black surface. The key feature of this project is learning to create opacity with a white medium, a technique that heightens the inherent transparency of alcohol inks, making colors shine bright against the dark background. The focus will be on using a loose painting style and allowing the unique properties of alcohol ink to create texture and visual interest. Through various techniques like dabbing, brush painting, blending, and splattering, you'll work with the ink to produce an array of textures and color blends that will pop, enhancing the overall impact of the artwork.

By Teresa K. Brown, *https://www.tkbrownart.com/*

Materials and Supplies

- Alcohol Inks in the following colors:
 - » Opaque white (Ranger's Tim Holtz Snow Cap Mixative)
 - » Indigo (Ranger's Tim Holtz Indigo)
 - » Red (Ranger's Tim Holtz Crimson)
 - » Pale Yellow (Ranger's Tim Holtz Lemonade)
 - » Yellow (Ranger's Tim Holtz Dandelion)
 - » Teal (Ranger's Tim Holtz Mermaid)
 - » Red-Purple (Ranger's Tim Holtz Wild Plum)
 - » Purple (Ranger's Tim Holtz Amethyst)
- Alcohol Ink Markers in the following colors:
 - » Cool Gray 10 (Copic Refill CG10)
 - » Orange (Zig Kurecolor)
 - » Brown
 - » Black
- 12" x 12" (30.5 x 30.5cm) Black Synthetic Paper Sheet (Dura-Bright)
- 91% or 99% Isopropyl Alcohol or Blending Solution
- Container (to hold isopropyl alcohol or blending solution)
- Small Condiment Containers (for color mixing)
- White Acrylic Paint Pen (Posca)
- Paintbrushes
 - » Medium Round
 - » Small Round #6 Synthetic Brushes
- Welled Palette
- Paper Towels

The artist used the products in parentheses. Substitute your choice of brands, tools, and materials as desired.

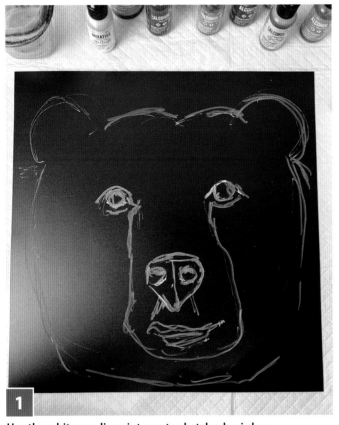

1

Use the white acrylic paint pen to sketch a basic bear.

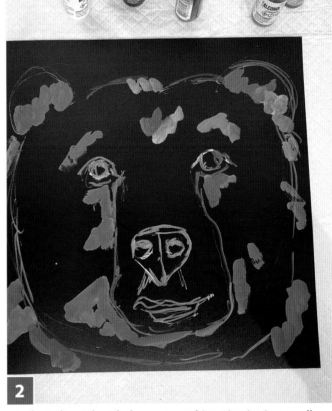

2

Mix the indigo ink with the opaque white mixative in a small cup. Using a dabbing motion, start adding the mixed color on the darker areas of the bear, where the shadows will be.

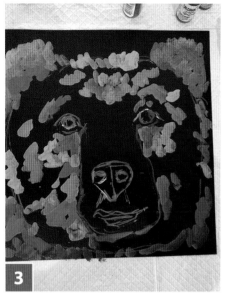

3

Mix the red ink with the opaque white mixative in one container and the red-purple ink with the opaque white mixative in a separate container. Dab in these colors to add more dimension to the darker shaded areas.

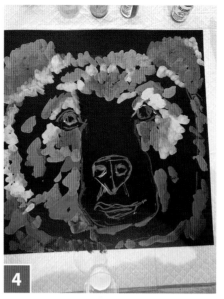

4

Mix the teal ink with the opaque white mixative. Dab in this mixture to build the midtones.

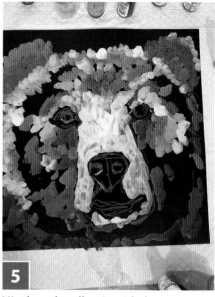

5

Mix the pale yellow in with the opaque white mixative. Dab this mixture to create the lightest areas. Dab a bit of yellow on top of the lighter mixture to create some shading and dimension within these light shades.

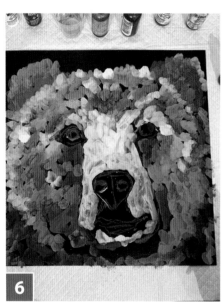

6

Mix the purple ink with the opaque white mixative and finish covering the surface of the bear's face, leaving the eyes, nose, and mouth black. When adding colors be mindful of placing colors that will mix well together to make the transitions smoother.

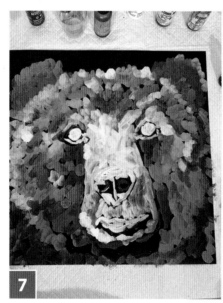

7

Use just the opaque white mixative to paint in the eyes and nose. *Some of the black can remain, but it is important to add the white to maintain the texture for the finished piece.*

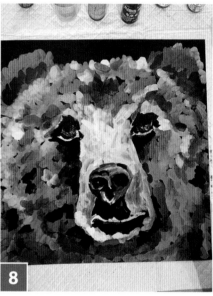

8

Place some of the ink from the cool gray marker in a palette or small cup and use the ink to place some dark values on the nose, leaving a bit of white. Use a brown brush-tip alcohol ink marker to add a bit of brown to the eyes.

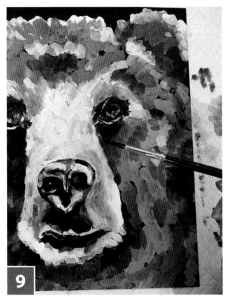

9 Use a black brush-tip alcohol ink marker to add the pupils and shadows of the eye socket. Then use white opaque mixative to paint highlights on the fur. Be careful to clean your brush in between painting on top of colors because they will mix and blend even if it seems like they are dry.

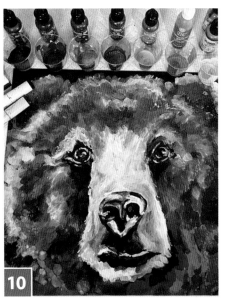

10 Dip a brush in isopropyl alcohol and start to blend the colors to create natural color and value transitions.

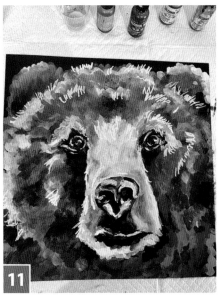

11 Use the white acrylic paint pen to add the realistic highlights to the eyes and a few more abstract scribbles indicating the direction and texture of the fur.

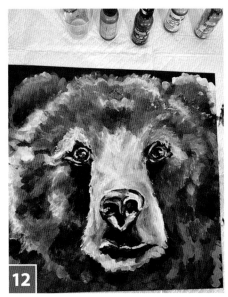

12 Use an isopropyl alcohol–dampened brush to blend the white paint marks into the colors underneath.

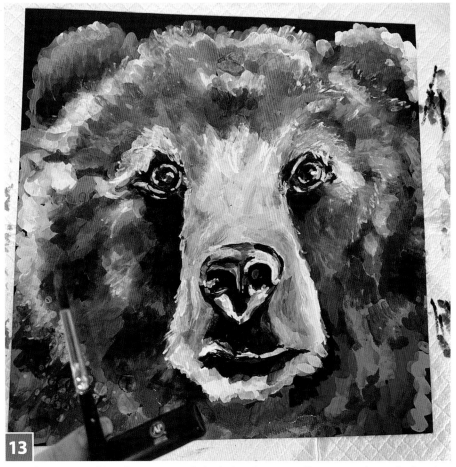

13 Dip a larger round brush in isopropyl alcohol and get it really saturated. Tap the brush against a pen or another brush to splatter some alcohol and create a speckled finish.

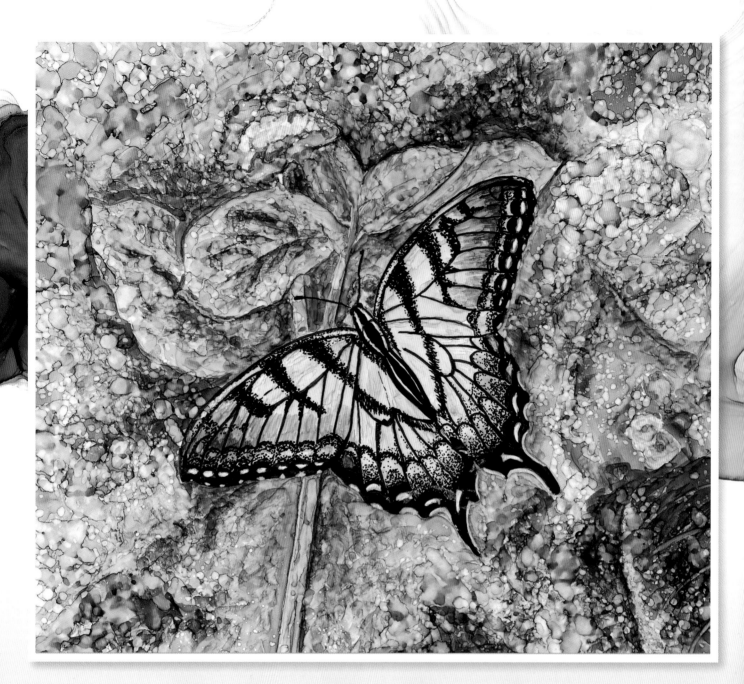

Butterfly Garden

In this project, we'll harness the unique properties of alcohol ink and detail markers to paint a vibrant butterfly amid a lush garden setting. You'll learn to manipulate the ink to create a painting rich with color and detail through a series of techniques, including masking, dabbing, brush painting, and stippling. Experience the satisfaction of crafting a realistic depiction of nature with a balance of fluidity.

by Laurie "Trumpet" Williams, https://trumpetart.com

Materials and Supplies

- Reference Photo from page 161
- Alcohol Inks in the following colors:
 - » Dark Green (Ranger's Tim Holtz Everglades)
 - » Yellow-Green (Ranger's Tim Holtz Limeade)
 - » Yellow (Ranger's Tim Holtz Sunshine Yellow)
 - » Orange (Ranger's Tim Holtz Sunset Orange)
 - » Light Blue (Ranger's Tim Holtz Cloudy Blue)
 - » Magenta (Ranger's Tim Holtz Raspberry)
 - » Orange Alcohol Ink Marker (Spectrum Noir Orange CR10)
- 8" x 10" (20.3 x 25.4cm) Photo Paper, back side (Amazon Basics)
- White Acrylic Paint Pen (Posca)
- 91% or 99% Isopropyl Alcohol
- Container (to hold isopropyl alcohol)
- Carbon Paper
- Pen or Pencil
- Artist's Tape
- Ultra-Fine Tip Black Marker (Sharpie)
- Fine-Tip Black Marker (Sharpie)
- Masking Pen (Molotow Grafx Art Masking Liquid Marker)
- Rubber Cement Eraser
- Paintbrushes
 - » #6 Filbert Brush
 - » #3 Round Brush
- Felt Applicator
- Welled Palette

The artist used the products in parentheses. Substitute your choice of brands, tools, and materials as desired.

1

Place the photo paper on your work surface, cover with the carbon paper face down, then top with the black and white reference photo. Secure the pieces with tape.

2

Trace the butterfly and some of the background flowers using a pen or pencil. The carbon paper will transfer the lines onto the white synthetic paper.

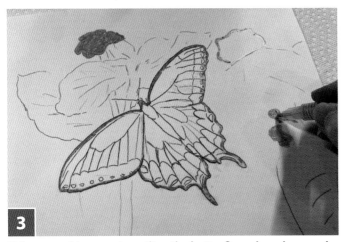

3

Using a masking pen to outline the butterfly and mask around the flower areas. Allow the masking fluid to dry completely.

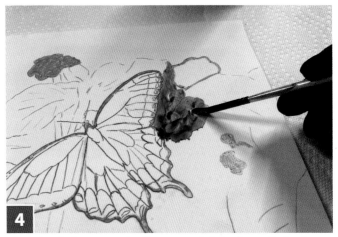

4

Place the dark green and yellow-green inks in the welled palette. Use the paintbrush to dab ink onto the background. Be careful not to get any green ink inside the masked-off butterfly area.

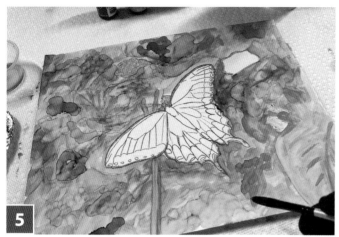

5 Dab yellow-green ink in areas where you need to define leaves and stems. Continue dabbing on the ink, alternating colors and adding dark and light areas until the background is completely covered.

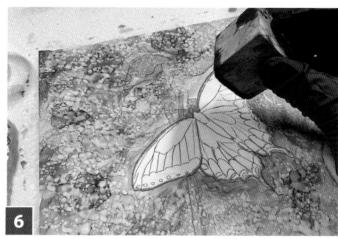

6 Add a few drops of isopropyl alcohol to a felt applicator and dab it randomly around the background to create tiny foliage-like textures. NOTE: it may be helpful to tap your applicator onto a paper towel to minimize the "wetness" of the felt and give you more control over the texture.

7 Use the rubber cement eraser to gently remove the masking liquid from the entire image.

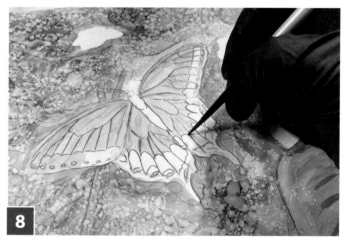

8 Place some yellow ink in the welled palette and allow some of the ink to evaporate. Use the #3 round brush to start filling in the yellow areas and base color layer of the butterfly.

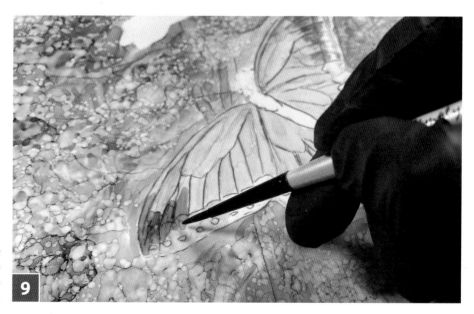

9 Place some orange ink in the welled palette. Referring to the reference photo, paint the orange areas.

Place some blue ink in the welled palette. Referring to the reference photo, paint the orange areas. Be careful to keep the blue ink as separated from the orange ink as possible to avoid creating brown "mud."

Use the #3 round brush and orange ink to start painting in some of the flowers behind the butterfly.

Pour some magenta ink in the welled palette and allow some of the ink to evaporate. Use the #3 round brush to paint in the pink flowers, referring to the reference photo for placement.

Paint in a little of the yellow ink to create the pistil area.

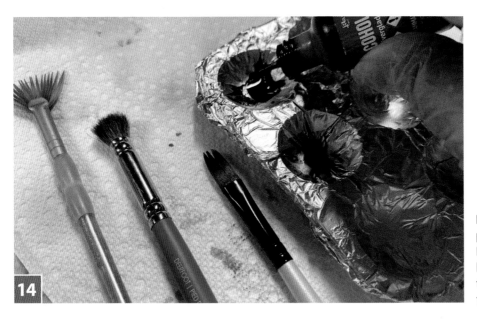

Place more dark green ink in the welled palette and allow it to evaporate a bit. Load some of the ink into the brush and begin painting around the outer edge of the butterfly to create more contrast with the background.

Blend the dark green into the rest of the background by dabbing with a brush dampened with isopropyl alcohol.

Use the dark green ink to add darker leaves to the background as needed. Paint veins into the lighter leaves.

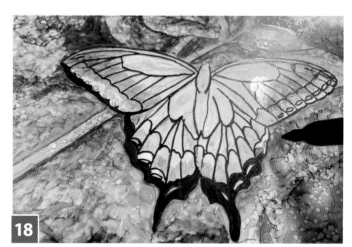

Use the ultra-fine black marker to outline the details of the butterfly and wings, working from the outside to the inner details.

Use the fine-tip black marker to fill in the solid black areas of the butterfly.

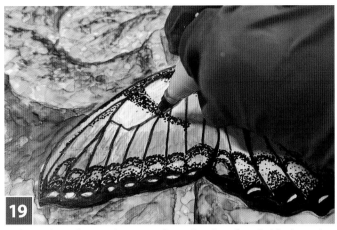

19

Refer to the reference image and use the ultra-fine tip black marker to add stippled details and shading (see the Tip below).

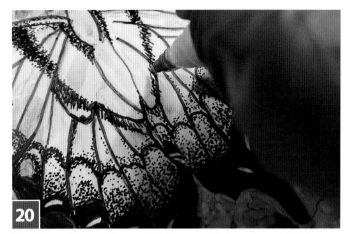

20

Use short diagonal lines to fill in some of these inner details as shown.

Tip: Stippling is a technique that adds value to an image using a series of dots. The closer together and more concentrated the dots are, the darker the value created. The farther apart and more sparse the dots are, the lighter the value created.

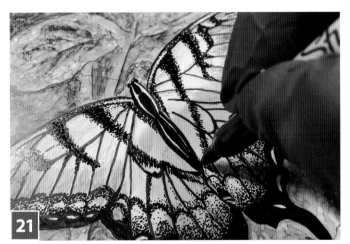

21

Use the fine-tip black marker to fill in the butterfly's black body detail and thicken the outline of the body.

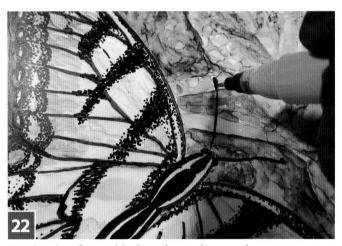

22

Use the ultra-fine tip black marker to draw on the antennae as shown.

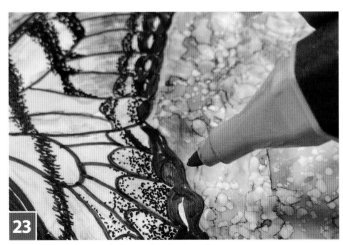

23

Using the orange marker, add the brighter orange accents shown in the reference image.

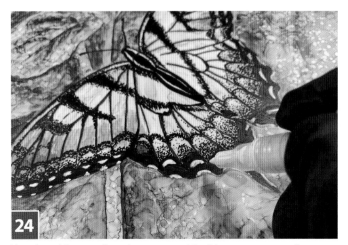

24

Use the white acrylic paint pen to add white accents, starting with the butterfly's body and then detailing the tips of the wings. Continue adding white accents until you are happy with your butterfly. You may need to add more than one **layer.**

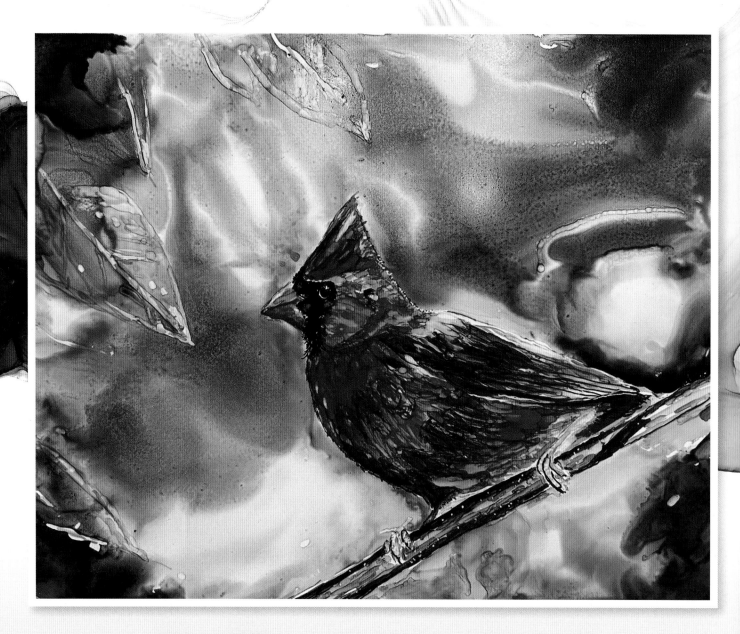

Brilliant Cardinal

For many bird lovers, the sight of a cardinal holds special meaning, sometimes evoking emotional or spiritual feelings. They say the vibrant red bird is an uplifting, happy sign that those we have lost will live forever, as long as we keep their memory alive in our hearts. When painting this bird, look at the photo in grayscale, as well as full color, to review the values in the image.

By Andrea Patton, *https://apatton.faso.com*

Materials and Supplies

- Black and White Reference Photo from page 160
- Color Reference Photo from page 160
- Alcohol Inks in the following colors:
 - » Yellow-Green (Ranger's Tim Holtz Limeade)
 - » Light Yellow-Green (Ranger's Tim Holtz Citrus)
 - » Bright Green (Ranger's Tim Holtz Botanical)
 - » Blue (Ranger's Tim Holtz Sailboat Blue)
 - » Yellow (Ranger's Tim Holtz Dandelion)
 - » Red (Ranger's Tim Holtz Poppyfield)
 - » Orange (Ranger's Tim Holtz Valencia)
 - » Deep Red (Ranger's Tim Holtz Cranberry)
 - » Black (Ranger's Tim Holtz Pitch Black)
 - » Dark Green (Jacquard's Piñata Color Rainforest)
- Alcohol Ink Markers in the following colors:
 - » Red (Prismacolor Crimson Red PM4)
 - » Orange (Prismacolor Spanish Orange PM123)
 - » Yellow (Prismacolor Canary Yellow PM19)
 - » Brown (Prismacolor Sienna Brown PM65)
 - » Dark Brown (Prismacolor Dark Umber PM61)
- 9" x 6" (22.9 x 15.2cm) White Synthetic Paper Sheet (Nara)
- 91% or 99% Isopropyl Alcohol
- Container (to hold isopropyl alcohol)
- 8B Pencil
- Masking Fluid (Pebeo Drawing Gum)
- Ultra-Fine Tip Black Marker (Sharpie)
- White Gel Pen (Gelly Roll)
- Paintbrushes
 - » #0 Round Brush
 - » #3 Round Brush
 - » #10 Round Brush
 - » #10 Flat Brush
- Welled Palette
- Alcohol Ink Blending Solution
- Blender Pen
- Soap Bar

The artist used the products in parentheses. Substitute your choice of brands, tools, and materials as desired.

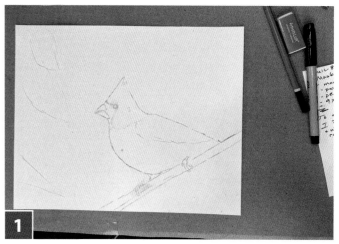

1 Referring to the reference photo, lightly sketch the cardinal on the white synthetic paper with the pencil. Add a branch and a few leaf details.

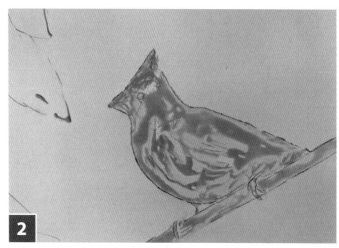

2 Dampen the soap bar and heavily coat the #10 flat paintbrush with the soap to prevent masking fluid from sticking to the brush bristles. Use the brush to fill in the bird with the masking fluid. Mask the branch and the tips of the leaves, as well. Let it dry completely.

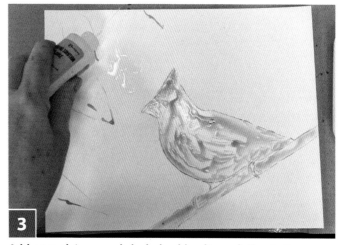

3 Add enough isopropyl alcohol or blending solution to the background to keep it wet for about five to ten minutes.

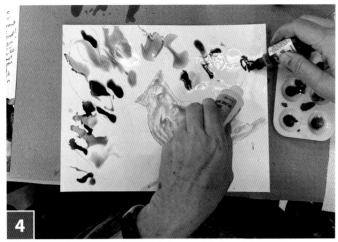

4 Nozzle apply yellow-green, bright green, and light yellow-green inks in the light and medium-value areas and apply the dark green ink to the dark areas.

5 **Spread the inks around with the flat brush.** Let the painting dry for at least 45 minutes.

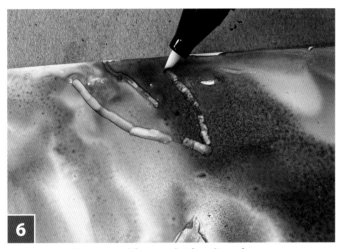

6 Use the blender pen to lift some leaf outlines from the background.

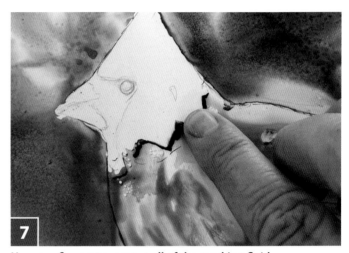

7 Use your fingers to remove all of the masking fluid.

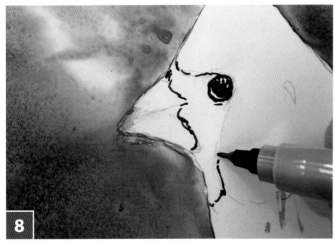

8 Use the ultra-fine tip black marker to fill in the eye, leaving white highlights. Outline the black mask of the face, as well.

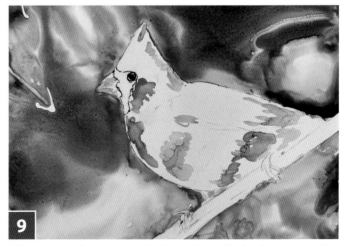

9 **Mix a range of colors and shades in the welled palette using the red, yellow, orange, and deep red inks.** Keep some true colors. Start painting the lightest areas of the cardinal as shown, using the palest, diluted colors.

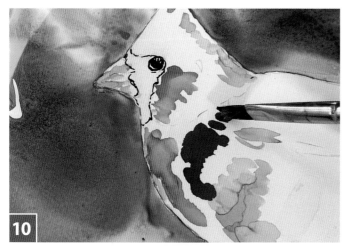

10 Add middle orange and red tones.

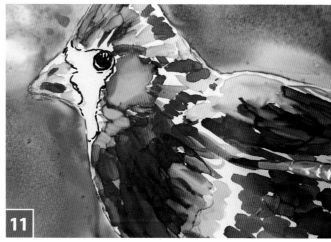

11 Use the red and deep red shades to fill in the darkest shades. Dilute the colors with blending solution as needed. Use the blending pen to remove any excess darkness and balance the colors.

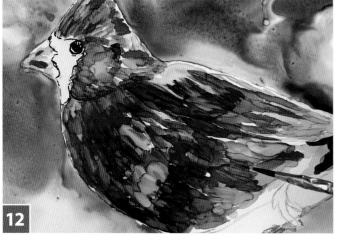

12 Dip a small flat brush in blending solution and dab the excess on a paper towel. Lightly brush over the body in a downward motion, following the direction of the feathers to create a textured effect.

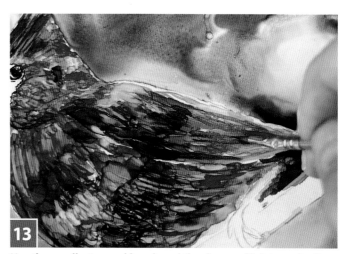

13 Use the smallest round brush and the deep red ink to make tiny lines on the wing. You can add more defined fine lines with the ultra-fine tip black marker if needed.

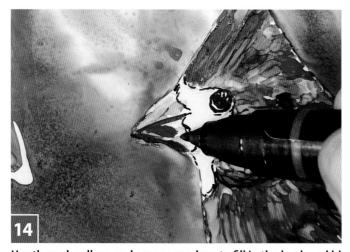

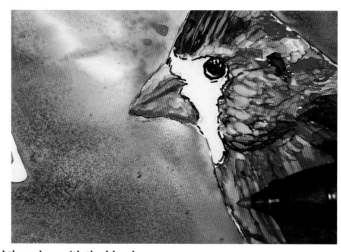

14 Use the red, yellow, and orange markers to fill in the beak and blend the colors with the blender pen.

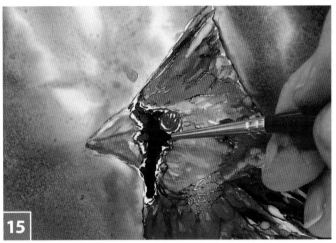

15

Dip a #0 round brush into the black ink and paint the mask on the face. Add minimal ink to this area.

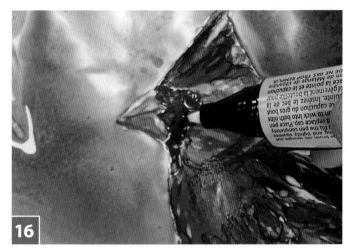

16

Lighten areas of the mask as needed with the blender pen.

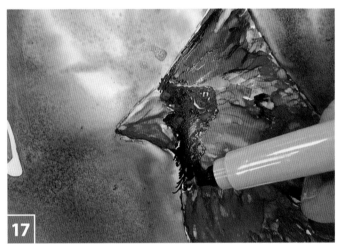

17

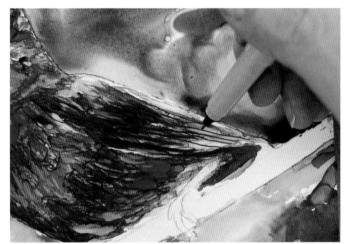

Use the ultra-fine tip black marker to add fine feathers around the mask and add more feather details to the wing.

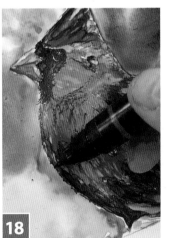
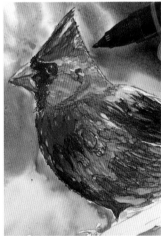

18

Use the fine tip of the red marker to add tiny feathers to the cardinal's breast and crest. Use the white gel pen to add highlights as needed.

19

Use a #0 round brush with diluted deep red ink to fill in the claw details. Fill in the outer edges of the branch with undiluted deep red ink.

Fill in the branch with diluted deep red ink. Layer on the brown and dark brown markers to create a nice shaded branch with light shades, medium shades, and dark shades.

Use the ultra-fine tip black marker to outline the claws.

Use the white gel pen to create tiny dots on the branch.

Use the blender pen and the yellow and light green markers to add a few highlights around the edges of the leaves. Use the blender pen to create natural light spots on the leaves.

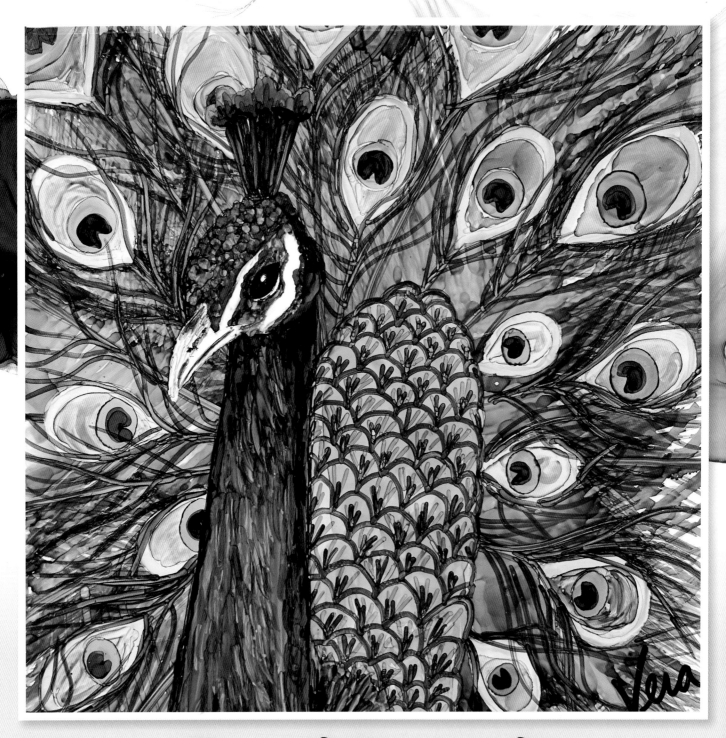

Proud Peacock

In this vibrant project, you will create a beautiful representation of a peacock, set upon a smooth white tile. The essence of the peacock, synonymous with elegance and vibrancy, is captured through a medley of techniques including nozzle application of ink for broader areas of color, brush painting for more refined strokes, and lifting for creating light and depth. The project is further enhanced with fine-tipped markers that are used to add intricate details, accentuating the peacock's distinctive plumage. This endeavor offers an engaging exploration of alcohol ink techniques, guiding you to create a stunning and realistic peacock portrait.

by Vera Worthington, *https://www.veraworthington.com/*

Materials and Supplies

- Color Reference Photo from page 163
- Alcohol Inks in the following colors:
 - » Turquoise (Ranger's Tim Holtz Mermaid)
 - » Green (Ranger's Tim Holtz Mojito)
 - » Olive Green (Ranger's Tim Holtz Lettuce)
 - » Light Yellow-Green (Ranger's Tim Holtz Citrus)
 - » Light Brown (Ranger's Tim Holtz Latte)
 - » Blue-Violet (Ranger's Tim Holtz Indigo)
 - » Yellow-Green (Ranger's Tim Holtz Limeade)
 - » Blue (Ranger's Tim Holtz Sailboat Blue)
- Alcohol Ink Markers in the following colors:
 - » Black (Copic 100 Refill)
 - » Olive Green or Light Brown
 - » Dark Brown
 - » Dark Green or Turquoise
 - » Blue
- Black Marker (Sharpie
- Black Acrylic Paint Pen (Posca)
- 6" x 6" (15.2 x 15.2cm) Ceramic Tile
- Blending Solution or 91% or 99% Isopropyl Alcohol
- 2 Containers (to hold blending solution or isopropyl alcohol)
- Paintbrushes
 - » Fan Brush
 - » Round Brushes, Sizes #00–#10
 - » Medium Round Brush
- Welled Palette
- Blender Pen (Fantastix)

The artist used the products in parentheses. Substitute your choice of brands, tools, and materials as desired.

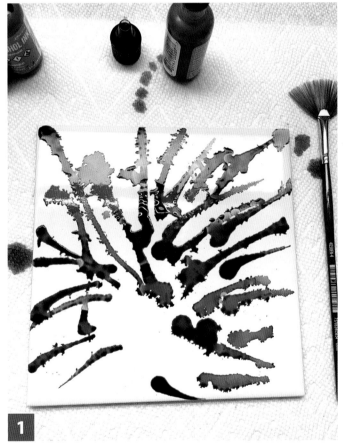

1

Clean the ceramic tile with isopropyl alcohol and apply the turquoise, green, and olive green inks straight from the bottle across the tile's surface.

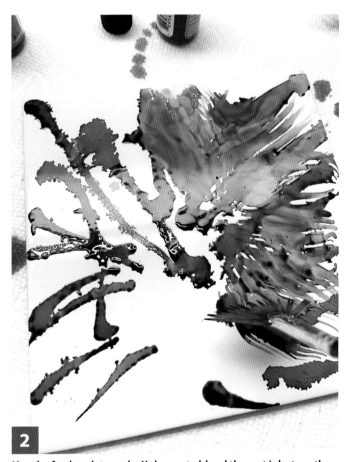

2

Use the fan brush to make X shapes to blend the wet inks together. Don't overmix—you want to be able to see the three different colors. Continue until the whole tile is filled with the feather texture.

3 Use the light brown or olive green markers to make strokes radiating out from the center. These will be the center spines (rachis) of the peacock feathers.

4 Dip the blender pen into the clean isopropyl alcohol and use it to lift off the ink and "draw" the peacock's head and neck, and the mass of smaller feathers behind the neck. Wipe the pen off on a paper towel between strokes and dip it into isopropyl alcohol as needed.

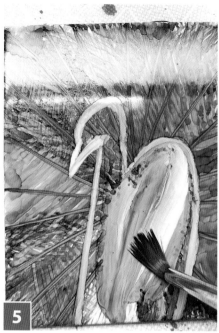

5 Dip a clean round brush into the clean alcohol and use the brush to lift off and wipe away the ink within the head, neck, and feather mass shape. Wipe the brush off on a paper towel, clean the brush in the cleaning alcohol jar, dip the brush into clean alcohol, and repeat until the area is cleaned back to the white of the tile.

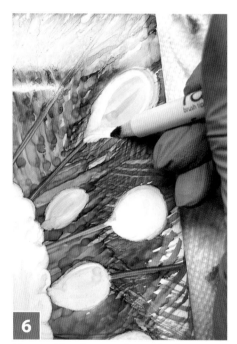

6 Use the blender pen dipped in clean isopropyl alcohol to scallop the edge of the feather mass and lift out the teardrop eyes that land along the peacock's feather spines.

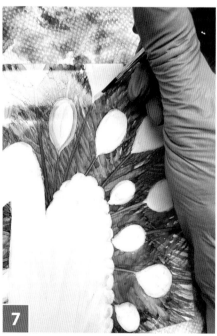

7 Put the light yellow-green ink in the welled palette and use a #2 or #4 round brush to outline the edge of each teardrop shape.

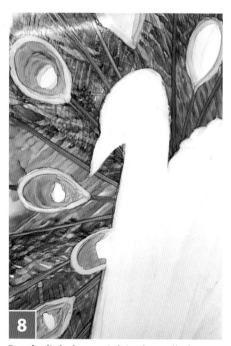

8 Put the light brown ink in the welled palette and use a #2 or #4 round brush to fill in the teardrop shapes, leaving an empty circle in the center of each. Use the blender pen if needed to clean up and enlarge these circles.

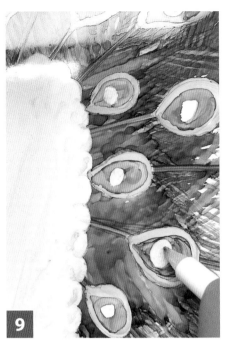

9 Fill in the circles on the teardrops with turquoise ink.

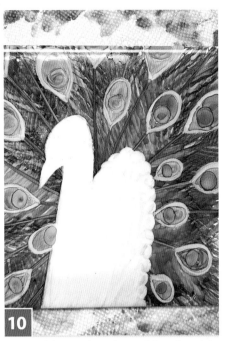

10 Use the blue-violet ink to add circles with a little triangular notch at the bottom as shown on top of the turquoise circles.

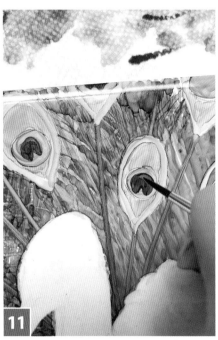

11 Use the dark brown marker to draw in wispy feathers. Start at the spines and draw the strokes away from the eye of the feather as shown.

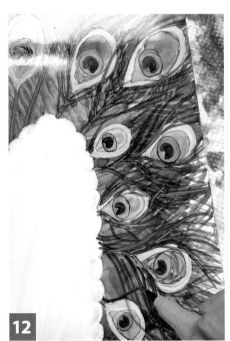

12 Paint the mass of feathers behind the peacock's neck with a #6 or #8 round brush and light yellow-green ink.

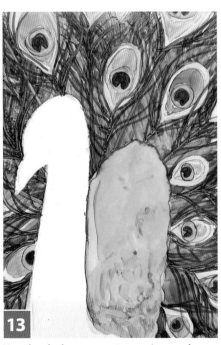

13 Use the dark green or turquoise marker to draw scallops on the mass of feathers, starting at the bottom and working toward the top.

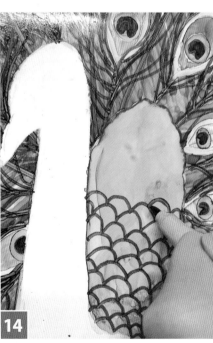

14 Use the dark brown marker to draw one or two strokes from the bottom of the scallops as shown.

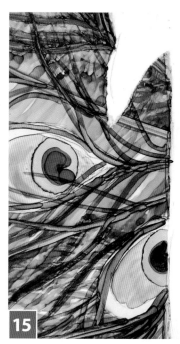

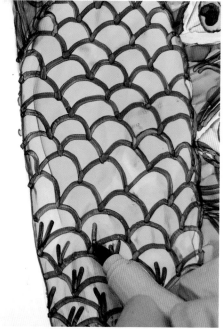

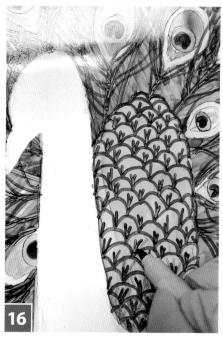

15

Use the blue marker to draw one to three strokes from the bottom of the scallop as shown.

16

Fill in the head, the long neck, and a few feathers at the bottom with a #4 or #6 brush and blue ink.

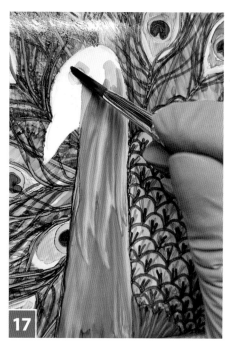

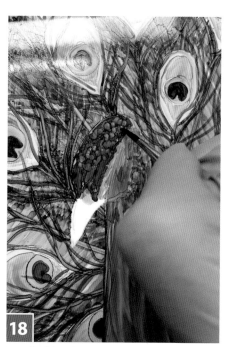

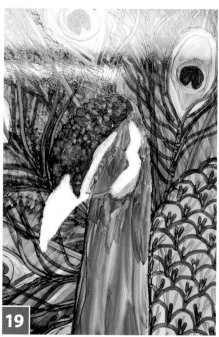

17

Use the violet-blue ink to paint the top of the head, dabbing it on in dots.

18

Use the blender pen to wipe away the white details on the head as shown and use the violet-blue ink to darken the right side of the head and neck, under the head, and along the right side of the white line above where the eye will be.

19

Continue shading the neck with short strokes, use violet-blue ink on the left and right edges and blue ink down the center. Under the head, use a bit of turquoise ink to shade and add interest.

20 Use the black marker refill thinned out with alcohol to paint in the top of the beak, the nostril, the eye, and the "mouth line."

21 Use the blender pen to lift out a series of dots above the head.

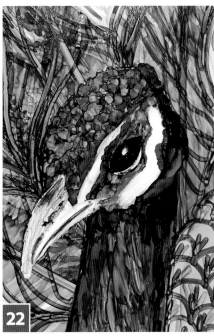

22 Fill these feathers with the blue ink and shade the bottoms with violet-blue ink.

23 Use the dark brown marker to connect the blue dots to the top of the head to create the top head plumage.

24 Use the black acrylic paint pen to paint the edges of the ceramic tile. Use the black marker to sign your painting.

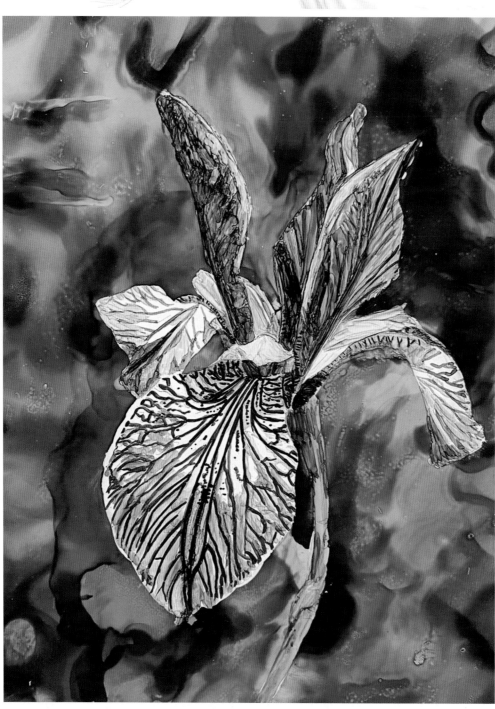

Iris Stunner

In this project, you'll create a stunning portrayal of an iris, a flower renowned for its elegance and vibrancy. Starting with a poured background, you set the stage for this botanical masterpiece, onto which you paint your subject using evaporated alcohol ink with fine brushes. The use of masking fluid enables you to preserve the flower's intricate details and contours. The detailing is further enhanced with markers, adding a level of precision and depth. Through this exploration, you'll learn to capture the delicacy of the iris while honing your skills with these unique techniques.

by Sheryl Williams, *https://sherylwilliamsart.com*

Materials and Supplies

- Color Reference Photo from page 163 printed
- Alcohol Inks in the following colors:
 - » Yellow-Green (Ranger's Tim Holtz Limeade)
 - » Bright Green (Ranger's Tim Holtz Botanical)
 - » Light Yellow-Green (Ranger's Tim Holtz Citrus)
 - » Dark Green (Ranger's Tim Holtz Everglades)
 - » Green (Ranger's Tim Holtz Mojito)
 - » Purple (Ranger's Tim Holtz Amethyst)
 - » Yellow-Orange (Ranger's Tim Holtz Butterscotch)
 - » Yellow (Ranger's Tim Holtz Sunshine Yellow)
- Alcohol Ink Markers in the following colors:
 - » Lavender Refill (Copic Refill Ash Lavender V22)
 - » Pale Purple Refill (Copic Refill Pale Blackberry V25)
 - » Blue Refill (Copic Refill Hydrangea Blue BV13)
 - » Blue-Violet Refill (Copic Refill Blue Violet BV08)
 - » Bright Blue (Copic Stratospheric Blue B69)
 - » Pale Blue (Copic Blue Berry BV04)
- 9" x 12" (22.9 x 30.5cm) White Synthetic Paper Sheet (Dura-Bright)
- 91% or 99% Isopropyl Alcohol
- Container (to hold isopropyl alcohol)
- Carbon Paper
- Pen or Stylus
- Artist's Tape
- Masking Fluid (Pebeo Drawing Gum)
- Paintbrushes
 - » Medium Round
 - » #2 Fine-Tip Brush (Creative Mark Rhapsody Round Kolinsky Sable Artist Brush)
- Soap Bar
- Brown India Ink Pen (Faber-Castell Pitt Artist Pen Brush Dark Sepia #175)
- Blue India Ink Pen (Faber-Castell Pitt Artist Pen Brush Indanthrene Blue #247)
- Welled Palette
- Blender Pen
- Scissors

The artist used the products in parentheses. Substitute your choice of brands, tools, and materials as desired.

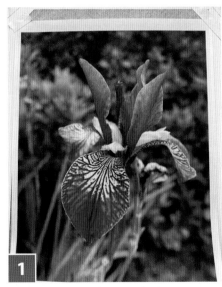

1 Place the sheet of white synthetic paper down on your work surface, cover with the carbon paper face down, then top with the reference photo. Secure the pieces with tape.

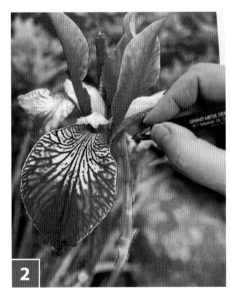

2 Trace the outside edge of the iris using a pen or stylus, including the spaces between the petals where the background shows through. The carbon paper will transfer the lines onto the white synthetic paper.

Tip: Mark the four edges of the reference photo so you can easily realign the image when working on the later steps.

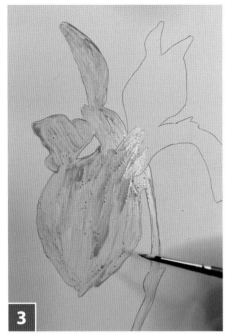

3

Dampen the soap bar and heavily coat the medium round paintbrush with the soap to prevent masking fluid from sticking to the brush bristles. Fill in the iris outline with the masking fluid and let it dry completely. It will be tacky to the touch.

4

Drip the yellow-green, bright green, light yellow-green, dark green, and green inks from the bottle onto the background to completely fill it. Leave the iris uncovered. Use a brush to dab on ink to fill empty background spots as needed.

5

Use your finger to remove the masking fluid.

6

Use a blender pen to lift out any mistakes.

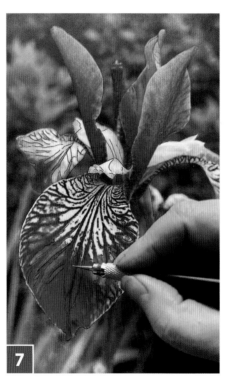

7

Place the carbon paper face down on top of the painting, then realign the reference photo on top. Secure the pieces with tape. Trace the inner details of the iris using a pen or stylus. The carbon paper will transfer the lines onto the white synthetic paper.

8

Place the lavender, pale purple, and blue refills and the purple ink in the welled palette. Paint the left standard with the pale purple refill.

9

Add a layer of purple ink on top, followed by a layer of the blue refill.

10

Paint a layer of freshly poured blue refill on the inner petals and use your blender pen to add a touch of evaporated pale purple refill on top.

11

Paint a layer of evaporated pale purple refill on the center standard.

12

Add layers of evaporated blue refill to create the dark veins in the center standard.

13

Paint a layer of blue refill on the right standard. Mix some of the blue refill with the purple ink and paint over the top of the right standard. Use the blender pen to lift the left edge as shown.

14

Paint veins on the right standard with evaporated blue refill.

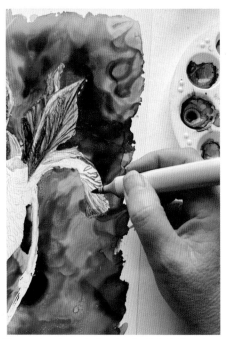

15 Use evaporated blue refill and blue-violet refill to paint the veining in the left fall and fill in between the veins with a pale blue marker. Repeat for the right fall.

16 Paint the yellow-orange ink into the yellow areas as shown.

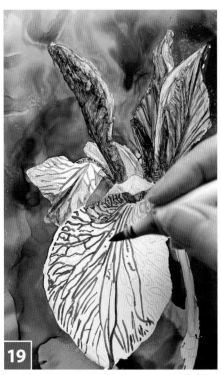

17 Use the brown India ink pen to add veining to these yellow sections.

18 Add the yellow ink to the top of the center fall and add dimension with the yellow-orange ink.

19 Outline the veining on the center fall with the bright blue marker.

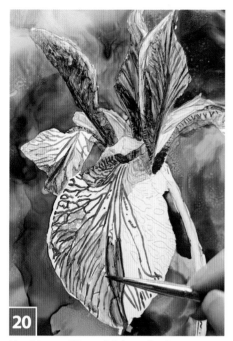

20

Use blue refill to add the color between the veins.

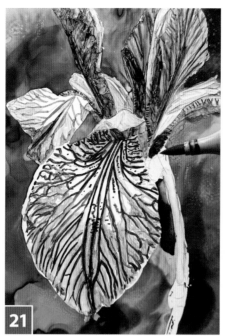

21

Go back over the darker veins in the center of the fall and add dotting with the blue India ink pen.

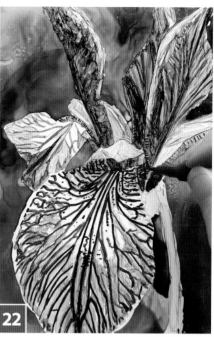

22

Use the brown India ink pen to add more of the brown detailing as shown.

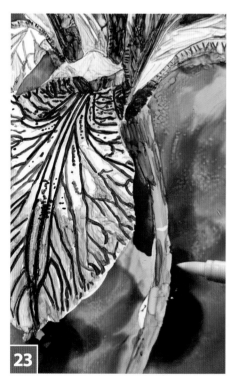

23

Paint the stem with long strokes of bright green ink and fill in the darker spots with the dark green ink.

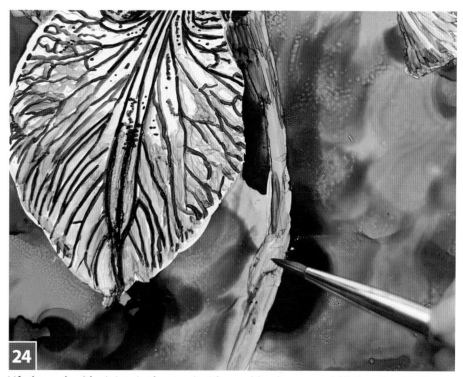

24

Lift the nodes (the joints in the stem) with your blender pen and fill them in with the yellow-orange and yellow inks.

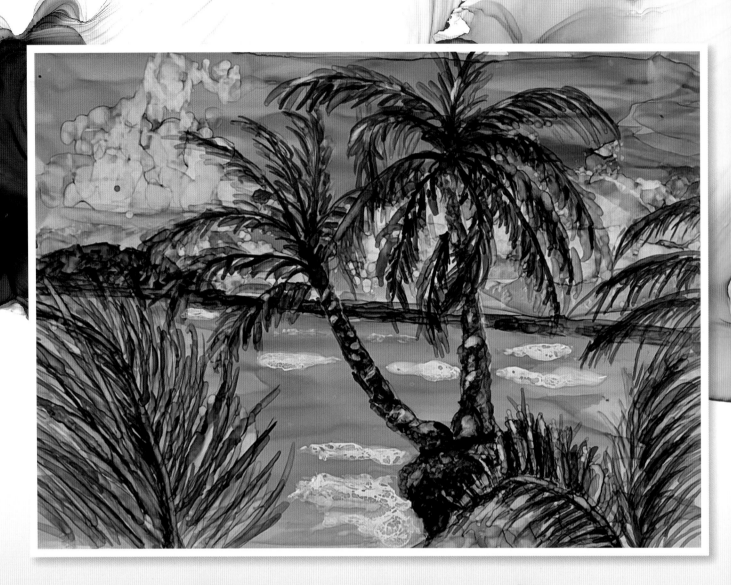

Tropical Beach

In this project, you'll bring the serene beauty of a tropical beach to life, employing an array of alcohol ink techniques to encapsulate the scene's vibrancy and tranquility. You'll explore painting wet into wet with inks straight from the bottle, providing a fluid backdrop for your setting. Techniques such as lifting and blending inks add layers of depth and detail, creating a truly immersive landscape. You will give this painting a delightful finishing touch with PVA glue and white mixative, emulating the frothy foam of the beach's gentle waves. This project invites you to paint not just a scene, but an experience of tropical bliss.

by Korinne Carpino, *https://korinnecarpinoart.com/*

Materials and Supplies

- Color Reference Photo from page 161
- Alcohol Inks in the following colors:
 - » Blue (Ranger's Tim Holtz Sailboat Blue)
 - » Aqua (Ranger's Tim Holtz Aquamarine Blue)
 - » Dark Blue (Ranger's Tim Holtz Denim)
 - » Green (Ranger's Tim Holtz Bottle)
 - » Bright Green (Ranger's Tim Holtz Botanical)
 - » Yellow-Green (Ranger's Tim Holtz Limeade)
 - » Yellow (Ranger's Tim Holtz Sunshine Yellow)
 - » Yellow-Orange (Ranger's Tim Holtz Butterscotch)
 - » Brown (Ranger's Tim Holtz Teakwood)
 - » Dark Brown (Ranger's Tim Holtz Sepia)
 - » Opaque White (Ranger's Tim Holtz Snow Cap Mixative)
 - » Black (Ranger's Tim Holtz Pitch Black)
- 5" x 7" (12.7 x 17.8cm) White Synthetic Paper Sheet (Dura-Bright)
- Blending Solution or 91% or 99% Isopropyl Alcohol
- Container (to hold blending solution or isopropyl alcohol)
- Paper Towel
- Carbon Paper
- Pencil or Pen
- Artist's Tape
- Pointed Cotton Swabs
- PVA Glue (Elmer's)
- Dinner Napkin
- Felt
- Paintbrushes
 - » #1 Round Brush
 - » #2 Round Brush
 - » #7 Round Brush
- Welled Palette

The artist used the products in parentheses. Substitute your choice of brands, tools, and materials as desired.

1

Fill the palette wells with the inks and let dry overnight. Place the sheet of white synthetic paper down on your work surface, cover with the carbon paper face down, then top with the reference photo. Secure the pieces with tape. Trace the general lines of the image.

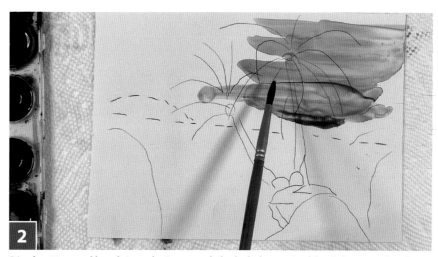

2

Dip the #8 round brush into the isopropyl alcohol, then paint blue ink across the sky from right to left. Keep the paper wet as you work.

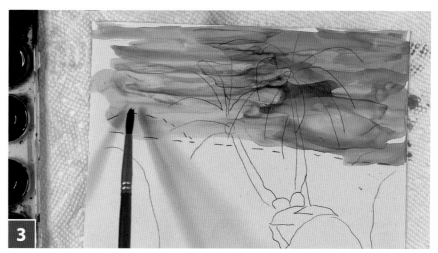

3

Wet the brush in isopropyl alcohol and paint aqua ink onto the lighter left side of the sky.

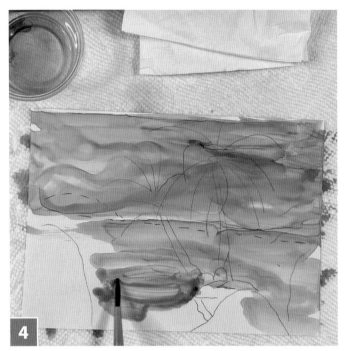

Repeat steps 2 and 3 to fill in the water. Wet the brush with isopropyl alcohol and dry it on a paper towel. Lightly drag the damp brush through the water to add horizontal texture and movement.

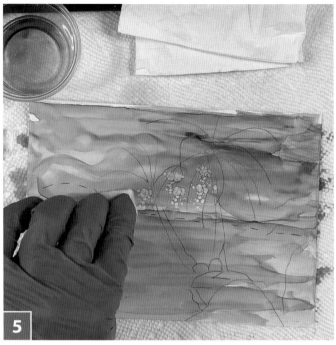

Wet a piece of felt with a little isopropyl alcohol and wipe it on a paper towel until it is just damp. Dab it onto the sky to remove ink and create clouds. Add more clouds on the left side than on the right.

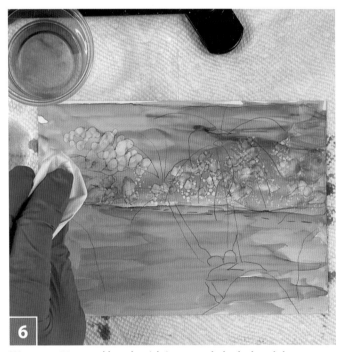

Wet your #2 round brush with isopropyl alcohol and drop alcohol from your brush into the left side of the sky. Blot the area with a dinner napkin to remove some of the ink and repeat as needed until this larger bright cloud looks how you want.

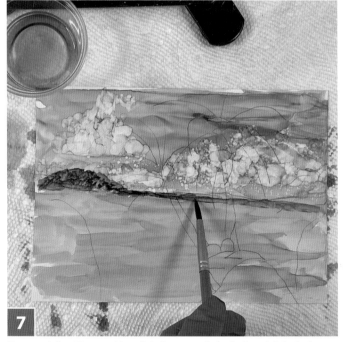

Dampen the #8 round brush in isopropyl alcohol and dab dark blue ink onto the piece to create the mountainous land mass on the left and the thinner line of land along the horizon line.

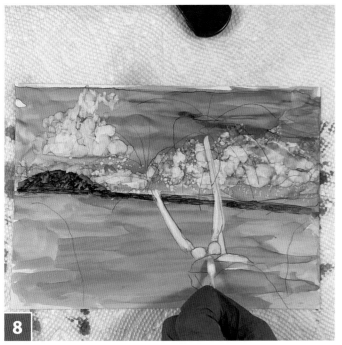

8

Use a damp cotton swab to lift out the ink in the palm tree trunks and the land masses under them. As you remove the ink, wipe the cotton swab clean on your paper towel. Use as many cotton swabs as needed to lift the ink out and return the paper in these areas to white.

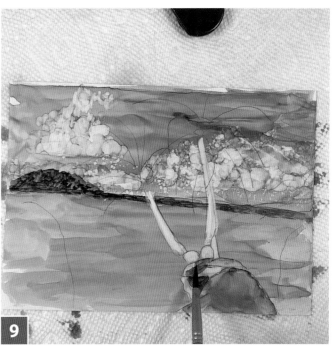

9

Use the damp #8 round brush to dab brown ink on the land below the palm trees.

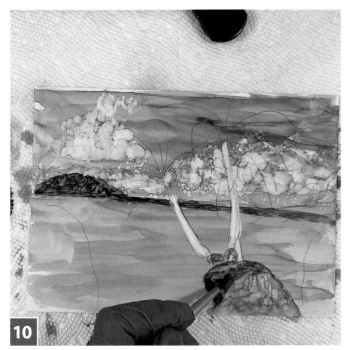

10

Use the damp #8 round brush to dab black ink onto the left side of the land mass to create the shaded side. Dip your brush in isopropyl alcohol, dry it, and then dab the top of the land mass to lighten some areas and add texture.

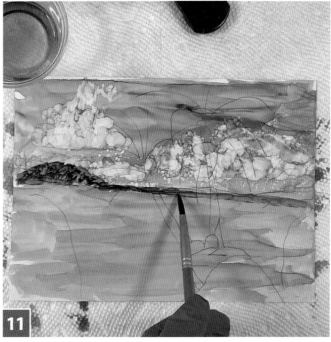

11

Clean your brush, then use the damp brush to dab yellow-orange ink to create highlights where the sun is hitting the top of the land.

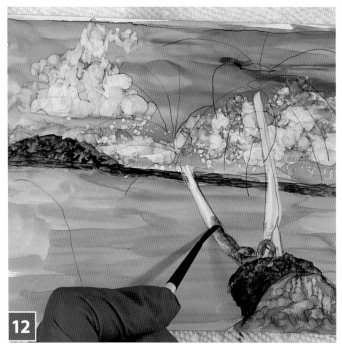

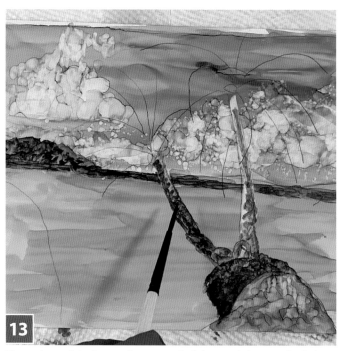

12 Dilute the black ink to create gray, then use the #2 round brush to paint the shadow on the right edges of the tree trunks. Use curved strokes from right to create a rounded shape.

13 Use a damp brush to paint some dark brown ink onto the left side of the trunks. Repeat, working your way across the trunk with the green and yellow-orange inks to fill them in.

14 Clean your brush and dry it on a paper towel. Use the damp brush to remove ink and create highlights at the base and middle of the trees. Wipe the ink on a paper towel as you remove it.

15 Use the damp #1 round brush to paint a thin line of green over the lines at the middles of the palm fronds.

16 Use the same brush and a curving stroke to add the fronds with green ink. Using the same brush, add some black details to the bottom sides of the lower fronds to create depth and shadow.

17 Use the same brush and dark brown ink to add the lower fronds on the larger tree.

18 Clean the paintbrush, then use it to paint yellow-orange highlights onto the lighter areas of the fronds, going over the green inks. Use the same method with the yellow-green and yellow inks. Use a clean damp brush to remove inks to create highlights. As you work, clean your brush on the paper towel.

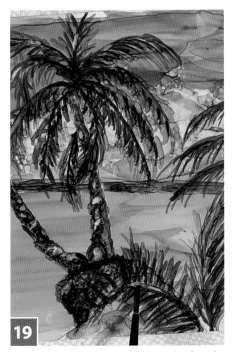

19 Repeat steps 15–18 to add the palm fronds on the left and right edges of the painting.

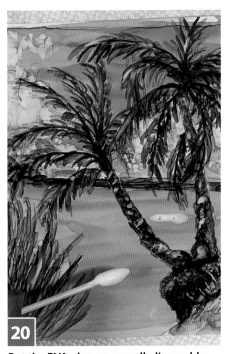

20 Put the PVA glue on a small, disposable piece of paper and use a pointed cotton swab to pick up some of the glue. Apply glue to the areas of the painting where you want waves or foam to appear on the water.

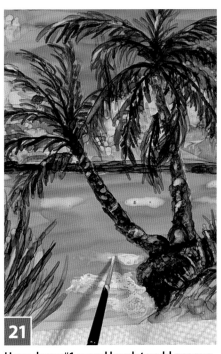

21 Use a damp #1 round brush to add opaque white ink to the glue. Let the ink move by itself in the glue to create a foamy look.

Tip: After using your brush in PVA glue, clean it in alcohol and wash with soap and water to fully remove the glue.

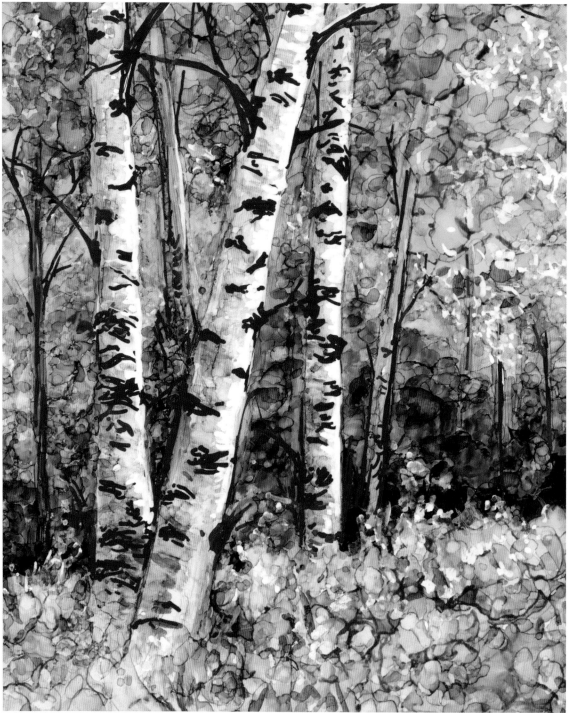

Fabulous Fall Foliage

This landscape uses similar techniques to those used by the early impressionist painters. Where the early impressionists used oil paints, we can achieve similar results using alcohol inks. You will be delighted to watch shapes emerge just by painting dabs of color and value!

by Francine Dufour Jones, *https://francinedufourjones.com*

Materials and Supplies

- Color Reference Photo from page 164
- Alcohol Inks in the following colors:
 - » Magenta (Jacquard's Piñata Color Señorita Magenta)
 - » Bright Yellow (Jacquard's Piñata Color Sunshine Yellow)
 - » Blue (Jacquard's Piñata Color Baja Blue)
- 5" x 7" (12.7 x 17.8cm) White Synthetic Paper Sheet (Yupo)
- 91% or 99% Isopropyl Alcohol
- Container (to hold isopropyl alcohol)
- Small Bottles (to apply isopropyl alcohol)
- Carbon Paper
- Colored Pencil
- Artist's Tape
- Fine-Line Masking Fluid Pen
- Small Watercolor Brush
- Welled Palette
- Cotton Cosmetic Rounds or Cotton Balls
- Cotton Swabs
- Paper Towels
- Blender Pen (Fantastix)
- White Acrylic Paint Pen (Posca)
- Fine Black Marker (Sakura Pigma Micron)

The artist used the products in parentheses. Substitute your choice of brands, tools, and materials as desired.

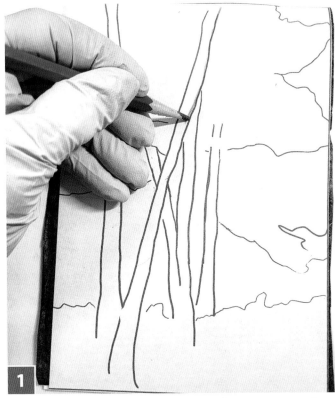

1

Place the sheet of white synthetic paper down on your work surface, cover with the carbon paper face down, then top with the black and white reference photo. Secure the pieces with tape. Trace the image using the colored pencil. The carbon paper will transfer the lines onto the white synthetic paper.

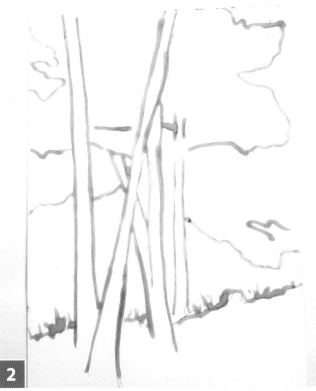

2

Trace the lines of the image with the liquid resist in a smooth line and let it dry thoroughly.

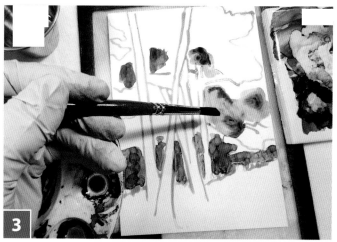

3

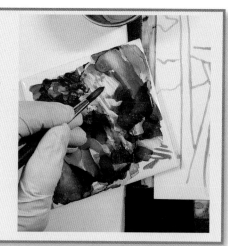

Tip: Keep clean white tiles on hand to use as mixing palettes. This will save time. No need to clean your palette in between colors—just swap in a fresh tile!

Use the three inks to mix some darker shades. The colors are not important, you just want dark values. Use deep purple and blue to paint in the darkest shapes.

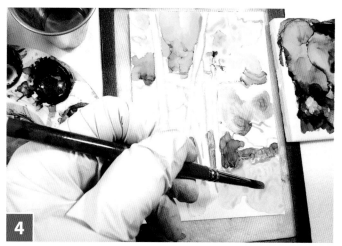

4

Drop very pale yellows and greens into the lightest areas.

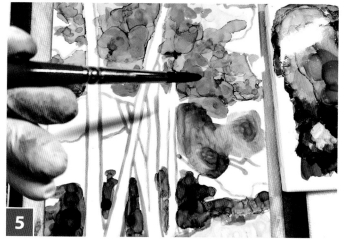

5

Add richer, "glowing" greens on top of this yellow base. Be sure not to remove all the yellow so that some shines through the green foliage.

6

Begin mixing oranges and fall shades, mixing and blending on a palette. Add dabs of these fall colors onto the foreground, middle area, and in lighter amounts to the trees' leaves. As you add more color, be sure not to completely cover the bottom layer.

7

Let your piece dry, then remove the resist.

8 Use a slightly damp blender pen or cotton swab to soften the edges and apply soft-edged shading to the inside of the tree trunks, creating a bit of separation between each. You can also pull color from the background onto the trunk and branches to soften the edges.

9 Add some brighter oranges to add depth to the darker areas using a damp blender pen or cotton swab. Add some dusty, grayish purple to create deeper shadows.

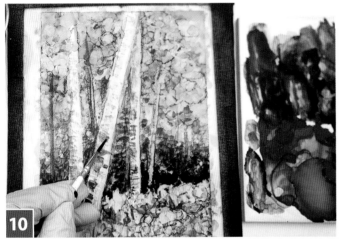

10 Add subtle shadows to the tree trunks with a small paintbrush some gray hues. Create grays by mixing greens, purples, and magentas.

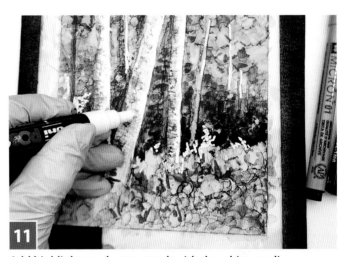

11 Add highlights to the tree trunk with the white acrylic paint pen.

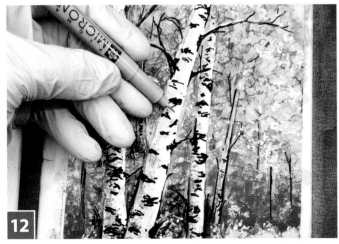

12 Add detail to the tree trunks using a fine permanent black pen.

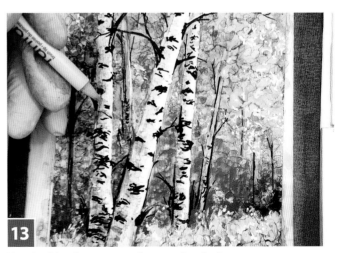

13 Use the blender pen to soften any hard edges.

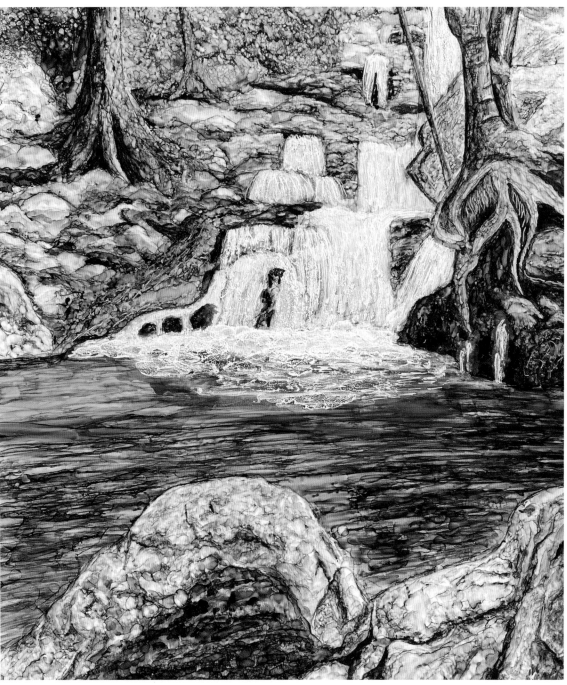

"Show Your Roots" Waterscape

In this project, you'll engage in painting a detailed waterscape featuring a waterfall descending into a vibrant blue pool. Key elements like trees, foliage, and stone will be accurately depicted using techniques such as value study for understanding light and dark, dripping ink for creating texture, brush painting, and pen-work for finer details. A unique method involving PVA glue is also introduced to achieve a protruding, realistic waterfall effect. This project combines various techniques and materials, enabling you to create a richly layered painting.

by Laurie "Trumpet" Williams, *https://trumpetart.com*

Materials and Supplies

- Black and White Reference Photo from page 162
- Color Reference Photo from page 162
- Alcohol Inks in the following colors:
 - » Light Yellow-Green (Ranger's Tim Holtz Citrus)
 - » Gray (Ranger's Tim Holtz Slate)
 - » Blue (Ranger's Tim Holtz Stonewashed)
 - » Dark Green (Ranger's Tim Holtz Everglades)
 - » Blue (Ranger's Tim Holtz Sailboat Blue)
 - » Yellow-Green (Ranger's Tim Holtz Limeade)
 - » Light Green (Ranger's Tim Holtz Moss)
 - » Dark Gray-Brown (Ranger's Tim Holtz Mushroom)
 - » Light Gray-Brown (Ranger's Tim Holtz Pebble)
 - » Yellow (Ranger's Tim Holtz Sunshine Yellow)
 - » Brown (Ranger's Tim Holtz Teakwood)
 - » Black (Ranger's Tim Holtz Pitch Black)
 - » Opaque White (Ranger's Tim Holtz Snow Cap Mixative)
- 8½" x 10½" (21.6 x 26.7cm) Photo Paper, back side (Amazon Basics)
- 91% or 99% Isopropyl Alcohol
- Container (to hold isopropyl alcohol)
- Carbon Paper
- Pen or Pencil
- Artist's Tape
- Palette Knife
- White Acrylic Paint Pen (Posca)
- Paintbrushes
 - » #5 Filbert Brush
 - » #3 Filbert Brush
 - » ¾" Deerfoot Brush
- PVA Glue (Elmer's)
- Ultra-Fine Tip Black Marker (Sharpie)
- Welled Palette
- Paper Towel

The artist used the products in parentheses. Substitute your choice of brands, tools, and materials as desired.

2

Starting at the top, use the #5 Filbert brush to fill in the background above the stone area with light yellow-green ink.

3

Drop gray and blue ink from the bottles onto the area where the rock beds appear.

1

Place the sheet of photo paper down on your work surface with the back side up, cover with the carbon paper face down, then top with the black and white reference photo. Secure the pieces with tape. Using a pen or pencil, trace over the main areas you want to transfer to the paper, including the trees and roots, the outline of the waterfall, the larger stones, and the landing pool.

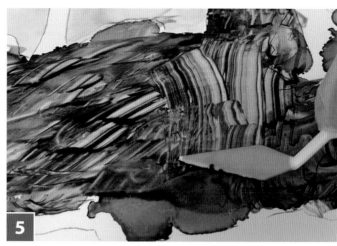

4

Use the palette knife to blend and spread the blue and gray inks across the page. Work the ink from the left to the right to mimic the direction of the stones, using the reference photo as a guide.

5

For the waterfall area, drag the palette knife downward in the direction of the water flow. Note: You may need to dip your palette knife into some isopropyl alcohol to reactivate the ink on the paper if it has dried.

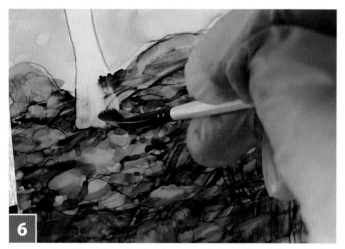

6

Wet the #5 Filbert brush with isopropyl alcohol and drag the brush along the area inside the tree trunks and roots. Use slight pressure to lift out any ink on the trees.

7

Pour dark green ink from left to right across the edge where the waterfall will meet the pool below.

8

Pour drops and lines of blue ink into the pool area.

9 Pour drops and lines of yellow-green ink into this same area.

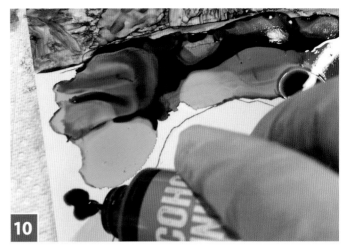

10 In the areas closest to where the foreground rocks meet the pool, add some drops of light green ink.

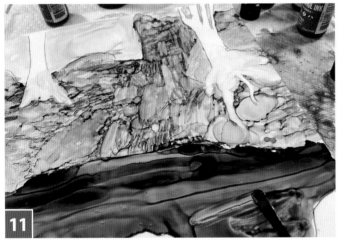

11 Use the #5 Filbert brush to gently blend the inks to create the blue-green pool. The ink will bleed a bit, but avoid the stones in the foreground as much as possible.

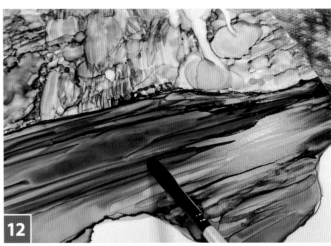

12 Create movement in the pool by dragging the brush from left to right to displace the ink. Continue with this until you are happy with the "flow" of the water.

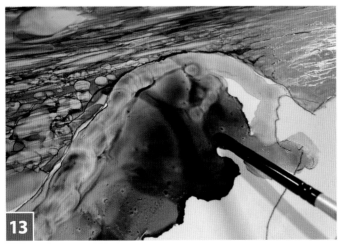

13 Drop a couple of drops of dark gray-brown ink onto the foreground rock on the left and use the #5 Filbert brush to completely cover the rock.

14 Add additional dark gray-brown ink to the bottom area of the rock to create the darker shadow.

15 The rock on the right-hand side has a bluer hue, so start by adding blue and gray inks. Use the #5 Filbert brush to distribute the mixture evenly over the entire rock.

16 Load some gray ink onto a wet #3 Filbert brush and paint the tree in the upper left corner of the painting. Use more of the ink on the left side of the tree and toward the roots to create depth and dimension.

17 Add light green ink to the #3 Filbert brush and paint in the skinny tree trunk.

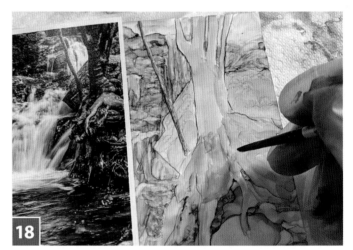

18 Paint in the larger tree and its roots using light gray-brown ink on the #3 Filbert brush.

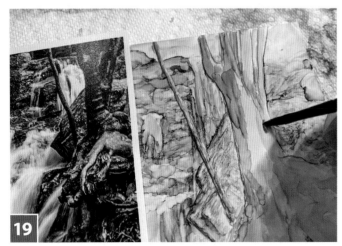

19 Add some dark gray-brown ink to the right side of the trunk and the area where those branches meet the main trunk to add dimension.

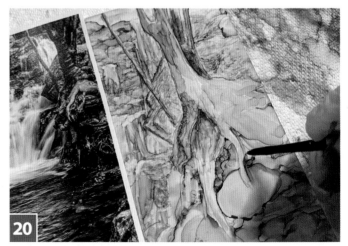

20 Continue to work on the tree and the roots, adding layers and texture using the #3 Filbert brush. The more layers and detail you add, the more realistic the tree will look.

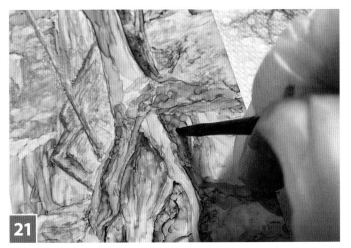

21

Add black ink under the root area to bring them forward and create depth.

22

Use a damp #3 Filbert brush to lift triangular, round, and rectangular shapes from the rock bed. Lift highlighted areas almost to white and create deeper shadows and crevices by adding more gray or black ink as needed.

23

Use the damp #3 Filbert brush to brush the ink in the direction of the water "flow" of the waterfall. Lift some of the ink, but not all of it. Lift out more of the ink at the top of each individual fall, as that is where the waterfall appears the whitest.

24

Next, brush some PVA glue on top of the waterfalls, following the direction of the water flow.

25

While the glue is still wet, use the #3 Filbert brush to add **opaque white on top.** This technique creates a realistic foamy waterfall effect that would not be possible with alcohol ink alone.

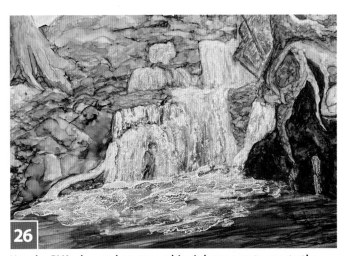

26

Use the PVA glue and opaque white ink process to create the foam where the waterfalls hit the pool. You can use the glue directly from the bottle since this area is thicker and whiter.

27 Using a ¾" deerfoot brush dipped in some wet dark green ink, randomly tap greenery into the background. Continue until this background is covered.

28 Use the #3 Filbert brush to paint the embankment under the tree roots black. This will create even more depth here and draw the eyes toward the roots and the waterfalls.

29 Create a stone-like texture in this area by defining random light and dark areas.

30 For the tree on the right side of the painting, define some of the indentions and areas around the roots by painting in some brown details.

31 Add yellow highlights to the tops of the roots.

32 For the tree on the left side of the painting, use the same color combination: brown ink to deepen the knots and roots and yellow to highlight the rounding of the roots.

33 Lift out some of the color where the light hits the top of the rocks by tapping the painting with a wet brush and dabbing with a paper towel to remove some of the ink.

34 Dab a few strokes of yellow ink on top of the rock to add a little warmth.

35 Use the ultra-fine tip black marker to draw cracks and crevices on the rock, using the reference image as a guide.

36 Use a damp brush to soften the marker strokes and blend them into the stone's texture.

37 Repeat steps 35 and 36 for the stone on the right.

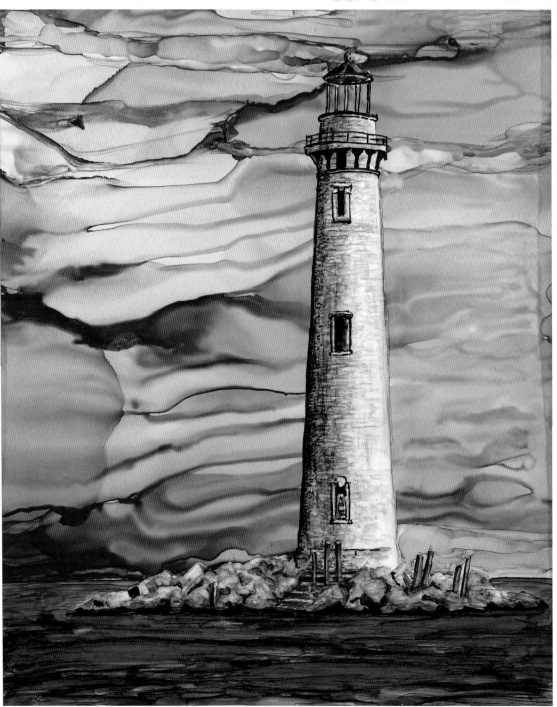

Dauphin Island Lighthouse

In this project, you'll be creating an intricate representation of the Dauphin Island Lighthouse using alcohol ink and starting with a value study to identify the light and shadow in the structure. We use a variety of techniques, such as dropping ink for broader color applications and brush painting for more controlled strokes. Details are added with fine-tipped markers and white acrylic pens. By the end of this project, you'll have a vibrant and detailed portrayal of an iconic lighthouse.

by Laurie "Trumpet" Williams, *https://trumpetart.com*

Materials and Supplies

- Black and White Reference Photo from page 163
- Color Reference Photo from page 163
- Alcohol Inks in the following colors:
 - » Red (T-Rex Inks Shiraz Red)
 - » Orange (T-Rex Inks Bellini Orange)
 - » Yellow (T-Rex Inks Sunshine Yellow)
 - » Dark Blue (T-Rex Inks Aegean Sea)
 - » Tan (Ranger's Tim Holtz Sandal)
- Alcohol Ink Markers in the following colors:
 - » Orange (Spectrum Noir Orange CR10)
 - » Brown (Spectrum Noir Brown BG8)
 - » Gray (Spectrum Noir Ice Grey IG10)
- 8½" x 11" (21.6 x 28cm) Photo Paper, back side (Amazon Basics)

- 91% or 99% Isopropyl Alcohol
- Container (to hold isopropyl alcohol)
- Carbon Paper
- Pen or Pencil
- Artist's Tape
- White Acrylic Paint Pen (Posca)
- Masking Fluid (Molotow Grafx Art Masking Liquid Marker)
- Rubber Cement Eraser
- Paintbrushes
 - » #10 Filbert Brush
 - » #3 Round Brush
- Dual Fine/Ultra-Fine Tip Black Marker (Sharpie)
- Welled Palette

The artist used the products in parentheses. Substitute your choice of brands, tools, and materials as desired.

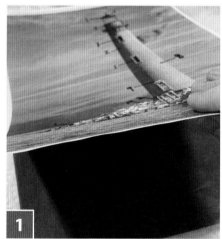

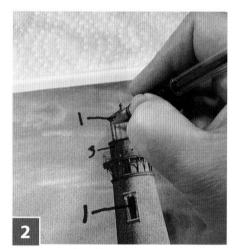

1 Place the sheet of photo paper down on your work surface back side up, cover with the carbon paper face down, then top with the black and white reference photo. Secure the pieces with tape.

2 Trace the lighthouse using a pen or pencil. The carbon paper will transfer the lines onto the white synthetic paper.

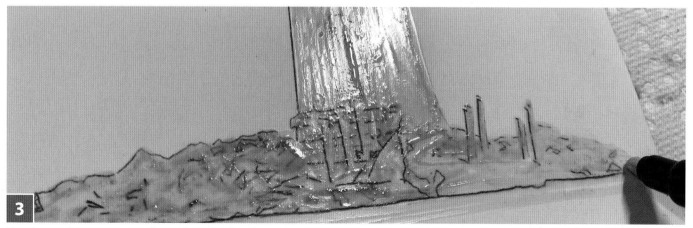

3 Use the masking pen to apply masking fluid to the entire lighthouse and the rock foundation. Let it dry for about 30 minutes.

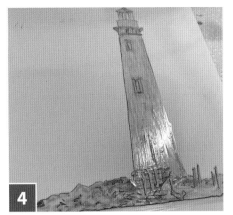

4

Drop a liberal amount of isopropyl alcohol onto the background so the inks will flow freely.

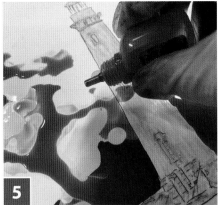

5

Add a few drops of red ink just above the masked horizon line. Drip orange ink above the red ink. Finally, drip yellow ink across the top of the paper.

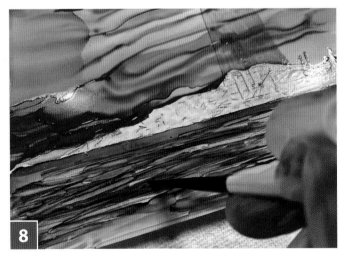

6

Tip: Less rocking will produce a smoother background, and you can pour more ink if one color dominates.

Rock the paper back and forth from left to right to get the ink flowing and cover the entire sky area. Allow the ink to flow naturally until the alcohol has evaporated and the ink is no longer flowing. Allow the ink to dry for about 10 minutes.

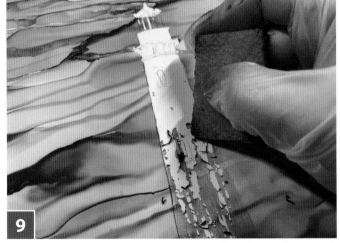

7

Add several drops of dark blue ink to the water section at the bottom of the painting. Use a #3 round brush to spread the ink across the page, filling up all the white space at the bottom.

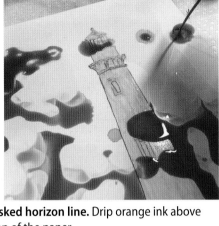

Use a brush that is wet with alcohol to stroke from left to right, creating texture in the water.

8

Use the rubber cement eraser to remove all of the masking fluid, starting at the top of the lighthouse and working down.

9

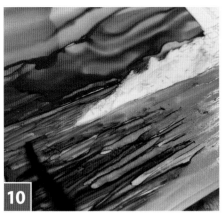

10 Use a wet brush to paint over the white area to extend the water around the rock formation on both sides. Make sure to paint the water on both sides at the same level.

11 Fill in the entire lighthouse with tan ink.

12 Use the wide nib of the gray marker to draw shadows along the left side of the lighthouse.

13 Use a #8 Filbert brush dampened with isopropyl alcohol to blend the ink from the marker toward the center of the lighthouse, working from the top to the bottom.

14 Clean the brush, then dip it into some of the evaporated tan ink. Paint a wide stroke of tan down the middle of the lighthouse to blend the brighter side with the shadowed side.

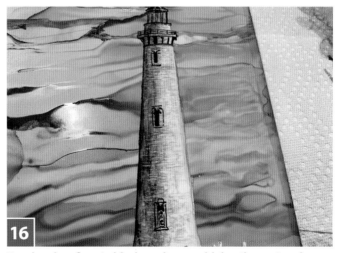

15 Working top to bottom and left to right, make small marks by tapping the tip of a round or filbert brush in tight rows. This will add a stony texture to the lighthouse and further blend the colors to eliminate the streaked look.

16 Use the ultra-fine tip black marker to add details, tracing the windows, the left side of the lighthouse, the gallery area, and the lantern and cupola.

17 Use the ultra-fine tip black marker to trace the sides of the posts. Then use the thicker fine tip to fill in the darker areas of this rocky foundation.

18 Use the gray marker to fill in the rocks. Don't worry about the details yet, just fill the entire area.

19 Dip the #3 round brush in isopropyl alcohol and wipe the excess on a paper towel. Lift out some of the gray marker in jagged triangles and rectangles. The more you vary the shapes and values of the gray and black, the more realistic it will look.

20 Add 3 or 4 horizontal steps, using the posts as a guide.

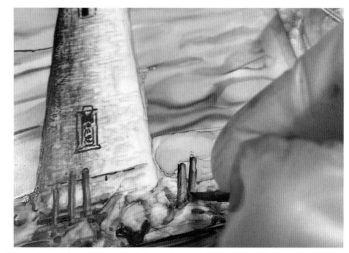

21 Use the brown marker to fill in the post, then use the damp #3 round brush to lift out some of the color and convey light hitting the posts.

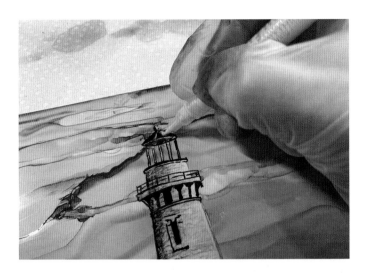

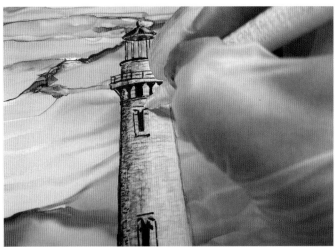

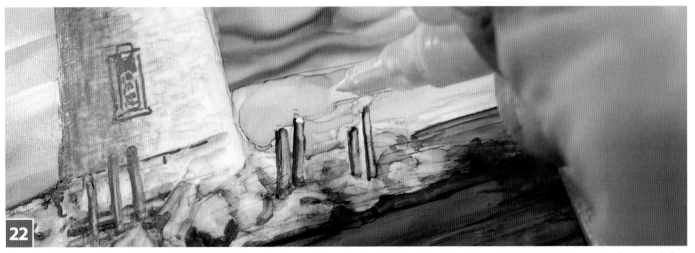

22

Use the white acrylic paint pen to add highlights, starting at the cupola and working down to add highlights to the windows and the tops of the foundation posts.

23

Using the ultra-fine tip black marker, redefine the edges of the windows as needed.

24

Use the #3 round brush to add a few hints of yellow to the foundation to convey reflections from the sun. Dab the ink to blend it in.

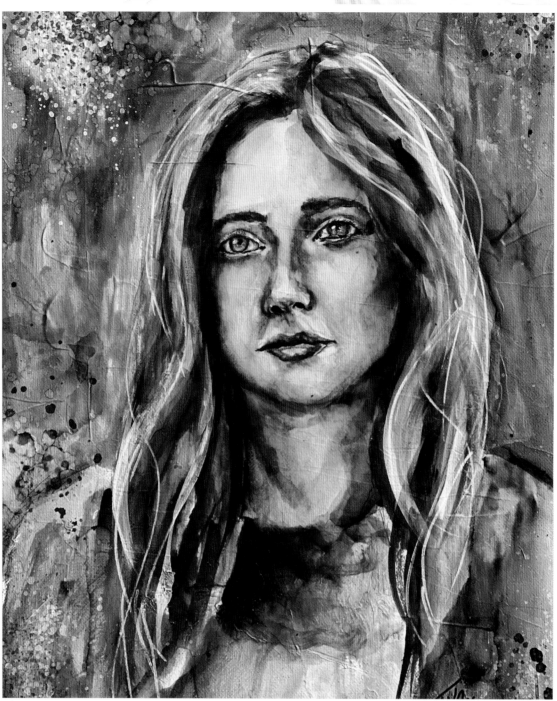

Portrait in Ink

In this project, you'll dive into the realm of portraiture, using alcohol ink on a textured, gesso surface. With a keen focus on value, this project invites you to closely portray the shape and depth of the face, thus bringing your portrait to life with realism and precision. Alcohol ink and markers are your primary tools here, offering a blend of fluidity and control. The techniques used range from brush painting, which provides the foundational form and color, to blending, a method used to soften and merge areas for a seamless finish.

By Teresa K. Brown, *https://www.tkbrownart.com/*

Materials and Supplies

- Black and White Reference Photo from page 162
- Color Reference Photo from page 162
- Alcohol Inks in the following colors:
 - » Light Apricot (Ranger's Tim Holtz Peach Bellini)
 - » Tan (Ranger's Tim Holtz Sandal)
 - » Pale Pink (Ranger's Tim Holtz Shell Pink)
 - » Red-Brown (Ranger's Tim Holtz Sepia)
 - » Brown (Ranger's Tim Holtz Teakwood)
 - » Gray (Ranger's Tim Holtz Slate)
 - » Opaque White (Ranger's Tim Holtz Snow Cap Mixative)
- Alcohol Ink Markers in the following colors:
 - » Gray Refill (Copic Cool Gray C10)
 - » Cream (Copic Brush Tip Pale Fruit Pink E000)
 - » Pale Peach (Copic Brush Tip Cotton Pearl E00)
 - » Peach (Copic Brush Tip Tea Rose E93)
 - » Warm Brown (Copic Brush Tip Copper E18)
 - » Tan (Copic Brush Tip Suntan E15)
 - » Brown (Copic Brush Tip Burnt Umber E29)
 - » Black (Copic Brush Tip Black 100)
 - » Green (Copic Brush Tip Marine Green YG99)
 - » Deep Red (Copic Brush Tip Dark Red R89)
 - » Pale (Copic Brush Tip Pale Cherry Pink R11)
- 9" x 12" (22.9 x 30.5cm) Hard Panel or Surface (Artefex ACM Panel)
- Acrylic Gesso
- Blending Solution or 91% or 99% Isopropyl Alcohol
- Container (to hold blending solution or isopropyl alcohol)
- White Acrylic Paint Pen (Posca)
- Black Liner Pen
- Palette Knife or Silicone Brush
- #6 Synthetic Round Brush
- Welled Palette
- Blender Pen

The artist used the products in parentheses. Substitute your choice of brands, tools, and materials as desired.

1

Use the back of a palette knife or a silicone brush to add a thick coat of acrylic gesso to the hard panel. This helps to give the panel some extra texture. Allow the gesso to dry completely.

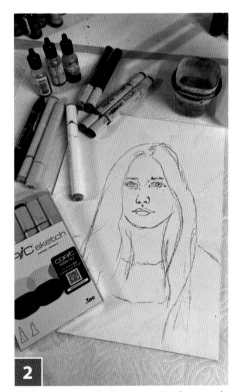

2

Sketch or trace the image onto the panel.

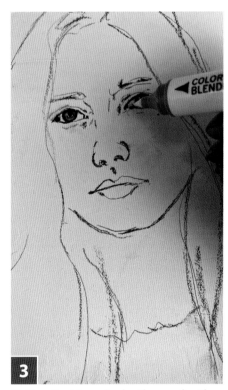

3

Outline the iris and color the pupil with the black alcohol ink marker. Dab the green marker to fill in the iris. Eyes are generally darker on the top by the lid. Use the brown marker to darken the iris, blending the colors with the blender pen.

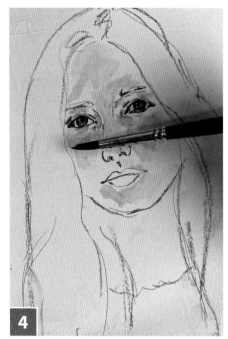

4

Use the cream and pale peach markers and a touch of the pale pink ink to put down the first layer of skin tones. Blend the colors and the pencil marks using a brush dampened with isopropyl alcohol.

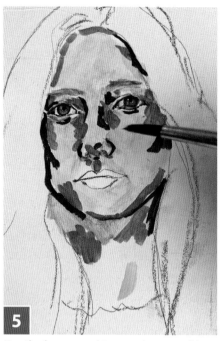

5

Use the brown and tan markers to add shading to the areas that are darker in the reference photo. Blend those colors in with a brush dampened with isopropyl alcohol.

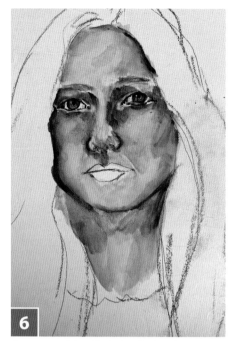

6

As you are blending the dark values in, blend in a bit of light apricot and pale pink ink as you work. Where you see highlights in the reference picture, add a bit of tan ink.

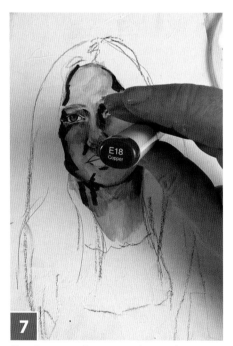

7

Use the warm brown marker to deepen the shading. Be careful not to put too much color down at once as it makes it difficult to blend. Instead work in layers and lift colors that are too dark with a blending pen.

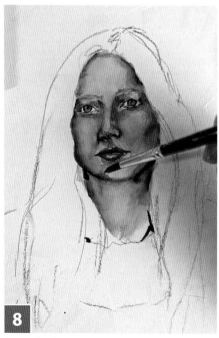

8

Paint the lips with the deep red and pale pink markers. Add a touch of the brown marker to the darkest areas. When painting noses and lips, try to capture shapes. For example, the bottom lip has a bit of a flattened oval shape. Leave the highlight unpainted.

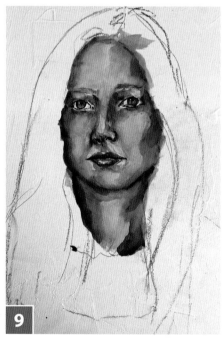

9

Add an additional layer of dark shades around the face under the chin and where the hair shades her neck. Blend it in. This darkness will add depth and roundness to her face.

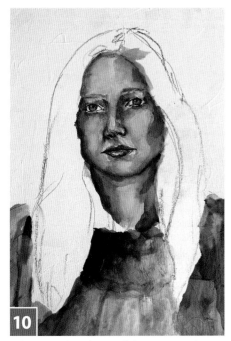

10

Add a good amount of the gray marker refill to your welled palette and use a very wet brush to apply the ink to the blouse.

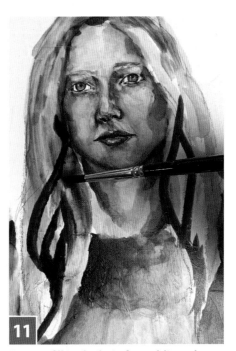

11

Start to fill in the hair, first adding a layer of tan ink, then a layer of red-brown ink, then finishing with a layer of brown ink. Be mindful to make brush strokes that mimic the hair's movement.

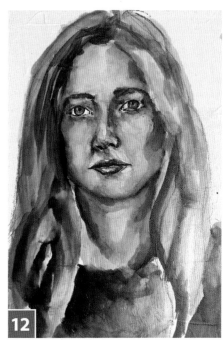

12

Blend the colors together with a dampened brush.

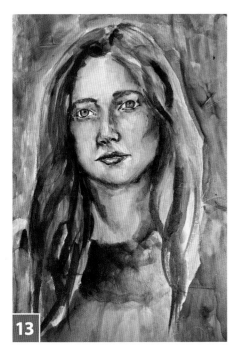

13

Saturate your brush thoroughly with isopropyl alcohol and apply the gray ink to the background with very light brush strokes.

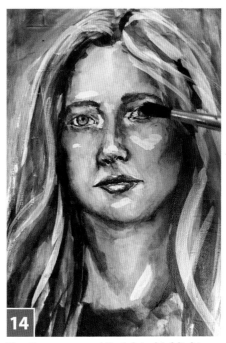

14

Use the opaque white ink to highlight the hair and the places on the face where there is a strong highlight. Blend it all in with a dampened brush.

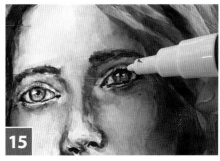

15

Apply just the hint of eyelashes using a fine liner pen and add a few more highlights to the corners of her eyes using the white acrylic paint pen.

16

Cover the face with a piece of paper or a paper towel. Use a very wet brush to splatter the portrait with some of the gray marker refill, some of the opaque white ink, and some of the alcohol from the container used to clean your brush. This creates a fun inky look.

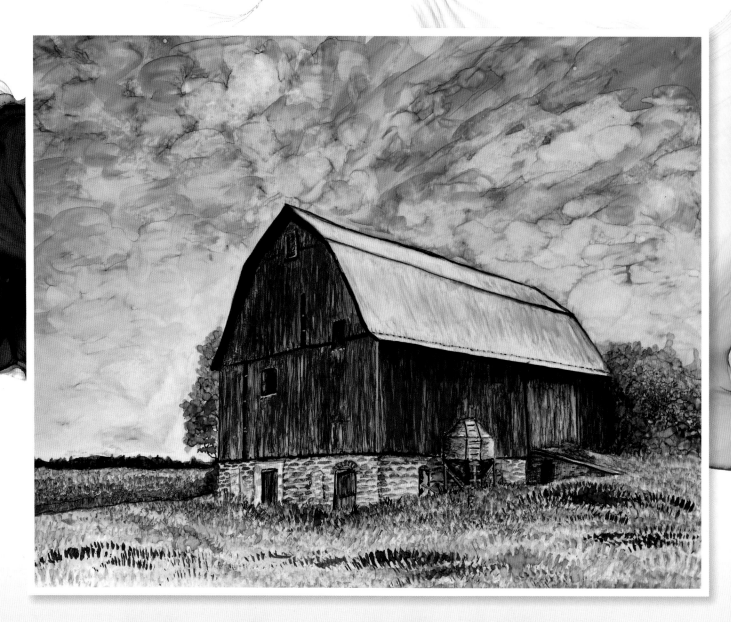

Weathered Red Barn

This project offers a comprehensive exploration of light and texture to depict the character and story of an old, weathered barn. Beginning with a value study, we can gain an understanding of the contrasts of light and dark that bring the barn's worn surfaces to life. Techniques like masking, dabbing, lifting, and painting are used to create the barn's unique textures. Most of the project relies on brushwork, with fine-tipped markers and a white acrylic pen being used to add intricate details.

by Laurie "Trumpet" Williams, *https://trumpetart.com*

Materials and Supplies

- Black and White Reference Photo from page 161
- Color Reference Photo from page 161
- Alcohol Inks in the following colors:
 - » Light Blue (Ranger's Tim Holtz Sailboat Blue)
 - » Dark Green (Ranger's Tim Holtz Everglades)
 - » Yellow-Green (Ranger's Tim Holtz Limeade)
 - » Gray (Ranger's Tim Holtz Slate)
 - » Red (Ranger's Tim Holtz Watermelon)
 - » Tan (Ranger's Tim Holtz Sandal)
 - » Red-Brown (Ranger's Tim Holtz Crimson)
 - » Black (Ranger's Tim Holtz Pitch Black)
- 9" x 12" (22.9 x 30.5cm) White Synthetic Paper Sheet (Dura-Bright)
- 91% or 99% Isopropyl Alcohol
- Container (to hold isopropyl alcohol)

- Carbon Paper
- Pen or Pencil
- Artist's Tape
- Masking Fluid Pen
- Rubber Cement Eraser
- Paintbrushes
 - » #2 Filbert Brush
 - » #10 Filbert Brush
 - » ⅜" Deerfoot Brush
 - » Fan Brush
- Black Marker (Prismacolor Premier)
- Ultra-Fine Tip Black Marker (Sharpie)
- Paper Towels
- Welled Palette
- Value Study (see page 46)

The artist used the products in parentheses. Substitute your choice of brands, tools, and materials as desired.

1 Place the sheet of white synthetic paper down on your work surface, cover with the carbon paper face down, then top with the black and white reference photo. Secure the pieces with tape.

2 Trace the line drawing with a pen or pencil. The carbon paper will transfer the lines onto the white synthetic paper.

3 Use a masking pen to apply masking fluid along the top edge of the landscape where the tree line and barn meet the sky. Outline the rest of the barn. Allow the masking fluid to dry.

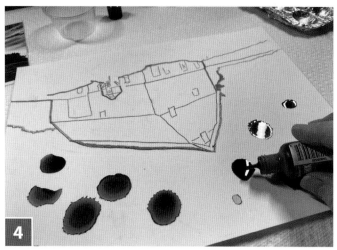

4 Turn the paper upside down and apply several drops of light blue ink to the sky area.

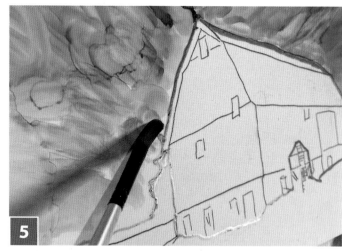

5 Use the #10 Filbert brush to spread the ink onto the paper, following the direction of the clouds as shown in the reference image. Proceed with care around the masked edges so the ink doesn't breach the barn and landscape area.

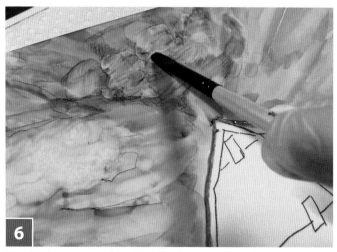

6 To add clouds to the sky, first dip the #10 Filbert brush into the isopropyl alcohol. Lightly tap the brush on a paper towel, then dab it on the area where you want to paint a cloud.

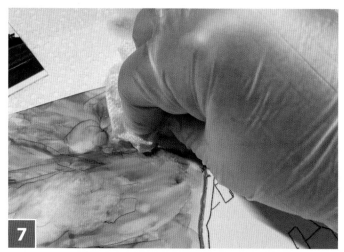

7 Dab a clean piece of paper towel on the area where you just added isopropyl alcohol and lift to reveal organic cloud shapes.

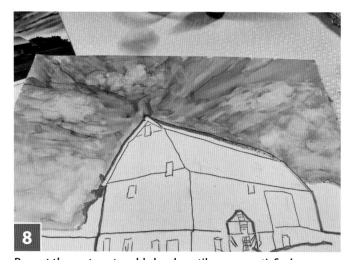

8 Repeat these steps to add clouds until you are satisfied.

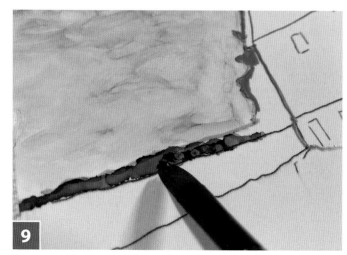

9 Drop some dark green ink into the welled palette and allow it to evaporate a bit. Use a clean Filbert brush to soak up some of the dark green ink and start tapping to fill in the tree line. Add multiple layers of tapped dark green ink to create the feeling of trees and depth.

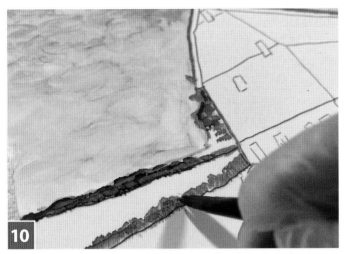

10

Tap in a line of greenery using the same brush and method along the lower line closest to the edge of the barn.

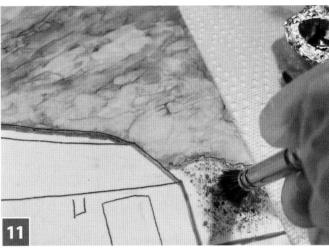

11

Dip the ⅜" deerfoot brush into the dark green ink and use a straight up-and-down motion to stipple in the bushes on the right side of the barn.

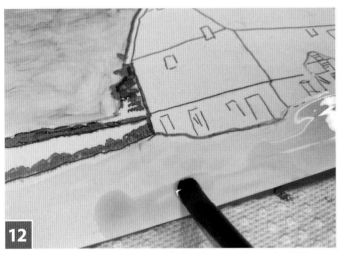

12

Add yellow-green ink to the welled palette and use the Filbert brush to apply a light coat of diluted color across the entire bottom of the grass area. Allow to dry.

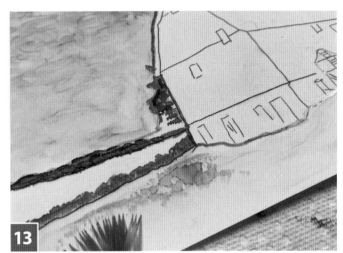

13

Dip a clean fan brush into the yellow-green ink and begin tapping it onto the grass area, using short taps to create a grassy look.

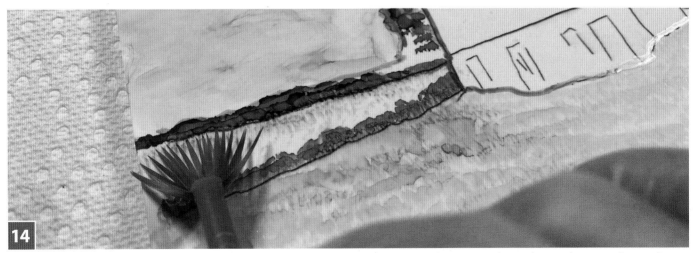

14

Continue tapping in the grass area until it is almost completely covered. Also tap yellow-green ink into the area between the tree line and foreground bushes.

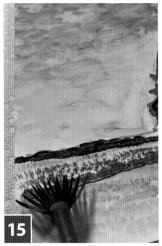

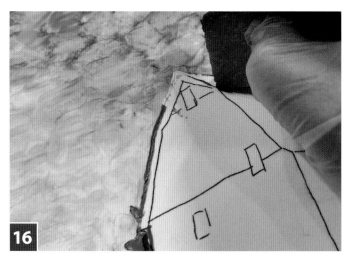

15 Add more dark green ink to the welled palette and dip the fan brush into it. Tap darker grass accents into the same areas you added the yellow-green grasses.

16 Using a rubber cement eraser, remove the masking fluid.

17 Use a damp #2 Filbert brush to fill in white areas along the tree line with dark green ink. Clean the brush and fill in any white spaces where the sky meets the barn roof with blue ink.

18 Pour some gray ink into the welled palette and dilute it with a couple drops of isopropyl alcohol. Use the #2 Filbert brush to paint the roof of the barn. The brushstrokes should follow the direction of the roof lines.

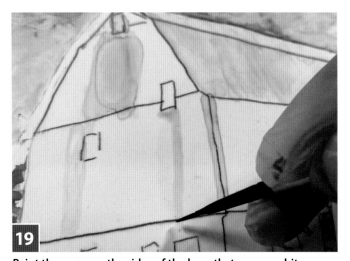
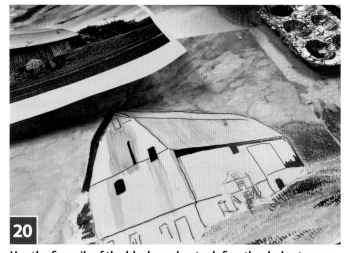

19 Paint the areas on the sides of the barn that appear a bit more gray in color.

20 Use the fine nib of the black marker to define the darkest areas of the painting. This includes the windows and the roof line.

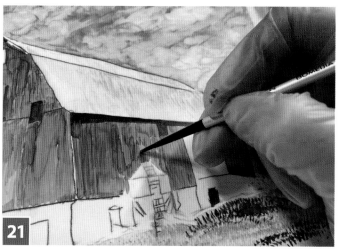

21

Drop red ink into the welled palette. Start painting the barn red using downward strokes to mimic the direction of the wood.

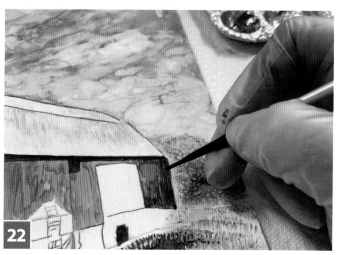

22

On the right side of the barn where the shadows are the heaviest, use the damp brush to blend the red in with the ink from the marker. This will create the dark shadow.

23

Add some tan ink to the welled palette and use it to paint a base color for the foundation, Allow it to dry.

24

Use a dampened #2 Filbert brush to lift out the stone area around the doors and windows. Clean the brush on a paper towel as you work until all of the lighter "stone" area has been lifted.

25

Use the gray ink already in the palette to paint in the doors in the foundation and on the barn.

26

Wet the #2 Filbert brush with isopropyl alcohol and dry the excess alcohol on a paper towel. Dip the damp brush into the evaporated red ink in the welled palette. Using short horizontal strokes, apply the red ink to the foundation to create bricks, staggering the bricks on each row.

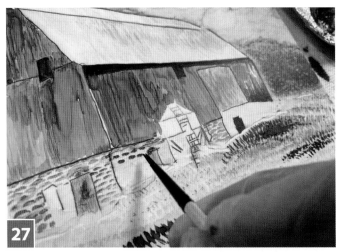

27 Continue adding these bricks around the side of the barn. Note that the angle of the bricks changes, as well as the detail and definition of the bricks. These changes are caused by the perspective.

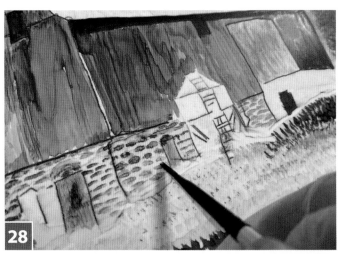

28 Come back in with a damp brush and soften the edges on all the bricks so they aren't quite as stark.

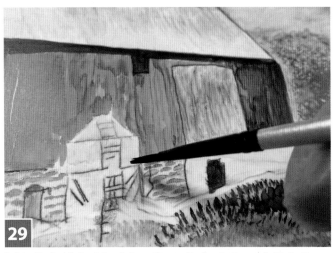

29 Add a little of the blue ink to the welled palette and dilute it with some isopropyl alcohol. Using the #2 Filbert brush, add a blue base coat to the grain bin.

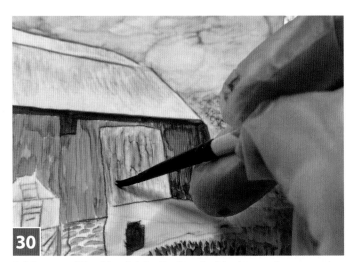

30 Add some of the blue ink to the barn's side door, using up and down motion to indicate the direction of the wood.

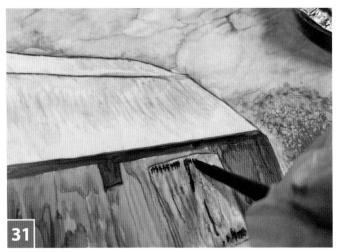

31 Add black ink to the welled palette and use the #2 Filbert brush to add random dark strokes on the door to convey the darker boards showing in the reference image.

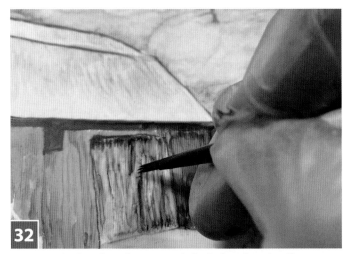

32 Dampen the brush with isopropyl alcohol and tap it off on a paper towel. Use the dampened brush to blend and soften the black with up and down strokes. This black will give the door a weathered, realistic look.

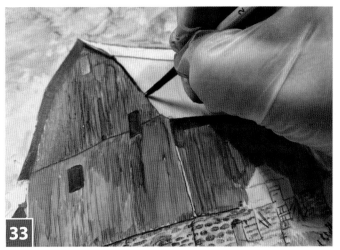

33 Paint black ink along the top edge of the barn to add the shadowing on this edge shown in the reference image.

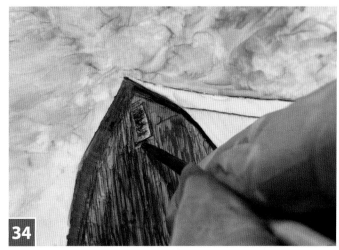

34 Lightly fill in the loft air vent with black and outline the bottom edge.

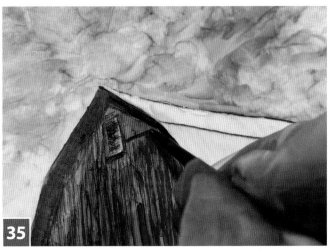

35 Add the horizontal eave lines where the boards meet on the barn face and thicken the roof line.

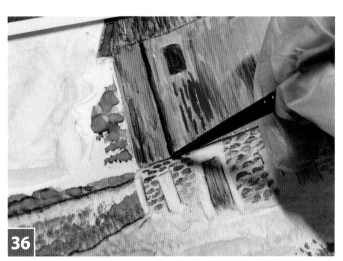

36 Use the black ink to create space for any missing boards.

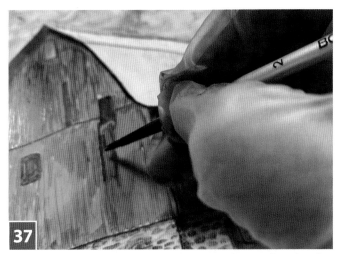

37 **Add more red ink to the welled palette.** Use the #2 Filbert brush to randomly add vertical strokes and add color variation to the wood on the barn.

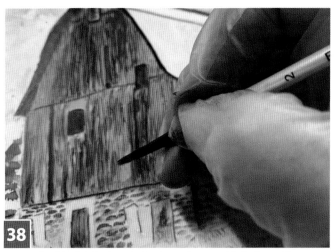

38 Using the black ink already in the palette, add dark strokes to various sections of the wood to create a weathered, graying look.

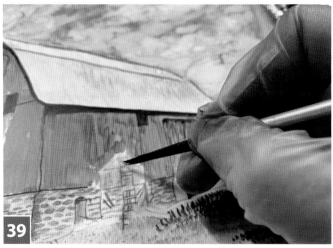

39

Using the blue ink already in the welled palette, paint the entire grain bin blue.

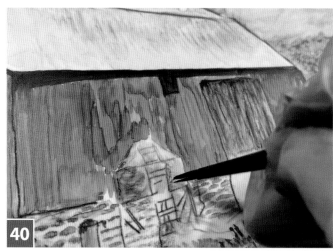

40

Using the gray ink already in the welled palette, paint over the blue on the left side of the grain bin closest to the barn to create the shadow.

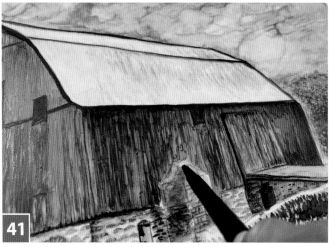

41

Add some highlighted areas on the top right of the grain bin by tapping it with a damp brush and lifting ink with a paper towel.

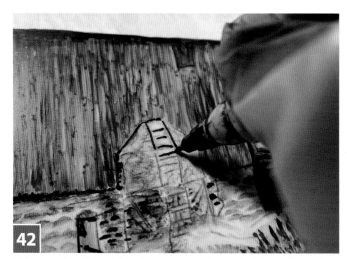

42

Using an ultra-fine tip black marker, outline the edges of the grain bin closest to the barn and draw in the spokes of the ladder. Add in the additional details, like structural elements and other darker marks.

43

Mix some of the black ink with some of the blue ink. Paint in the lower part of the grain bin to depict its darker value.

44

Using an ultra-fine tip black marker, **add a dashed line going across the bottom edge of the roof.** There are hundreds of tiny details in this painting, so feel free to add the details you find most interesting.

45 Using the damp #2 Filbert brush, soften the dots by dragging the brush tip horizontally across the line.

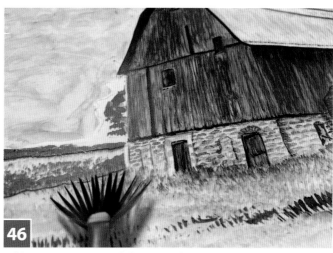

46 Add more grass around the base of the barn if needed using the fan brush and the yellow-green and dark green inks.

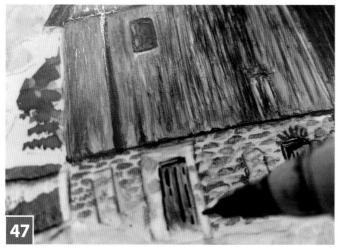

47 Use the ultra-fine tip black marker to outline the doors and windows and add more detail and depth.

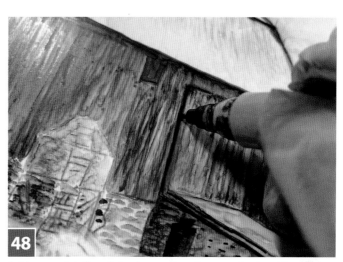

48 Add more detail and shadow to the elements in the side door ramp.

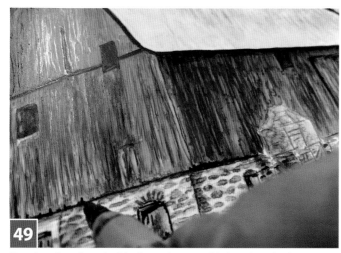

49 Use the ultra-fine tip black marker to add detail to the bottom edge of the barn's wood to create a more weathered, rough look. Use the #2 Filbert brush dampened with isopropyl alcohol to blend this edge.

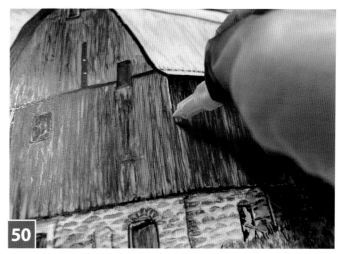

50 Use the white acrylic paint pen to add highlights in missing boards, at the edges of windows, and anywhere the light might reflect.

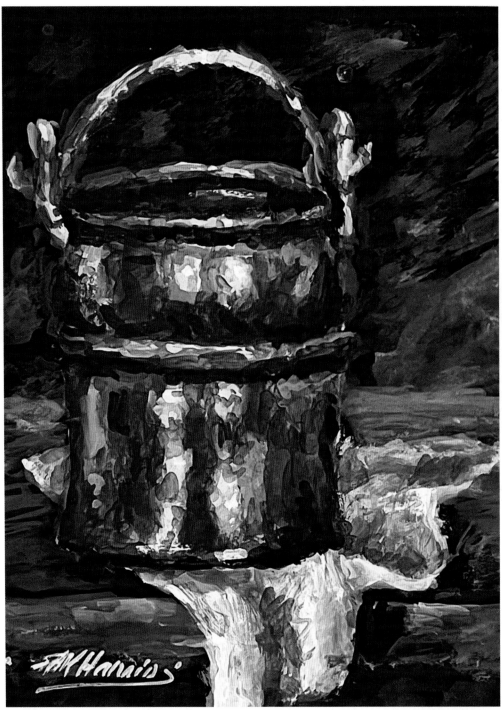

Shining Copper Pot

This beautiful still life starts with a white opaque sketch on black card stock. You can always trace the final painting and transfer it to the paper with charcoal transfer paper, but I encourage you to give sketching a try!

by Sharen AK Harris, *https://sharenakharris.com/*

Materials and Supplies

- Alcohol Inks in the following colors:
 - » Yellow (Ranger's Tim Holtz Dandelion)
 - » Mustard Yellow (Ranger's Tim Holtz Honeycomb)
 - » Red-Brown (Ranger's Tim Holtz Sepia)
 - » Orange (Ranger's Tim Holtz Valencia)
 - » Brown (Ranger's Tim Holtz Teakwood)
 - » Opaque White (Ranger's Tim Holtz Snow Cap Mixative)

- 5" x 7" (12.7 x 17.8cm) Black Card Stock (Ranger)
- 91% or 99% Isopropyl Alcohol
- Container (to hold isopropyl alcohol)
- Small #2 Round Paintbrush
- Paper Napkins
- Welled Palette

The artist used the products in parentheses. Substitute your choice of brands, tools, and materials as desired.

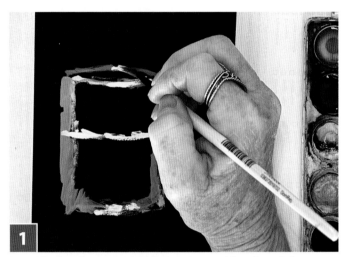

1 **Roughly sketch your pot with the #2 round brush and the opaque white ink.** Draw in a rectangle a bit off center, divide the rectangle about a third of the way down, and add an ellipse to represent the top edge.

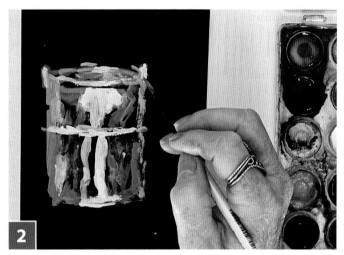

2 Paint in the highlights, applying as many coats as needed to create a strong light base.

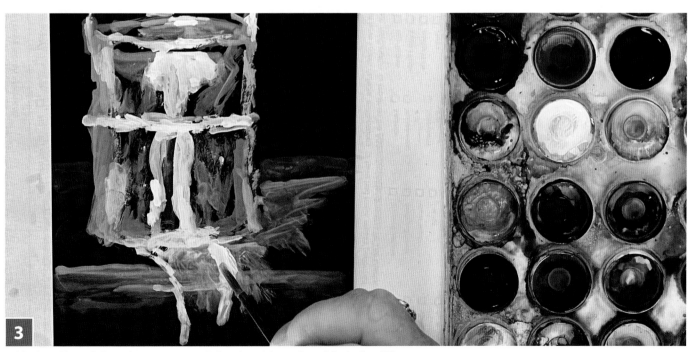

3 Add a handle and the side supports and sketch in where the tablecloth will be.

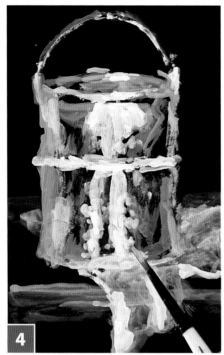

4 Reinforce the light areas as needed and add texture to the pot by lifting your brush straight up and down.

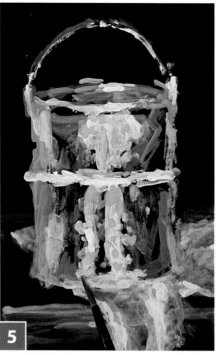

5 Add all the inks to the welled palette. Add yellow first. Since it's the brightest and lightest color it will help you control your values.

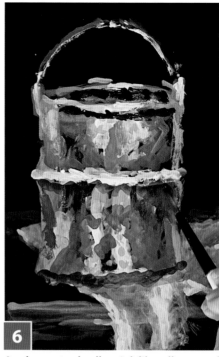

6 Apply mustard yellow ink liberally around the light areas.

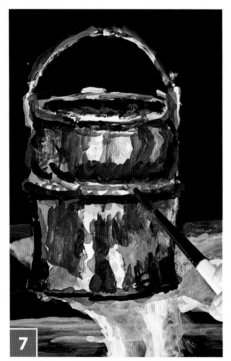

7 Add red-brown ink in the darkest areas, then add orange ink in between the very dark and medium values. Blend these transition colors.

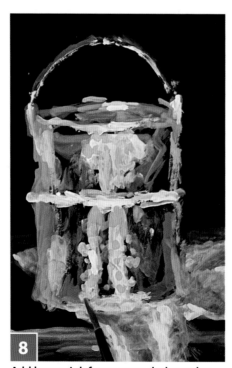

8 Add brown ink for an even darker value.

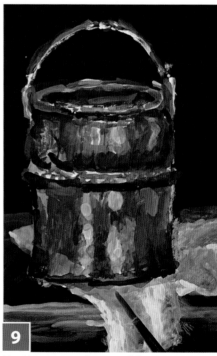

9 Use the same colors used for the pot to add the medium value area of the tablecloth.

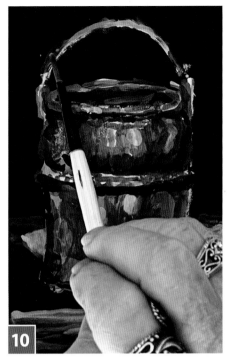

10

Add the colors to fill out the handle. If you like a sharper line, add more layers.

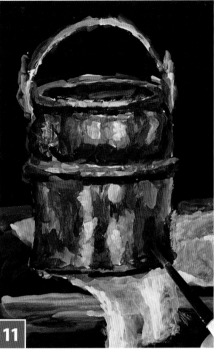

11

Use the darker ink colors to deepen some of the shadows in the pot.

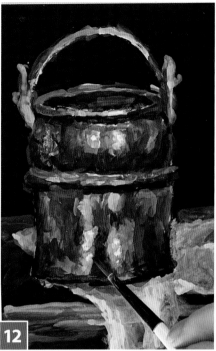

12

Use the opaque white ink to add the highlights created by the light reflecting off the tablecloth.

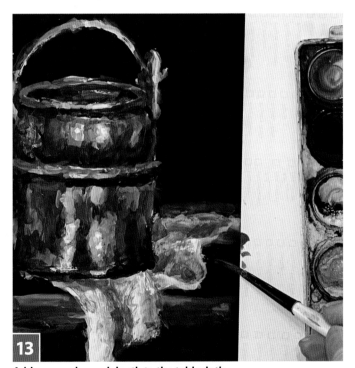

13

Add more color and depth to the tablecloth.

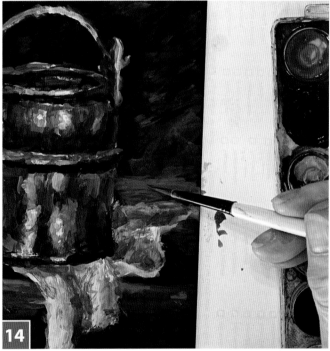

14

Use the same brush, without cleaning it, to scribble in abstract texture on the background.

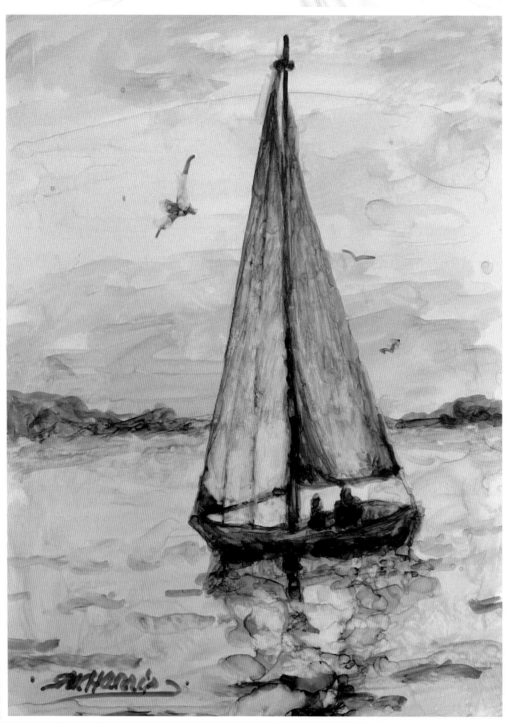

Serene Sailboat

The more layers you add to a painting, the more realistic it will get. It's all about layers and patience. I love a more impressionistic artsy finish but remember to go with what you enjoy as an artist.

by Sharen AK Harris, *https://sharenakharris.com/*

Materials and Supplies

- Alcohol Inks in the following colors:
 - » Aqua (Ranger's Tim Holtz Aquamarine)
 - » Mustard Yellow (Ranger's Tim Holtz Honeycomb)
 - » Red-Brown (Ranger's Tim Holtz Sepia)
 - » Brown (Ranger's Tim Holtz Teakwood)
- 5" x 7" (12.7 x 17.8cm) Transparent Synthetic Paper Sheet (Yupo)

- 91% or 99% Isopropyl Alcohol
- Container (to hold isopropyl alcohol)
- Paintbrushes
 - » #2, #4, and #6 Round Brushes
 - » #01 Liner Brush
- Paper Napkins
- Welled Palette

The artist used the products in parentheses. Substitute your choice of brands, tools, and materials as desired.

1 Apply a thin layer of aqua ink to the top section of your paper and a layer of mustard yellow ink below it as shown. Work in many layers and apply paint a little at a time.

2 Add more aqua ink to the bottom of the paper and softly blend very lightly between the layers with an almost-dry #6 round brush.

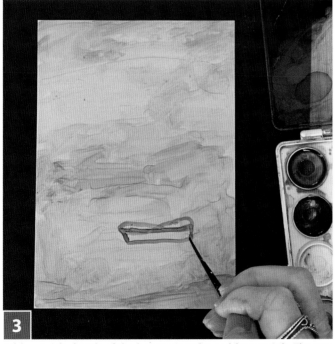

3 Add a rough sketch of the boat using the red-brown ink. The top of the boat basically makes an *8* or infinity symbol shape. The base is a rectangle.

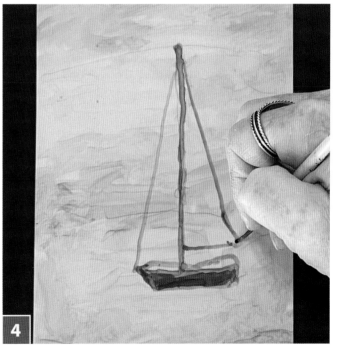

4 Fill in the base of the boat and add the mast and triangles for the sails.

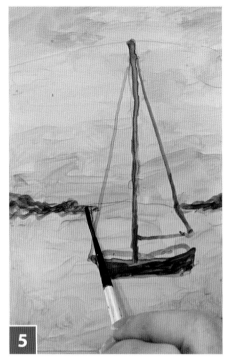

5 Make a mixture of the red-brown and brown inks and apply it to the base of the boat. Use this same color to add in the distant land and place a touch of aqua ink on top.

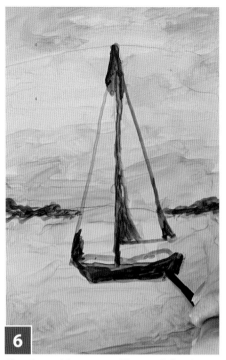

6 Use the red-brown and brown ink mix to add the dark areas to the corners of the sails. Layer to reach the desired darkness.

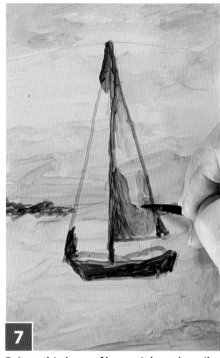

7 Paint a thin layer of brown ink on the sails.

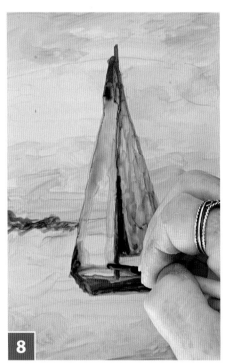

8 Add mustard yellow ink to the body of the sails and blend.

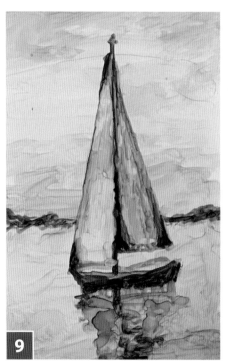

9 Make the waves closest to the boat lighter, then make them darker as they move away from the boat. Go back and forth reinforcing your lights and darks.

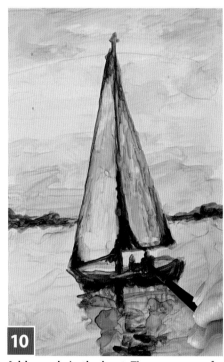

10 Add people in the boat. They are more of a silhouette because of being backlit in the scene: basically two rectangles with small circles at the top.

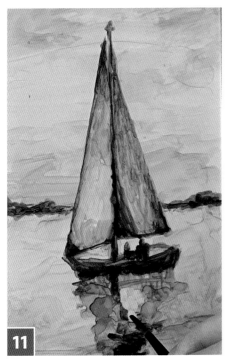

11 Lift a bit of the ink in the reflection by adding alcohol and patting the area with a napkin.

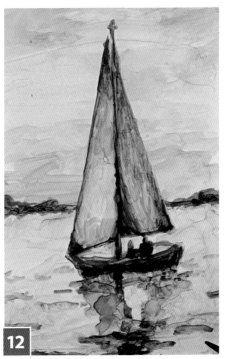

12 Add darker aqua waves to the water. The waves closer to the boat are lighter and thinner.

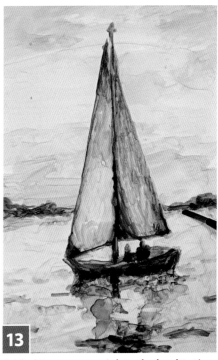

13 Add a bit more aqua ink to the land to tie the painting together.

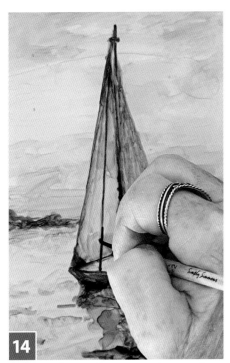

14 Make two brown dots, one at the top of the sail and the other at the bottom and drag a line between them across the sail. Moving the brush with your whole arm and shoulder rather than just your hand will help keep the line straight. Repeat to add a second rigging line.

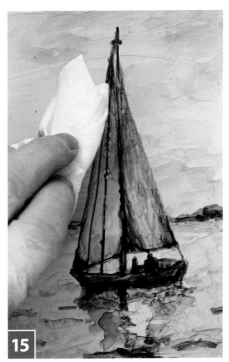

15 Go back and break up the rigging lines with a damp liner brush, then lift off ink as shown. It gives the rigging a natural look.

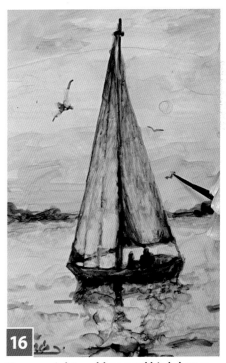

16 Use aqua ink to add general bird shapes in different sizes and flying in different directions. I added three, but feel free to add a whole flock or none at all. Break up the color on the birds a bit with the same lifting technique used for the rigging.

TEMPLATES

While some of the exercises and projects in this book rely on the free-flowing nature of alcohol inks to create loose, organic pieces, most are best achieved if you start by copying the templates below and use the images as working guides. Enlarge or reduce these templates as needed to fit your medium.

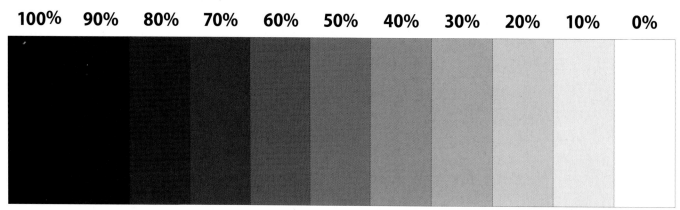

| 100% | 90% | 80% | 70% | 60% | 50% | 40% | 30% | 20% | 10% | 0% |

Gray Scale, page 46

Using Masking Fluid and a Brush, page 54

Push and Glide Painting, page 58

Layering Inks, page 60

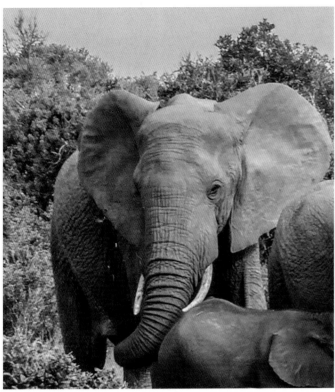

Elephant in Primary Colors, page 70

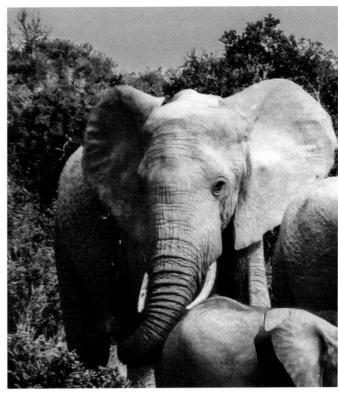

Elephant in Primary Colors, page 70

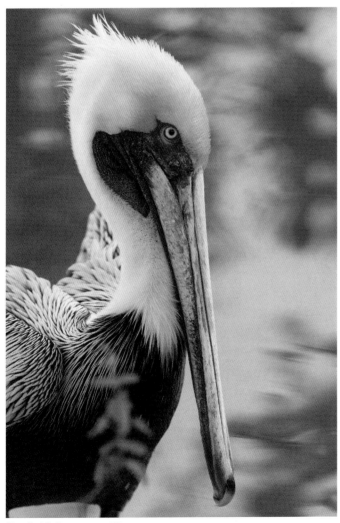

Shaded Pelican, page 78

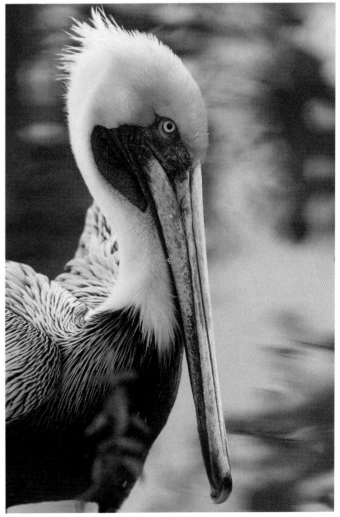

Shaded Pelican, page 78

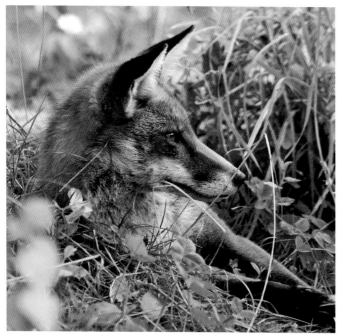

Fox in the Grass, page 64

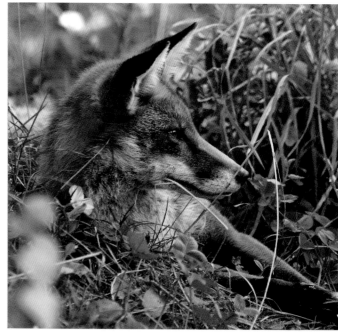

Fox in the Grass, page 64

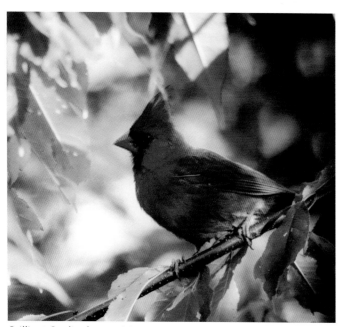

Brilliant Cardinal, page 94

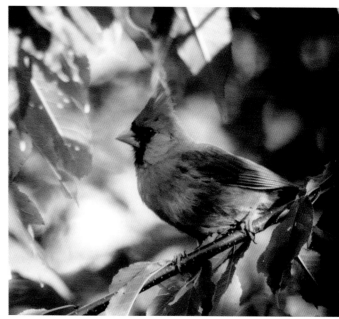

Brilliant Cardinal, page 94

Tranquil Sea Turtle, page 74

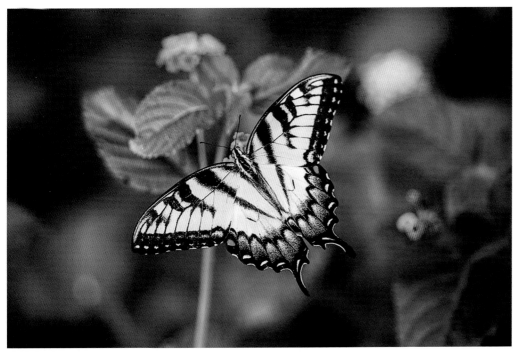

Butterfly Garden, page 88

Tropical Beach, page 112

Tropical Beach, page 112

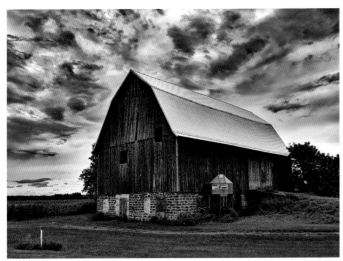

Weathered Red Barn, page 140

Weathered Red Barn, page 140

"Show Your Roots" Waterscape, page 122

"Show Your Roots" Waterscape, page 122

Portrait in Ink, page 136

Portrait in Ink, page 136

Dauphin Island Lighthouse, page 130

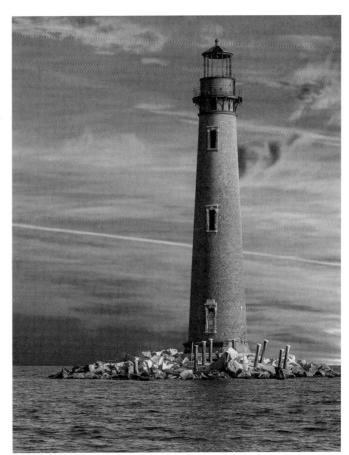

Dauphin Island Lighthouse, page 130

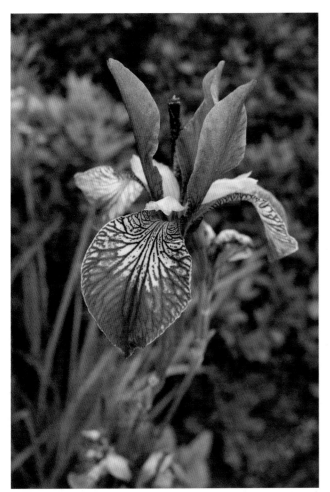

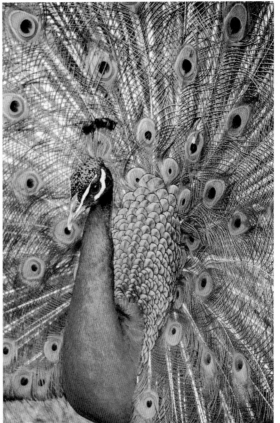

Proud Peacock, page 100

Iris Stunner, page 106

Fabulous Fall Foliage, page 118

Contributors

The projects in this book have been graciously provided by some of the most talented alcohol ink artists and instructors in the field. These contributors consistently support the alcohol ink community and share their expertise at our Alcohol Ink Art Conferences. Each contributor has her own unique style and approach to creating with alcohol ink. Be sure to visit the contributors' websites to learn more about them and their art.

Andrea Patton
https://apatton.faso.com

Francine Dufour Jones
https://francinedufourjones.com

Korinne Carpino
https://korinnecarpinoart.com

Sandy Sandy
https://www.sandysandyfineart.com

Sharen AK Harris
https://sharenakharris.com

Teresa K. Brown
https://www.tkbrownart.com

Teri Jones
https://terijones.com

Vera Worthington
https://www.veraworthington.com

Acknowledgments

We extend our heartfelt gratitude to the fellow artists and valued members of the Alcohol Ink Art Community/Society who have been an integral part of our journey. Throughout the years, your unwavering support and shared experiences have propelled us forward, leading us to explore uncharted realms and unravel the enchantment of alcohol ink. With deep admiration, this book is dedicated to those exceptional alcohol ink artists who have channeled their passion toward the creation of astonishingly realistic artwork.

Our extreme gratitude goes to the creative contributors who graciously provided their expertise and talents by sharing their artistic projects in this book. Without your input and support, this book would not have been complete. Thank you, Andrea Patton, Francine Dufour Jones, Korinne Carpino, Sandy Sandy, Sharen AK Harris, Teresa K. Brown, Teri Jones, and Vera Worthington.

Thank you to everyone at Fox Chapel Publishing, especially to our editorial and PR team, Amelia Johanson, Sherry Vitolo, and Elizabeth Martins, who kept us on track and provided guidance through the entire publishing process, and to our designer, Mike Deppen, whose clever design gave life to our vision.

And, last, though certainly not least, we would like to thank our families and friends, who continue to encourage and support us.

> "I would like to thank my husband, Jim, and daughters, Christina and Michelle, for their continuous support in my artistic endeavors. I would also like to thank Sheryl and the contributors for their expertise. I've learned so much from all of you. Finally, I would like to thank my amazingly talented uncle, David Gallagher, for giving me my first real art lesson when I was just six years old and being my ongoing inspiration to create art."
>
> —Laurie "Trumpet" Williams

> "I would like to thank Laurie for her joy and creative energy, smart ideas, and drive to complete this first book. And I also want to thank all of my online alcohol ink students who pushed me to find ways to always be clear and concise and effectively share my love of the medium."
>
> —Sheryl Williams

Index

About the Authors

Laurie Williams

Laurie "Trumpet" Williams is a mixed-media and alcohol ink artist, instructor, and influencer. She has been creating with alcohol ink for over a decade and is a community builder and unwavering evangelist for the medium. She has an unbreakable bond with the vivid colors and spontaneous nature of alcohol inks and loves spreading the joy they bring to everyone she meets. She believes that alcohol ink is a gateway medium for many beginners and that anyone with a will to create can become an artist.

Laurie founded the Alcohol Ink Art Community™, the Alcohol Ink Art Society™, and Mixed Media Mad™ to bring together artists of all levels and mediums from around the world. Additionally, Laurie, along with coauthor, Sheryl Williams, founded the CreateSmART Academy™, an online marketplace for alcohol ink and mixed-media instruction. Collectively, these educational and inspirational resources inspire over 70,000 artists.

Outside of her art career, Laurie is a professional graphic designer and internet marketing consultant, helping creative entrepreneurs succeed online. She's the founder and CEO of Trumpet Marketing™ and she runs an art marketing and consulting business called ArtBugle™, which helps fellow artists build and promote their brands online. She lives in Boyds, Maryland, with her husband, Jim, her lovely daughters, Christina and Michelle, and her maltipoos, Ruby Tuesday and Penny Lane. She enjoys music, art, theater, and being outdoors.

To learn more about Laurie and her adventures, visit her online at *https://laurietrumpet.com* and *https://trumpetart.com*, and on Instagram, Facebook, YouTube, and TikTok @*laurietrumpet*.

Sheryl Williams

Using the deep, rich colors in alcohol ink, Sheryl Williams plays with light and shadow and brings her heart, laughter, and joy to her paintings. She only paints images that touch her soul and hopes they will touch you as well. She pushes the envelope to create realistic, vibrant, detailed paintings in a medium best known for abstract beauty. After many years of experimenting with this new medium she found success and joy controlling the "uncontrollable."

An award-winning artist in watercolor, alcohol ink, oil, and charcoal, Sheryl loves to teach. Her greatest thrill is the moment when a student "gets it" and can truly express themselves in their art. She teaches her skills online to through the CreateSmART Academy, offering an online Alcohol Ink Master Course that starts at the very beginning and works all the way up to advanced representational art. She is excited to bring the joy of alcohol inks to students who love color and want to try their hand at combining representational art with beautiful, poured backgrounds.

You can see her art in multiple mediums at *https://sherylwilliamsart.com*.

Alcohol Ink Art Community
Learn, create, and share your alcohol ink art at *https://alcoholink.community*

Alcohol Ink Art Society
Join an inner circle of alcohol ink artists at *https://alcoholink.community/society*

Create SmART Academy
Explore courses and lessons for alcohol ink and mixed media at *https://createsmart.academy*